MILLENNIUM MODE

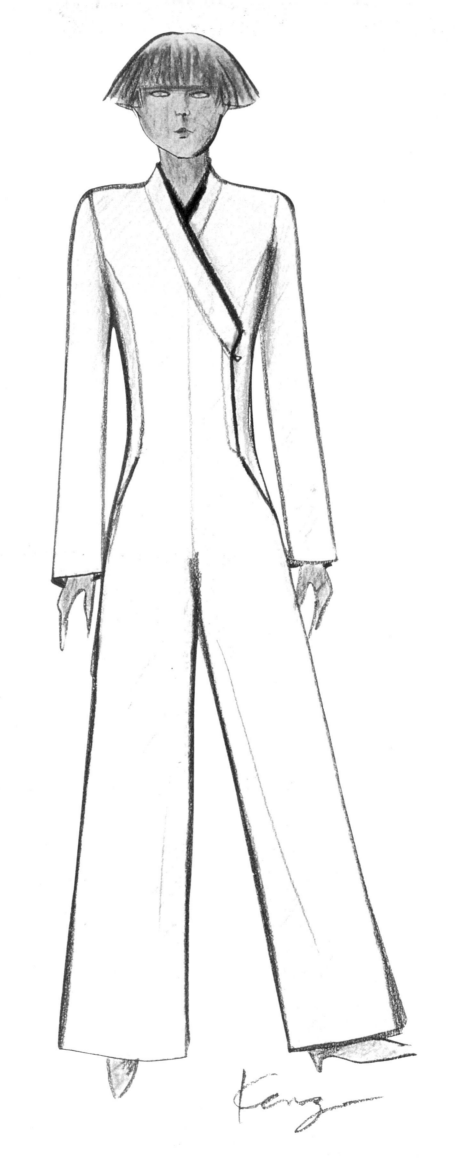

PHOTOGRAPHY: **TRUDY SCHLACHTER**

TEXT: **ROBERTA WOLF AND TRUDY SCHLACHTER**

INTRODUCTION: **RICHARD MARTIN**

MILLENNIUM MODE
FASHION FORECASTS FROM 40 TOP DESIGNERS

RIZZOLI
NEW YORK

SPECIAL THANKS TO THE MEN IN OUR LIVES, OUR MOST ARDENT FANS | MARVIN, BRAD, SCOTT, AND KRISTOFER SCHLACHTER | FRANK, JEFFREY, AND GARY WOLF

First published in the United States of America in 1999 by
Rizzoli International Publications, Inc.
300 Park Avenue South
New York, NY 10010

LYCRA® is a DuPont–registered trademark for its brand of
elastane fiber. Only DuPont makes **LYCRA®**.
Usage of the term **LYCRA®** in quotations from this book must
be accompanied by a registered trademark.

PANTONE® is a registered trademark of Pantone, Inc.
PANTONE Color names are from the **PANTONE
TEXTILE Color System®**.
Usage of the term **PANTONE®** in quotations from this book
must be accompanied by a registered trademark.

ISBN 0-8478-2114-5
LC 99-70710

Art direction and design by Peter Yates

On front cover: Liskula for Escada
On back cover: Siew Longhorn for Dolce & Gabbana

Printed in Singapore

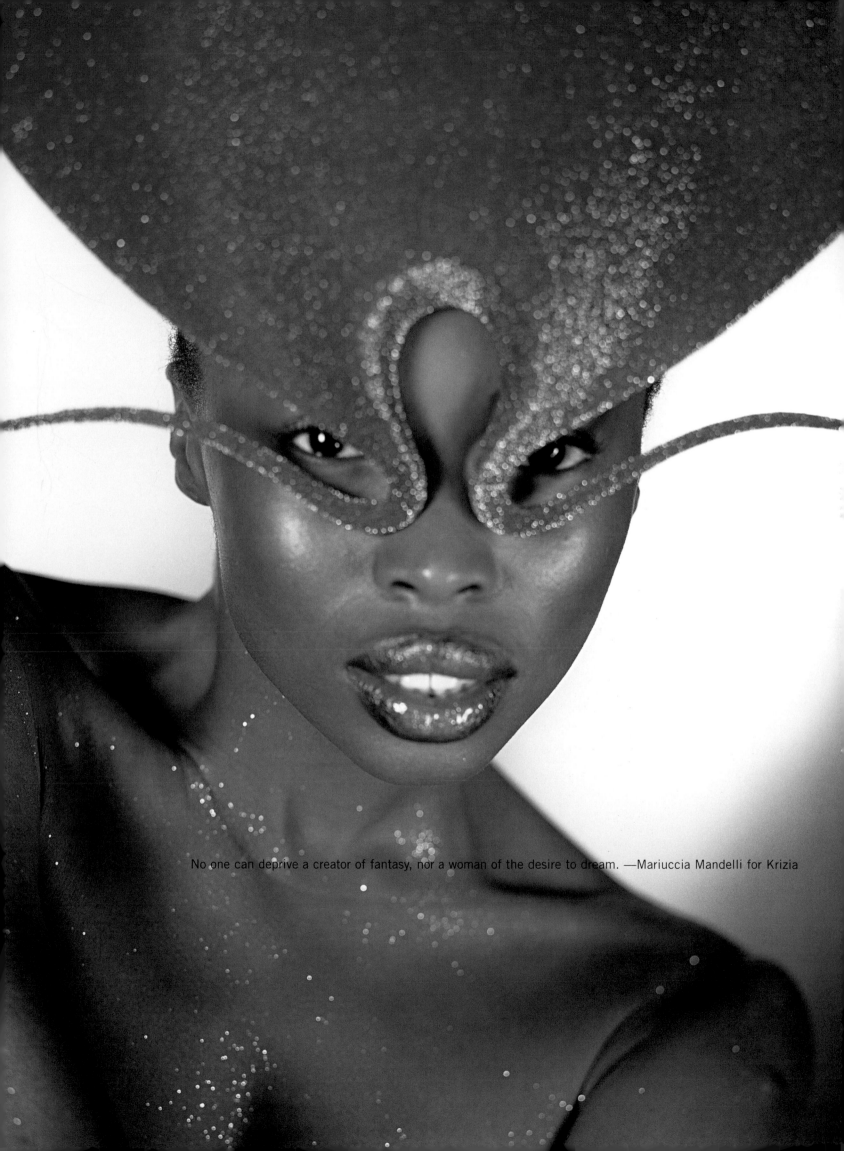

No one can deprive a creator of fantasy, nor a woman of the desire to dream. —Mariuccia Mandelli for Krizia

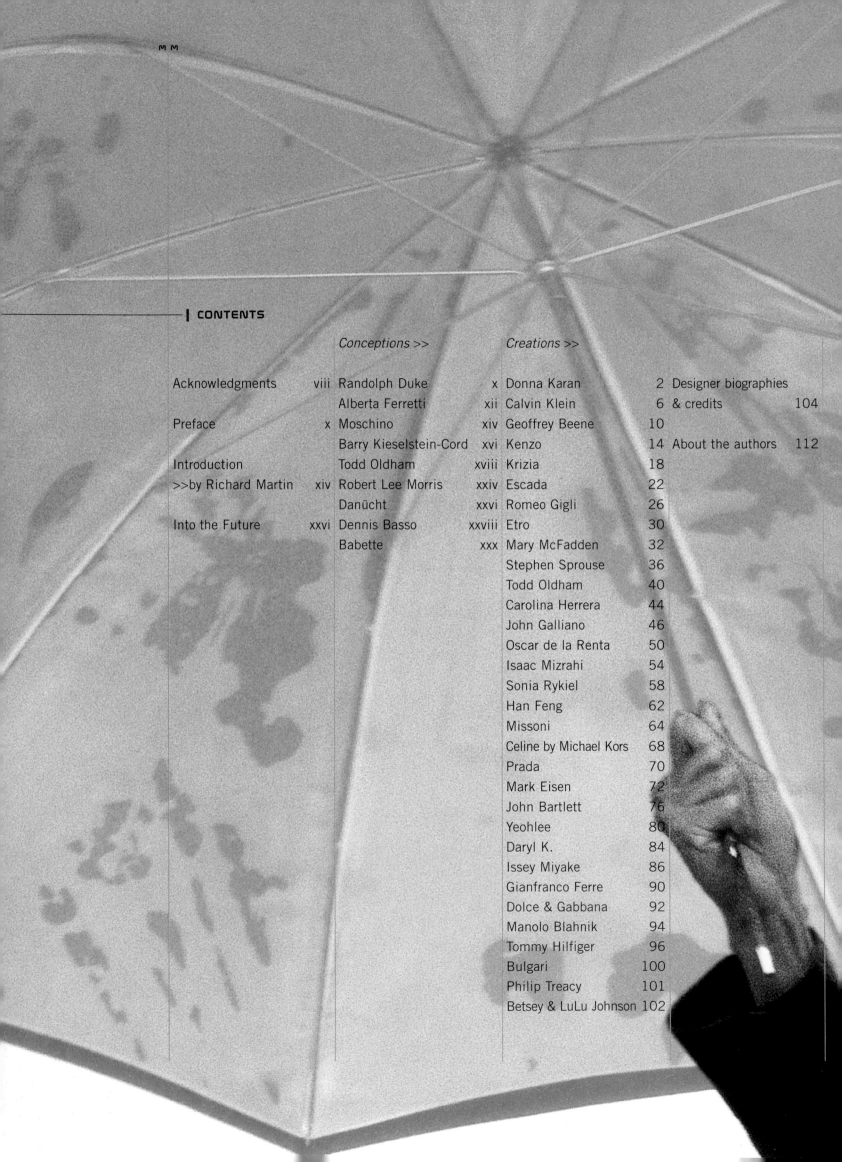

| CONTENTS

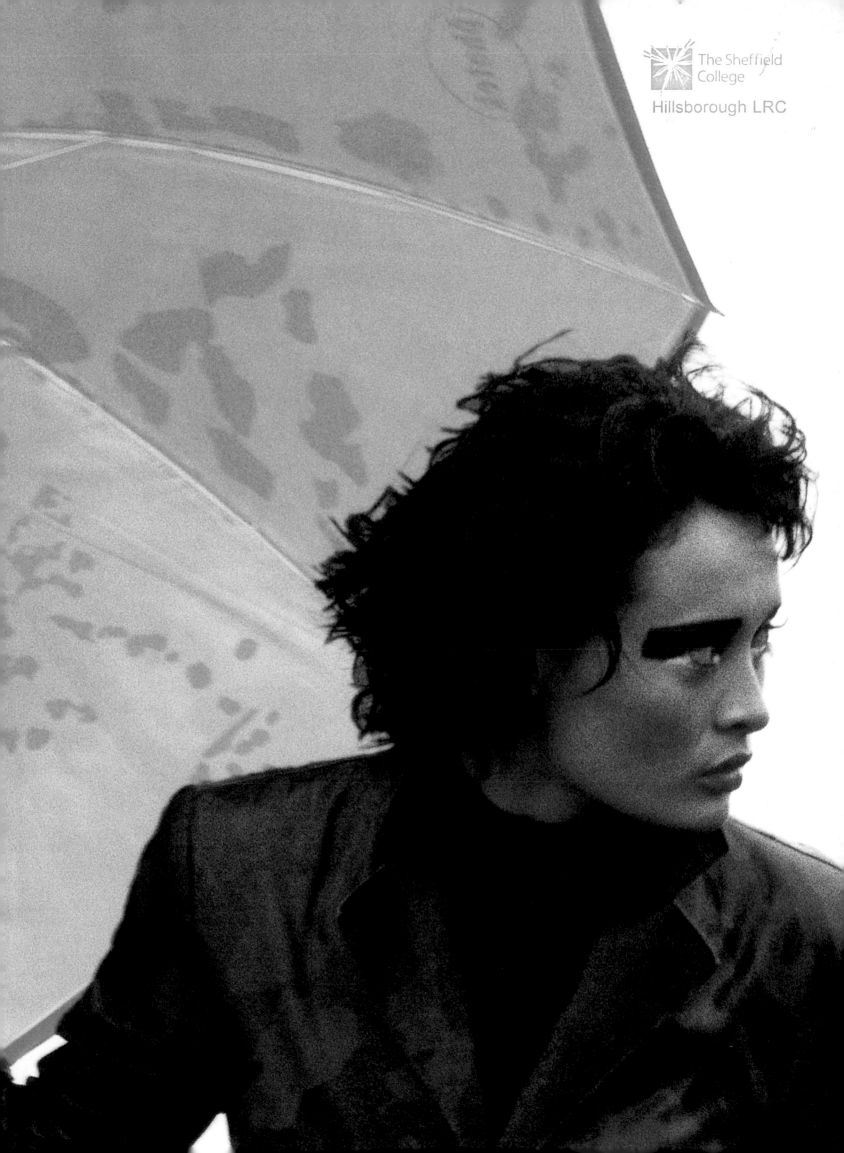

THIS BOOK WOULD NOT HAVE BEEN POSSIBLE WITHOUT

THE GENEROUS SUPPORT OF OUR PRESENTING SPONSOR: DUPONT LYCRA

AND ADDITIONAL SPONSORS **|** **PANTONE** **|** DUGGAL COLOR PROJECTS

The generosity of DuPont Lycra was critical for producing our book. We acknowledge Frank Oswald and Verne O'Hara for recommending our project. Our special thanks to Karen Eways at DuPont and Andrea Berken and Beth Kulick at The Rowland Company for their enormous contribution.

Our appreciation goes out to Evelyn Dallal for introducing *Millennium Mode* to Lisa Herbert at Pantone, whose generosity and support helped make this book a reality.

The generous contribution of Dave Duggal at Duggal Color Projects, Inc. also helped make this book possible. Their film processing, duplicating, and fine color printing enhanced the quality of the photographs of *Millennium Mode*.

An enormous thank you to Richard Martin, curator of The Costume Institute at the Metropolitan Museum of Art, who gave generously of his time and knowledge. When we started our project, Richard Martin was on our wish list as the writer of the introduction...our wish came true! He brought invaluable historical and scholarly perspective to *Millennium Mode*.

Sincere gratitude is extended to Solveig Williams, our publisher at Rizzoli, who believed in our project from the onset and whose expertise and guidance served as a foundation for *Millennium Mode*. Her patience, cooperation, and support throughout the project were invaluable.

We were fortunate to have the guidance of associate publisher, Elizabeth White, and Melissa Moyal, our editor. We thank them for their insight and judgment.

For his creativity, vivid imagination, and hi-tech sensibility, we thank Peter Yates, our talented graphic designer.

Gratitude is extended to each designer's staff and/or P.R. agent. You all served as a support system in helping us secure the interviews and the garments. You were indispensable:

Susan Sokol, Patti Cohen, Gary Nelson, Virginia Smith, Ottavia Asinari, Nina Santisi, Cindy Wachter, Kristin Flores, June Mattheson, Mary Loving, Pilar Crespi, Paul Wilmot, Russell Nardoza, Lisa Pomerantz, Luigi Mazzel, Claudine DeSola, and *Barton Friedland*

Many thanks to the representatives from the model and talent agencies, whose cooperation throughout the project was indispensable:

Steven Howley/Elite Celebrities, Lisa Haberman/Elite, Stuart Ross/IMG, Mae & John/Women, Phillipe Buka/Karin, Andrew Broz/Company, Drew Lineman/DNA, Donny Miller/Timothy Priano, and *Robin Krasner/Trilese*

Behind the scenes we would like to thank:

Desiree Kennedy and Cindi Harris, our studio managers, who from the beginning were devoted and enthusiastic. This project could not have been done without their expertise in coordinating all the endless details involving the book;

Carmen Salcedo, our talented production coordinator whose unique creative spirit enhanced the book;

The unflappable *Jennifer Davidson*, for your availability, professionalism, and organizational skills;

Delphine Pousson, our charming and capable intern;

Mamiya, for the complimentary use of the RZ67;

and *Francesca Hayslett*, for editing and some text.

—Roberta Wolf and Trudy Schlachter

On the woman of the future:
She will be highly evolved in her understanding of life. Her interior development will grow in tandem with her technological expertise. That is, there will be an organic counterweight to our technological advancement as women and men discover who they really are and learn to define and integrate that into their lives.

On fabrics of the future:
Fabric is the basis for clothing, or body covering, as we know it. In fact, I prefer the term "body covering." We must learn to think in new ways to find the future, open our minds to the infinite possibilities of expression as well as the utilitarian nature of body covering. It is not farfetched to imagine a body covering with built-in micro computer chips, or fabrics that transcend the traditional properties of fibers as we know them. On the other hand, an organic backlash or revolution may also occur, pushing us in more natural, earth-bound directions. I suspect a combination of these two tendencies will emerge.

—Randolph Duke

PREFACE

We began working on this book for the simple reason that we love fashion. We love everything about it—the business, the personalities, the drama, the gossip, and of course, the clothes. As New Yorkers, we revel in the frenetic activity that consumes the fashion world each spring and fall: the high theater of runway presentations, the critics' quick judgements, the slower but ultimately more critical judgement rendered by women in the streets. As fashion professionals, a photographer/art director and a public relations director, respectively, we read the fashion press religiously. We lament the loss of talented designers such as Isaac Mizrahi to a difficult financial system and wax nostalgic about the long-gone boutiques that punctuated the past. The fact is that, deep down, we believe that fashion truly matters.

A unique form of expression, it captures the political, social, economic, and cultural strands of a distinct period in time. Take, for instance, the feminist movement of the 1970s. The launch of the women's rights movement and the introduction of the Equal Rights Amendment in government will always be equated with the symbol of a burning bra—the boldest of fashion statements. Women designers such as Diane von Furstenburg started up their own companies and created form-fitting fashions such as the wrap dress, which allowed women to assert their independence by embracing their sexuality. Beneath the glitz of celebrities and supermodels, fashion is a reflection of our society, from the rampant drug abuse epitomized by "heroin chic" to economic booms in the stock market, which brought a return to luxurious clothing such as fur. Because we believe fashion matters in this way, we are profoundly curious about its future.

The book itself started out as a modest venture. The opportunity to style and photograph fashion in a non-commercial, creative manner was an irresistible challenge. We thought we'd ask a few designers about their visions of the future, photograph their creations, and publish a small diary. But almost as soon as we started, the project took on its own momentum, growing in size and scope until we found ourselves involved in a full-scale appraisal of the millennial moment in fashion. In hindsight, perhaps we shouldn't have been surprised at the response. There are few creative fields more acutely attuned to time—past, present, future, and the evanescent, almost indefinable "moment"—than fashion. Designers are futurists by nature, exceedingly sensitive to the social and aesthetic forces that propel us forward in our lives. They see, they feel, they sense that which is most personal, most compelling, most certain to carry us into the next day, the next season, the next millennium.

From the start, we were determined to gather only original material for the book. We didn't want a compendium of futurist visions from decades past. We wanted a new and forward-looking view of the future, a snapshot of designers' hopes and visions for the next millennium taken at the very threshold of the new era. This proved easier than we knew. Despite the already enormous demands on their time and energy, many designers were willing and eager to discuss and describe the future. They took our questions seriously, devoting time and thought to a question far from the demands of next season's collection. For some, it was a chance to explore ideas they had only half thought through, for others it was an opportunity to express fears and desires they've had for years. In the end, we arrived at a remarkable assemblage of fashion photography and sketches by forty of the most influential designers of the world, designs that were in most cases created expressly for *Millennium Mode.*

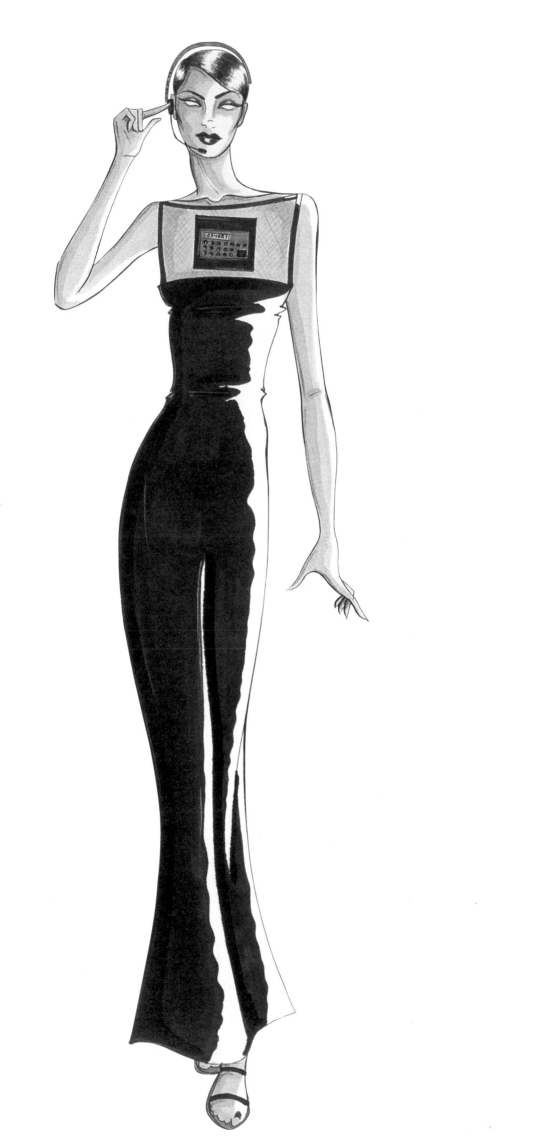

Of course, the devil is in the details, and there were days when we lived in hell. Coordinating the production, delivery, photography, and return of so many one-of-a-kind garments required logistics on a scale usually seen in small wars. There were times when we worried that the project would not be finished in time for the millennium. But despite the grand scale of the venture, or more likely because of it, we found ourselves increasingly enthralled by the possibilities implied in fashion's future. Every statement we received, every sketch, every item of clothing increased our enthusiasm for our project. Inevitably, we started to find references to fashion's future everywhere we turned. We found futurist designs and the extraordinary work of the MIT Media Lab on the Web; friends brought us tales of virtual fabrics, computer-aided design, and wearable computers; we started reading cyberpunk books and pondering the prophetic words of past visionaries such as Rudi Gernreich and Claire McCardell.

Interestingly, the creations we received from designers fell into several clear-cut categories. From designers like Donna Karan came pieces that can only be considered spiritual. Others, like Stephen Sprouse, provided clothes that are utterly and exhilaratingly high-tech. It appears there will still be a classic school in the future, designed by the aesthetic heirs to Michael Kors and John Bartlett. And in the hands of Todd Oldham and John Galliano, fantasy prevails.

While all the designs in this book are beautiful, not all the designers are optimistic about what the new millennium heralds. The dehumanizing impact of technology is a subject that weighs heavily on the minds of many designers, who worry about a world run by megalithic corporations and awash in human alienation. For them, the designer's role in such a world is to tend to the individual's soul, to probe and nurture that which is creative, expressive, irreducibly human. Describing a world of violence and alienation, Robert Lee Morris says, "In this context fashion and art become increasingly important as an antidote, as something low-tech that allows people to remain human."

For others, the future represents possibility, the open-ended promise of a world made more hospitable—and a fashion system more responsive—through technology and higher understanding. Some, like Mariuccia Mandelli of Krizia, see society moving toward a more equitable foundation. "The world is in the hands of women," she states. "If we can trust them we shall move toward a time that is less violent, with fewer wars, less injustice, more respect for the environment." Others look toward fabric innovations and color developments that will open fashion up to the needs of the wearer. Explains John Bartlett, "As the millennium nears, I see fashion as a wonderful fusion between old and new, urban and rural, male and female…Clothing will become lighter, more protective, and much more multifunctional but will also fulfill the need for individuality and personal self-expression." In all cases, though, the designers we talked to bore a tremendous sense of responsibility for the social and creative values of the future. If these are indeed the design forces that lead us into the millennium, we all have cause to be optimistic.

In the end, then, the creation of this book became for us as much an education as a labor of love. We began with an appreciation of the importance of fashion as a medium of expression, both socially and artistically. Thanks to the thoughtful contributions of so many talented individuals, we finished with a far greater awareness of—and excitement about—what the future may hold. And what an extraordinary role fashion is sure to play in it.

—Trudy Schlachter and Roberta Wolf
New York City, 1998

ALBERTA FERRETTI

On fashion in the next millennium: Already, at the end of this millennium, women have learned to adapt fashion to their own needs. The third millennium will see women become more and more independent of fashion—capable of making their own style. Finally they will use fashion rather than be used by it.

On future inspiration: New events will occur, new artists and photographers will become known, new communications media will be discovered, all of which will surpass the existing ones. We will start traveling toward new worlds and it will be extremely stimulating. Designers of the year 2100 will have everything, and they will finally copy the old 1990s of the second millennium. It's the fashion game.

—Alberta Ferretti

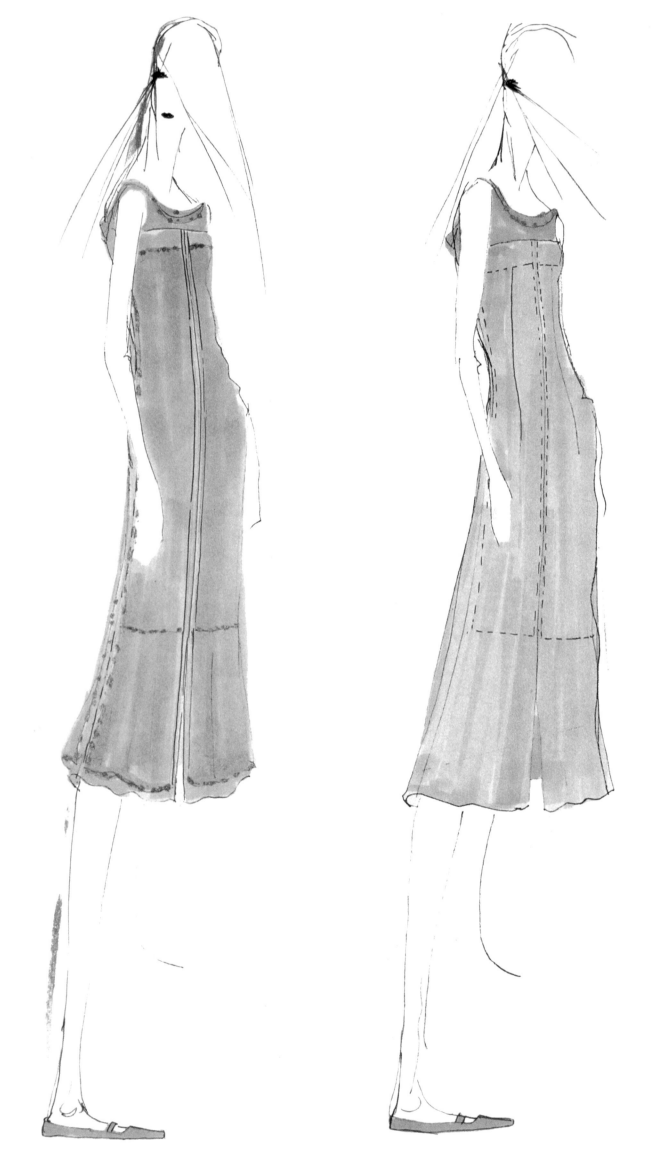

WORK IN PROGRESS...

| INTRODUCTION BY RICHARD MARTIN

> Time has no divisions to mark its passage, there is never a thunder-storm or blare of trumpets to announce the beginning of a new month or year. Even when a new century begins it is only we mortals who ring bells and fire off pistols.
> —Thomas Mann, *The Magic Mountain*

Perhaps all of us had expected a future of Zomboid personalities attired in space-age reductivism. I cannot yet testify to all the specifics of the temperament we can expect at the millennium and 2001, but I know that the imminent time will not be as sleek nor as uniformed as many imagined. The Orwellian sense of conformity paramountly expressed in fashion is clearly not going to happen in the next year. Further, that early 20th-century expectation of the self-sufficient, revolutionary uniform is not a vision of the foreseeable future, but a harkening back to the ideas of Tatlin, Goncharova, Balla, and others working in an early 20th-century utopian mode. They were seeking a uniform for the modernist revolution.

What we are coming to for 2001 bespeaks not only a different fashion, but even more demonstrably a wholly different *Weltanschauung*, or worldview. The obedience and robots, later totalitarianism and robotics, that animated the desires and the anxieties of our century have waned in influence. Now we know that the future will have more congruity with the Banana Republic than any republic dreamed of by Wells, Huxley, or Orwell. Philosopher Gilles Lipovetsky writes in *The Empire of Fashion*, "In our day we dress more for ourselves, more as a function of our own tastes, than in terms of an obligatory, uniform standard. For centuries, individuals could assert autonomy only in the choice of styles and variants; the overall aesthetic standard was not accessible to the exercise of individual freedom." So many possibilities, so many sensibilities present themselves in the pages of this book. Can a romantic and spiritual vision in fashion represent the style for 2001? Can a techno-futurist conceptualization signify the millennium? What of the unabashed conservatism and classicism that declares inconsequential change between 1999 and 2001? This book—like the future, itself—holds a place for the many options, so that all can be accommodated. How relieved we should be that no mandatory style manual or dress code has been delivered!

And why would the bold dreamers have thought that conformity and uniformity lay ahead? For much of the 20th century, fashion seemed to be a sovereign system, imposing styles on a complacent or complicit population. Certainly, at mid-century in the thralldom of Christian Dior's New Look, any Millennialist would have imagined that fashion then dictated would be equally dictated in the next century. But fashion is not so decreed and ordained in our time. This book is the wondrous testimony to fashion's pluralism and flourishing license. Arguably, no other art today—fine arts, music, dance, all ironically more subject to critical vogue than fashion—has such an open, broad entitlement: We have recognized that fashion is ungovernable and inherently democratic, chiefly due to the breakdown of the strict class system and the upheaval of women assuming a more

MOSCHINO

The Future is a WORK IN PROGRESS. Tomorrow is often a result of Today. Our actions shape the world for our children. The Future is theirs.

The Moschino woman has never been preoccupied with the length of her skirt or the width of her jacket. She is self-confident, she has a dynamic lifestyle, she thinks of her career, she plans her vacations, yet her priorities remain her family and home. Because tomorrow is already here, time, peace, and serenity are her true luxuries!

In the future the dress will be an accessory for a woman. It will not be her main priority. She will become more comfortable with her body as the concept of nudity becomes increasingly acceptable.

The Moschino woman will express her femininity in 2000 different ways. She will be rich—rich with humor.

—Rossella Sardinia, Creative Director, Moschino

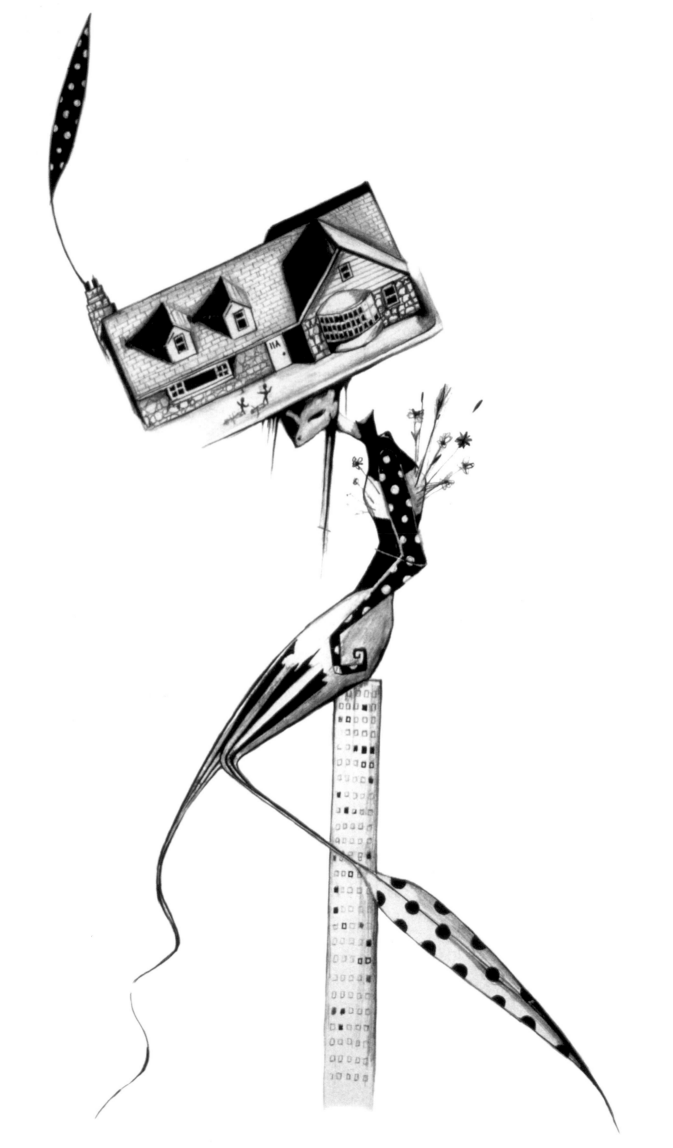

equitable role in the world. Women who rule (even with glass ceilings) will not be ruled by fashion. We know that, but Orwell and the old patriarchy didn't know (or want) that.

Fashion is inexorably propelled toward multiplicity and is a true indicator of democracy. The joy is that this beautiful, expansive book is just the first set of options. Fashion's choices abound; our choices abound. We will not be uniformed at millennium's turn, but neither will we be uninformed. Why does it seem so eminently right and indisputable that sculptor-designer Barry Kieselstein-Cord says of the future role of fashion, "Fashion will bring into play status, chic, social position, and the love of beauty—same as it always has."

We are more acutely aware of fashion and its power today than perhaps at any time in history, having given up the assumption that fashion would control the means of self-expression. The generations of modernism posited a model for future dress in their own reductivism and anxiety. It has proved to be inaccurate. One might argue that we would today go along with our prevailing chaos theory and allow fashion a like clutter simply because we have not studied or comprehended it. But I would argue for the incumbency to address fashion in a manner that would behoove other media as well, even as we may choose to keep faith with painting and sculpture of the old-fashioned kind. One need only read the designers' statements in this book to recognize how seriously fashion designers think about their work and their world. Fashion is a responsible and necessary discourse to prevent our falling into a uniformed and uninformed culture. The very principles of formlessness and "art in flux" now seem to complement a reasoned and effective consideration of fashion by showing that

we can examine that which appears utterly unexaminable.

The continuing "Millennium Notebook" in *Newsweek* reported in a new mode on August 4, 1997 regarding the expectations for fashion in an essay by Kendall Hamilton and Kimberly Martineau entitled "Future Fashions Are Not Quite Ready to Wear." A few paragraphs seemed to be still be of a Flash Gordon prophecy, but the real revelation was how predictable and how likable the future is that *Newsweek* foretells for apparel. At the juncture between aesthetics and science, clothing lends itself to futurist divination. One must remember that fashion designer Geoffrey Beene has spoken frequently of the Alec Guinness film *The Man in the White Suit*, about the creation of a fabric that putatively lasts forever, as one of his favorite films.

Newsweek also goes along with a DuPont fabric scientist in anticipating the presence of smart fabrics, those materials for body covering that will not only wick away perspiration, but vary their hindrance to air, hot, or cold, in accordance with the body and skin temperature. In short, clothing becomes a controlled environment and one can perhaps imagine that we'll never have to shuck off the fall sweater as the day grows warmer. Instead, the sweater will simply become more permeable and allow more air through. A cognate report advances greater stain-resistance in clothing and easier garment care, both phenomena well-articulated and occasionally advanced as product goals for the last fifty years or more.

Specifically, "Elsewhere at DuPont, they're busy making Teflon-coated cloth. 'If you spill red wine on your dress, it rolls right off,' says Paige Wheeler of the company's Teflon division. 'And with mayonnaise, you can just lift it off with a napkin.' They're already making socks

BARRY KIESELSTEIN-CORD

On fashion's role in the next millennium: Fashion will bring into play status, chic, social position, and the love of beauty—same as it always has.

On the global nature of fashion:
While globalization will bring a worldwide appreciation of the clothing of different cultures, pockets of individuality dictated by fashion superstars will still carry the day. And the media will have an even greater impact. The impact of these media will be total. It will be possible to reach a worldwide audience, as well as to direct design to specific groups. Design will influence the entire world through the Internet and worldwide entertainment.

On the fabrics of the future:
Fabrics will change with the weather, responding to temperature and environment. New developments in molecular technology will give birth to fibers such as U.V.-aware materials, etc.

—Barry Kieselstein-Cord

GLOBAL LINK.
VOICE ACTIVATE PHONE
WATCH
MEMO
BINOCULARS.

ERGO PACK.

Vacuum-form
—Solar activated - phyto sensitive fiber.
Sun Screen.

Jewelry Temperature
Regulator
no use for coat

Chap Bag.

KIESELSTEIN-CORD
KIESELSTEIN-CORD

with low-friction Teflon toes and heels to fight blisters; other chafe-prone garments, like bicycle shorts, sports bras and pantyhose, may eventually benefit from similar technology." All of this is, of course, a heartening prediction, but it hardly seems to be major news. The technology of clothing science seems subtle and nuanced, asserting its presence in our lives every day, not commanding dramatic change only because it is so omnipresent. Yeohlee's wondrous new clothing technology is so fully integrated with her design sensibility that stain-removal and exciting design are indivisible, not a conundrum of art versus science. Here, art and science are one: that is one of fashion's paramount virtues, one surpassing many other visual arts. And, as Issey Miyake says in his statement, "This marriage [art and science] has produced textiles and clothing that are both beautiful as well as functional. As we move into the next century, one hopes that the fruits of this union will only continue to evolve and flourish."

Newsweek succumbs, however, to one designer who has planned a so-called "Atlantis" line of clothing that apparently harkens forward as much as the name draws one back. Paul Compitus projects some compelling ideas, including "clothing that fits like a second skin—and even grows and regenerates like skin." If this sounds a little like a bionic person's wardrobe, *Newsweek* also offers some skepticism. To Compitus' claim that seamed areas could accommodate weight loss or gain and split seams would grow together again, *Newsweek* wryly observes, "Sounds like bad news for the Salvation Army." A fashion person might think it bad news for Sonia Rykiel, Rei Kawakubo, and Martin Margiela, too. Yet the fashion designers in this book—such as Celine by Michael Kors—rightly anticipate a time

when needle and thread, fashion's primary tools, are no longer needed and other fusings and bondings will prevail.

Of course, if we cannot expect major changes in fashion for the future, what is the point in including fashion in the scope of millennial predictions? Perhaps we have to admit that fashion, the force most keenly associated with modern fluctuation and change, is now relatively stable and may even be more constant than art. Thus, if Beverly Semmes, Maureen Connor, Christine LoFaso, Rosemarie Tröckel, and other artists of our time have taken clothing as a critical exercise and template, if not fashion per se, are they not choosing a model more eternal than art itself in using clothing as the contrasting reference to the ephemerality of their art? Hamilton and Martineau say carelessly that "Fashion changes faster than a traffic light," but that cliché hardly rings true today. On the contrary, one might say that Chelsea galleries sensibilities change at least as fast as the Tenth Avenue traffic lights. Rather than dismissing fashion for its fluctuation, perhaps we have to recognize it for its persistence. Apparel's great avatar, if not fashion's, is Penelope, who worked in an unending, never-advancing task of weaving. Realistically, has anyone tried out that canard about hem length on you in the past ten years? Does anyone really think that fashion is now that fickle? When Miuccia Prada says later in this volume that the tenets of fashion "will never change," she is absolutely right.

A recent case in point would be the Milan of the past year or so. Did anything change with Gianni Versace's murder? Donatella Versace has proved not unexpectedly that she could continue Gianni Versace's signature style. But Versace is not the only house perpetuating its tradition. The Apollonian-Dionysian antithesis

TODD OLDHAM

We tried to think about what endures: the pocket-T endures. And people will always respond to things that are sexy. So we decided to take the pocket-T and stretch it very, very, very long. The length is a metaphor for two things: the passage of time, and also luxury—the opulence of things that are not practical. The fabric is polyester and Lycra jersey, which you truly can drag over mountains and swim in. The dress is pink because pink is a wonderful color that brings divine qualities to all sides of our life....Technology and nature together—it's important not to go to extremes.

—Todd Oldham

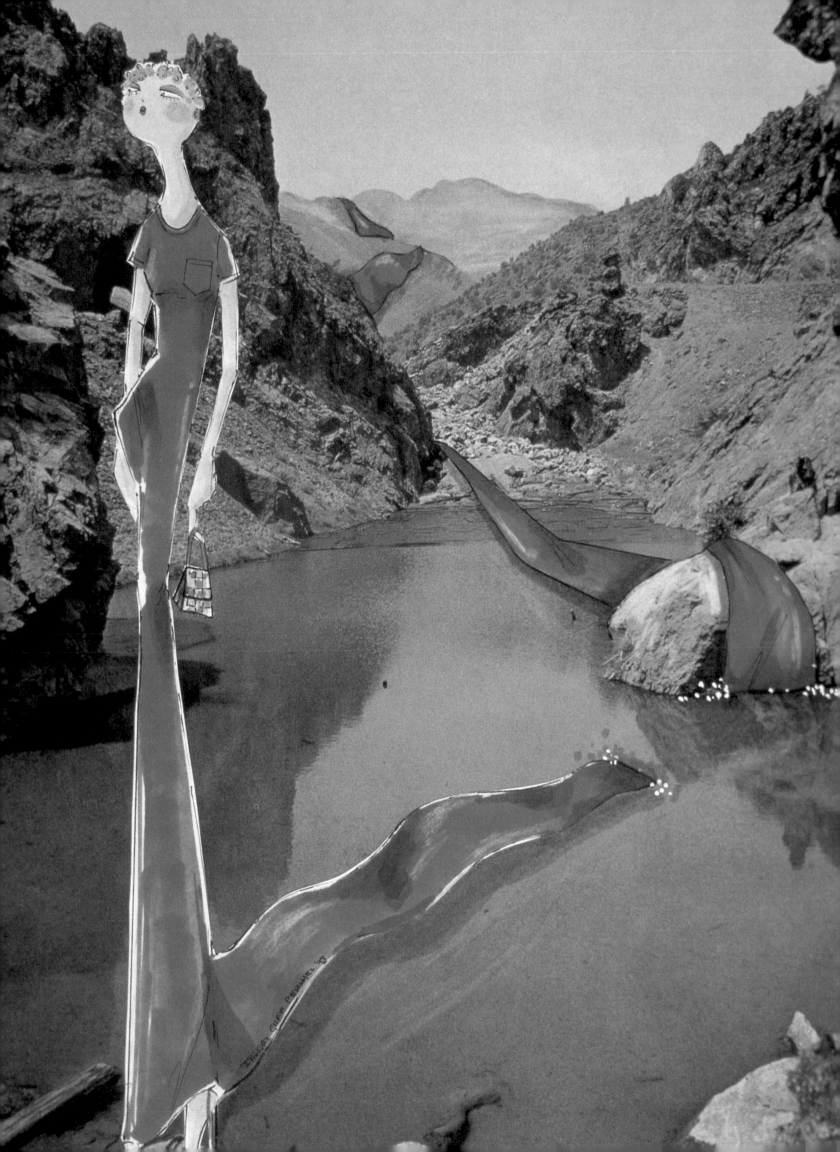

in Milan is between Versace and Armani; for more than ten years, Versace has been doing archetypal Versace and Armani has been doing classic Armani. These are indurated styles and in that I see something very positive, allowing refinement; the viewer and the client know what to expect. This is commerce and not caprice. She or he who wears Jil Sander is not likely to wear Vivienne Westwood; she or he who wears Rei Kawakubo is not likely to pick up a Valentino, except perhaps for comic relief. Designers may function a little like brand names, but they function even more potently as designers, offering at best a definite sensibility. "The Future," says Rossella Sardinia of Moschino in this book, "is a work in progress."

For some, I might be developing a prologue to a proposal of or tolerance for historicist recollection and pastiche, much of the kind which has been prevalent for fashion in the 1980s and 1990s. Indubitably, nostalgia is a powerful force in popular culture in which the television and, to a lesser extent, movies of the past fifty years or so are being constantly recycled before our eyes. It is not Tom Ford at Gucci who is making us aware of the 1970s, but the channel-surfing that we all do that allows us to glimpse *The Mary Tyler Moore Show* and its time-capsule of dress or glancing seconds of a retrospective of rock as favored by VH-1 and MTV and then back to the present again. Nearly fifty years of fashion are in constant use in the world of the channel surfer and keep reappearing as options, all but displaced from their original time. Hence, we should not be surprised by the fashion historicism, initially prompted by higher ideals of post-modernism from the sister discipline of architecture but sustained by our collective channel-surfing, which never disposes of a style beginning

with *I Love Lucy*'s version of Dior New Look style in Lucy Ricardo long, full skirts and tight bodices. But historicism is already proving its succinct utility and its distressing sense when one despairs of anything feeling new or different. Once everyone copies Halston, the pleasure in the nonchalant inventiveness of that clothing dissipates, just as the widespread use of cynicism in modern advertising has made it difficult to see the brilliance of that first Kenneth Cole ad, now ten years old—"Imelda Marcos bought 2,700 pairs of shoes. She could have at least had the courtesy to buy a pair of ours."

Moreover, the same metaphor of fashion channel-surfing has been used by the contemporary anthropologist Ted Polhemus in his book *Style Surfing: What to Wear in the Third Millennium* (Thames and Hudson, 1996). Polhemus described style tribes as the concomitance of many style groups in our time, each with identifiable characteristics in dress. He explains contemporary freedom not in individuality, but in clusterings or tribes. Likewise, even in a speculation of the 1990s and of the future, Polhemus sees clubs of affinity in sexual minorities outside the mainstream, extreme club-kids in Tokyo, London, or New York and rave styles, and other hyperbolic styles. But Polhemus's penchant is to be fascinated by every kind of extremism. The truth of diversity is socially linked and is more mainstream. Tommy Hilfiger may have proved to be coin of the realm among affluent suburban teenagers and indigent urban African-Americans of like age because of similar tastes in music, but may still suggest differences in styling and many differences in their separate groups. Polhemus, as social scientist, extols the subgroup at some sacrifice to an individuality that I, as an art historian, would prefer to praise. Polhemus's massive

evidence, however much he seeks "people like us" as a motivation for subgroups, testifies to the inherent complexity, diversity, and laissez-faire sensibility that underlies our visual culture.

Heterogeneity, the goal that I am seeking, tolerates historicism, but does not empower it. Specifically, the layers of history are always important to the young for whom some exploration through a remembered and not-personally-remembered past is an important exercise. So often in fashion, as we all say in the full acerbic ripeness of adulthood, one only would want to revive the taste of the 1960s or 1970s if he or she didn't live through the polyesters, paper dresses, and peacock revolutions. In the concept of style tribes, generations make a big difference, but in the bigger business of fashion it is hard to see that designers who are mere historicists are able to engender the patronage of anyone other than the young, those least likely to be able to afford fashion's prices. Fashion cannot finally be counted in chronology or achronology alone.

Fashion today disposes heterogeneity and diversity and aesthetic principles and principles in choice. One of the reasons why fashion is so interesting in the 1990s is because it embraces the social intricacy and complications of our time. Ethnicities, individual choices, and personal sensibilities related to identity and gender are evident in fashion without our being led toward uniformity.

One must remember that photographer Lucille Khornak assayed a similar fashion prediction in her book *Fashion 2001* (Viking Press, 1982). For Khornak, who had not yet seen the portended 1984, the Kubrick future was occasionally slightly romantic, but was paramountly Space Age, bringing Barbarella into a variety of transfigurations. British milliner David Schilling told Khornak, "I imagine

that I'll be designing a very exotic space helmet for the year 2001."

And, long ago, fifty-three years ago to be exact, there was a prescient model for this view of fashion and even for such a sentiment of the world's future. In 1946, James Laver, in recuperation from the War and preparation for whatever might be ahead, wrote a small book, *Letter to a Girl on the Future of Clothes* (Home & Van Thal, London) fictitiously writing to a girl then aged ten. Laver assumes a fundamental dialectic in which clothing is not in the camp of brown shirts or uniforms with swastikas, but arrayed with those who believe in freedom. Laver uses fashion as an instrumentality for freedom and as a metaphor for freedom. Further, even before the juggernaut of the New Look, the costume curator and historian Laver was advancing a non-imposed fashion of options, not the sovereignty of the designer or the designer system.

As he writes at the book's conclusion, contrasting fashion's presence to the world of communism, "There is to me something inexpressibly moving and gallant about the gay little banner, the pennants, the oriflammes, the funny hats with which humanity marches forward into the thick fog of the Future. These fragile wisps of stuff seem to have a life of their own. They are like the pseudopods of a polyp pushing into the Unknown; they are our own antennae, sensitive as those of a moth and as easily hurt. They explore the darkness, they beckon us onward. If we could only read their message we should be wiser than seers." With Holocaust and War so proximate, Laver could recognize fashion as either a partner with or a perquisite to liberty, a true agent of self-identity in a technological time. With the millennium imminent, Laver's formulation seems more than ever

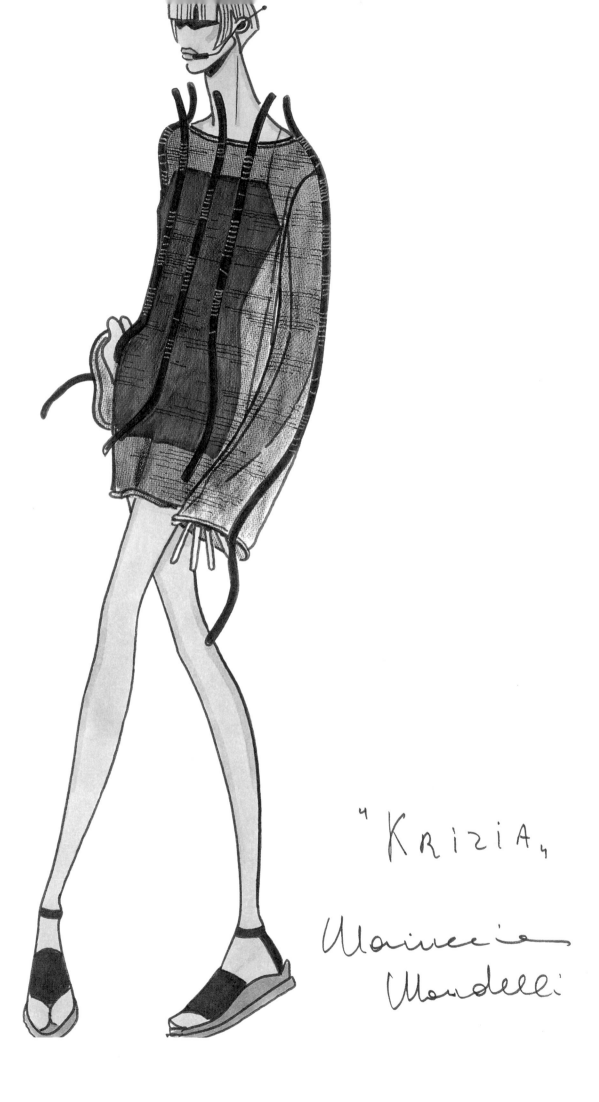

"KRIZIA,

Mariuccia
Mandelli

true and clever. Laver shrewdly anticipates Lipovetsky's parallel of fashion with freedom, not merely for the future, but as an observed condition of contemporary life.

If we can evade the individualism-snatching bane of uniforms, what can we really expect of fashion for and in the new millennium? Fashion has been invented in capitalist freedom and exalted self-expression in the 19th and 20th centuries; where does it take us from here?

Of course, I am as unsure where the history of fashion will take us as I am unsure of future history as well. But I am certain that the visual culture that we achieve is, for good or bad, one that is indivisibly linked with our culture. I go along with the ideas of one of the youngest designers in this book, Daryl Kerrigan, when she says: "As always, fashion will continue to play an important role in all our lives. It may not be fashion as we know it today, but rather people dressing according to their personal styles and tastes." Any culture that continues to prize freedom and diversity will yield fashion worth looking at and worth thinking about, not the banality and not the legions in uniform that had once been predicted. All of our speculations about the future are based in the present. Some have known little of and wished little for, let us say, painting and sculpture and have perceived scant future for either. Some have known little of and wished little for fashion and have foreseen regiments and regimentation. Instead, I see the marbling and unfolding diversities of individuals and cultures in the rich spectrum of fashion's possibilities not ending, but continuing. Individuality in fashion is not the relic of our time, but its birthright. In that, we see a significant affinity to art and our aspirations for art. As Gianfranco Ferre advises so well, "The future has begun."

ROBERT LEE MORRIS

The piece I've designed is a vision of my future, a symbol of my collaboration with M. Fabrikant (a large diamond concern) and their resources, which have provided me the opportunity to work with diamonds and platinum and pearls. I'm now able to make things that are truly wondrous in terms of technology but everything I do will be done with a concept and a spirit and a story. I see it as bridging the gap between fashion and fine jewelry, which for too long has been primarily about decorative, intrinsic value. It's all about how many diamonds can you get on something or how pretty can you make it, but there's never been much of a concept. My whole push is that there should be a message in everything you do. It shouldn't just be commercial material, a product for someone to buy. It should hold your heart and soul and a vision.

This piece is called "Web of Life." If you look under a microscope you see thousands of cells and in the center of each cell is a nucleus. This is the great cosmos. We're all made up of these tiny, finite particles.

It's art that keeps us connected to those things, and fashion is a part of art.

—Robert Lee Morris

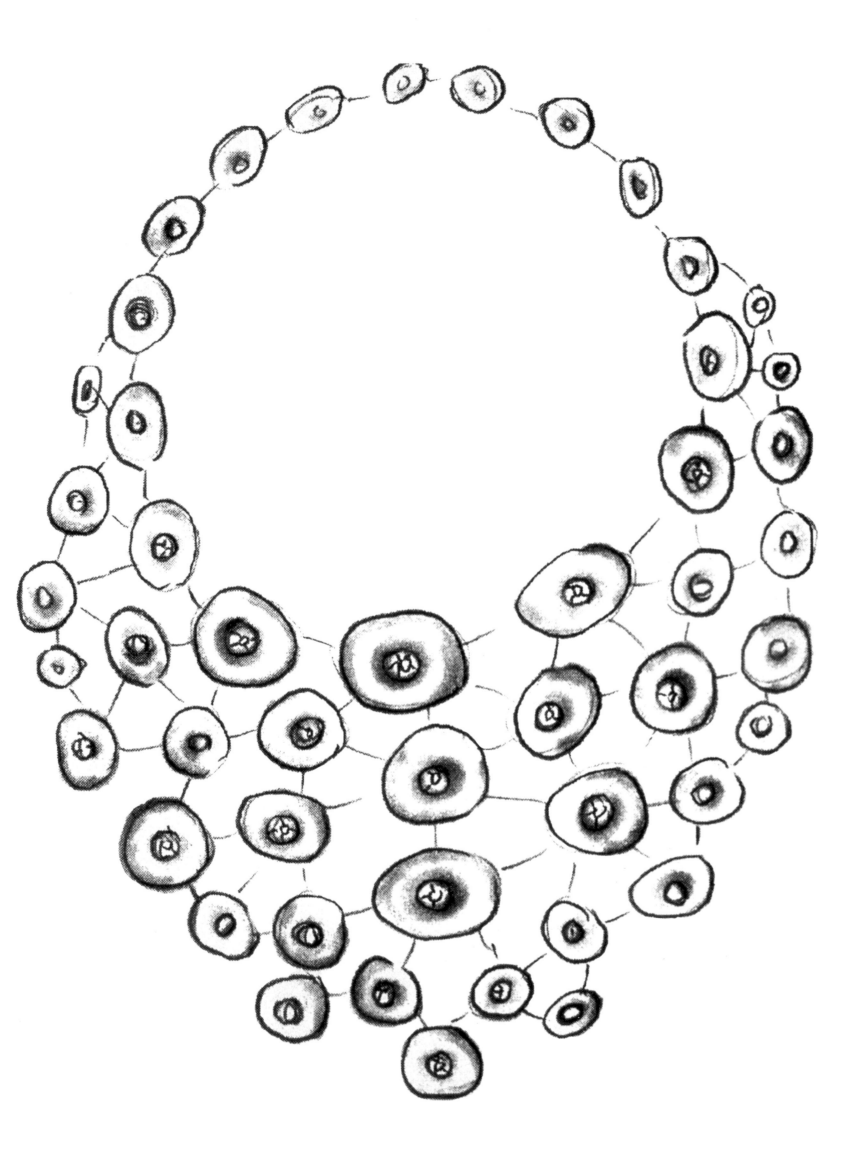

| INTO THE FUTURE

The Panther Modern leader...wore a polycarbon suit with a record-ing feature that allowed him to replay backgrounds at will... Case watched the suit crawl with color and texture.

—William Gibson, *Neuromancer*

So every few dozen feet there's a large man with erect posture wearing an acid green windbreaker with ENFORCER spelled out across the back. Very conspicuous, which is how they like it. But it's all done with electropigment, so if there's trouble, these guys can turn themselves black by flipping a lapel switch.

—Neal Stephenson, *Snow Crash*

In the fall of 1997, as the spring ready-to-wear shows were taking place in the world's fashion capitals, a different kind of fashion event was being held in the decidedly academic environs of Cambridge, Massachusetts. There, on the campus of the Massachusetts Institute of Technology (MIT), fashion students from Paris, Milan, Tokyo, and New York, together with students from MIT's renowned Media Lab, presented "Beauty and the Bits." The show, the brain-child of Alex (Sandy) Pentland, Ph.D., head of the Media Lab, was designed to explore the ways in which computer technology and fashion may intersect in the future.

As invited guests sipped their drinks and discussed John Galliano's most recent lav-ish spectacle, models strolled about dressed in creations seemingly drawn from the pages of a cyberpunk novel: an organza ballgown that lights up when the wearer moves; a convertible suit that responds to a coded ID card in the waist pocket, changing shape, color, and size according to the wearer's preferences; a "Living Knit" body-suit and dress made of biomorphic fabric that responds to temperature with changing colors and textures. There were other inge-nious inventions as well, such as a vest with built-in microphone, computer, and speak-ers that allows for simultaneous language

translation; a floral headpiece that houses a tiny e-mail device; glasses equipped with a laser range-finder, compass, and differential GPR (global positioning system); and a child's safety helmet with earphones, ID card, and a homing device coordinated with a receiver at home.

It is axiomatic that advances in tech-nology by industry leaders such as DuPont and Pantone will influence the future of fashion. Indeed, it could be argued that their influence on fashion will be more pro-foundly felt than any individual designer's work. One hundred years ago there were no zippers or Lycra, nor was there a universal color language; life without any of these things would be unimaginable today. The spheres of chemistry and high fashion are drawing ever closer together, redefining the boundaries of what is wearable. In the same way, it's certain that "smart" fabrics, commu-nications-ready accessories, and computer-generated colors will be the norm in the future. Not surprisingly, today's designers are intrigued by the resources they will be offered in the future. "The fabrics (and non-fabrics) of the future will give designers a lot of freedom to invent," enthuses Mariuccia Mandelli, designer for Krizia. "They will also make those who wear them very happy."

DANÜCHT

Tapped into the main line of fashion and style, Danücht takes its influ-ences from fine art, street style, and the art of per-sonalization to create an anti-trend clothing line that embodies the lifestyle and mentality of its consumers, adding a spiritual dimension to couture and paving a new lifestyle movement into the next millennium.

This dimension is much needed in the "every-thing-has-been-done" fashion world. Fashion houses must have a "sig-nature look" and provide their consumers with pieces for all of their con-ceivable fashion needs and/or situations. Fine art will never cease to influence designers, but as proven with the recent demise of certain fashion houses, careful attention needs to be placed on the "fashion show." [This must become] more inter-active between the designer and the onlooker. Lifestyle marketing, posi-tioning, and placement will all determine the future of fashion.

—Danücht group

DENNIS BASSO

Designers worldwide are using fur as fabric, translating the ultimate luxury into ready-to-wear, as seen with this Russian Broadtail cocktail suit with coq feather trim. Furs will step into the next century with style and grace.

—Dennis Basso

Although the designers featured in this book forecast how we'll live and what we'll wear in the future, in truth no one really knows how life will proceed in the new millennium. There is, however, one safe assumption: new ideas will continue to find their way out of the lab and into our daily lives.

The milestones of fashion's future—like those of its past—will remain linked to new directions in fiber and fabric technology. Already we have witnessed the birth of smart synthetics: fibers that move and stretch, fabrics that are strong yet lightweight, and clothes that are easy to wear and maintain. Tomorrow's innovations will build upon what works now as well as introduce textiles that will take fashion to new heights. "New materials are always a source of fresh creativity," agrees Romeo Gigli. "For the future of fashion I see them as being rather like the genie of Aladdin's lamp." This genie has been unleashed before, often to great effect. For example, the introduction of Lycra in 1959, a unique fiber that has the ability to stretch up to 600% and spring back to its original shape, brought increased comfort and flexibility to clothing. Once associated only with body-conscious, form-fitting clothing, designers have since discovered that a touch of Lycra enhances the drape, fluidity, and wrinkle-resistance of fabrics in any silhouette. It's hard to imagine the tailored and flowing designs of Donna Karan, Miuccia Prada, and John Galliano, let alone those of Gottex, La Perla, and Nike, without the freedom of movement that Lycra brings to fabrics.

Other examples of fiber innovation include microfiber polyesters, which feel like silk but are cheaper and easier to care for, as well as nylon and polyester fibers that wick moisture away from the body, keeping the wearer feeling cool and comfortable longer. "As an industry, our advances will come mostly from fabric innovation and function," says Karan. "Everything stems from that—the shapes, the system of dressing, everything. It's about what works with the climate, the environment." "The future has begun," says designer Gianfranco Ferre. "The challenges of the new millennium have already been set down. Nowadays, creating clothes means evaluating the urges and needs leading into tomorrow. It means, for example, acknowledging the importance of freedom, comfort, functionality, maximum use. And it means grasping the significance of textile research, using evolving and innovative fibers, which grant my style new horizons and new spheres of reference on a market level."

The use of color in fashion has also been enormously affected by science. Indeed, the very fact of looking at color with light shining through it—the way we see colors on a computer screen—appears to have changed people's sense of what colors are appealing. According to a consumer preference study conducted by Pantone, young people are far more drawn to "cyber hues," the bright, vivid hues created by the red, green, and blue tubes in a computer monitor, than are their elders, who were raised without a monitor in the living room. "Sensitivities regarding color change very fast," notes Mandelli. Designers have already leapt at the opportunities presented by this new computer technology. Says Todd Oldham, who once designed a print on the computer with over 1700 colors in it, "I find it's an incredible feeling to synthesize things and come up with something brand new. I also think of it as an homage. Technology so rarely pays tribute to nature, but color reworked by a computer is absolutely that."

While the natural palette has been augmented by these computer-generated colors, inventions ranging from Day-Glo and iridescent finishes to acid washes have vastly

Illustrated by Monica Lind

expanded the range of tone and nuance available to designers. Our color vocabulary will continue to expand in the next millennium with a greater number of cyber hues, as well as the hybridization of hues, the barely discernable—almost subliminal—presence of a color in a fabric that engages the human eye. Consider these PANTONE Colors of the future: Blue Titanium, Sapphire Silver, Ethereal Amethyst, and Chrome Verdigris.

It is likely that technology will soon alter even the way in which we perceive color, providing glasses, contact lenses, and implants that broaden the so-called visible spectrum. Then, too, it is possible that the emotional and psychological ramifications of color will one day be made manifest in clothes that change hue based on our mood—a modern-day update of kitschy "mood rings." "Wearing color expresses a certain state of mind, just as color can influence the well-being of a person," says Angela Missoni. "Color will always be used to express changes in life and society." In fact, it seems likely that the importance of color in fashion can only grow, as men and women increasingly seek to distinguish themselves in a homogenized world. It is, after all, the universal communicator. "Fashion must aid in the search for identity that men and women are going to be increasingly anxious to find within the mass-mentality of globalization," agrees Romeo Gigli. The antidote to uniforms, in other words, is costumes. And what's a costume without color?

While the impact of science on fashion is both huge and inevitable, without individual acts of creativity—the singularly imaginative contributions of fashion designers themselves—the clothes of the future are not possible. The mere existence of a technology does not guarantee its widespread use. "The technology needs to exist," agrees MIT's Pentland, "But somebody also has to construct it to be appealing. In fact, as technology becomes more personal, design will become more important." Thus the ability of tomorrow's design community to interpret and integrate these advances into garments that people want to wear is critical. "Technology is changing at an exponential rate," says Pentland, "and designers are generally unaware of what is already possible. But designers have an understanding of the concerns and excitements and values of regular people that many technology experts don't share. The vocabulary of designers is going to expand hugely going forward."

The possibilities offered by this expanding vocabulary are nothing less than astounding. According to sources at DuPont, we may soon see fabrics that help blood circulation, prevent allergies, reduce the effects of aging on the skin; fabrics that reshape the body, keep clothes smelling fresh, even soothe skin and promote a sense of well-being. Already, working prototypes exist of such science-fiction novelties as conducting fabric—that is, fabric with computer chips embedded in it—and threads that change color. You could soon be wearing a jacket cell-phone, with buttons that change color when you have a message (an actual project at the Media Lab). Or perhaps you'll buy a shirt with sophisticated health monitors built in, to warn of an imminent heart attack or the pending birth of your baby. A dress that changed hue based on the time of day would eliminate day-to-evening dressing, while one that reflected the wearer's emotional states would be an extraordinary act of self-expression.

The social implications of these advances are of course enormous. And as always, fashion will play the dual roles of protagonist and witness, mediating the gap between technology and people while recording, in cloth and dye, the impact of millennial changes.

BABETTE

The reality of the crossover to the next millennium is that January 1, 2001 is just another day. To draw a line in the sand and say that everything will change on a certain day is a meaningless gesture. But we will think differently anyway. No matter what we do or say, change is always gradual. Optimism leads to forward thinking.

Clothing will represent the illusion of the moment without really changing. Color in strong and pure tones will communicate the energy of the time.

Fabric innovation is no different. Nothing is new but everything is different. Performance enhancers continue to evolve, changing the way we look at fabric. Designers will keep taking inspiration from their usual sources, but with a newfound optimism.

—Babette Pinsky

CREAT

WE WILL NOT BE UNINFORMED AT THE MILLENNIUM'S TURN

IONS

BUT NEITHER WILL WE BE UNIFORMED. —RICHARD MARTIN |

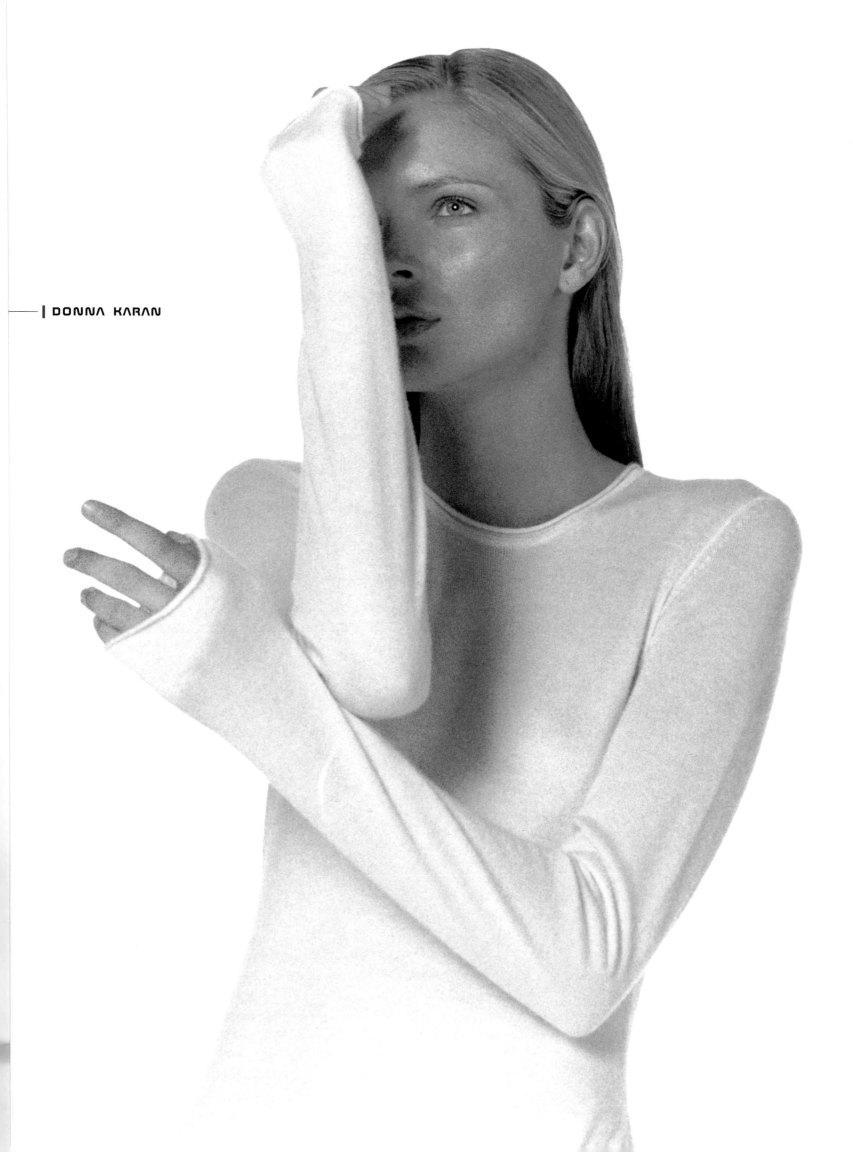

CALVIN KLEIN

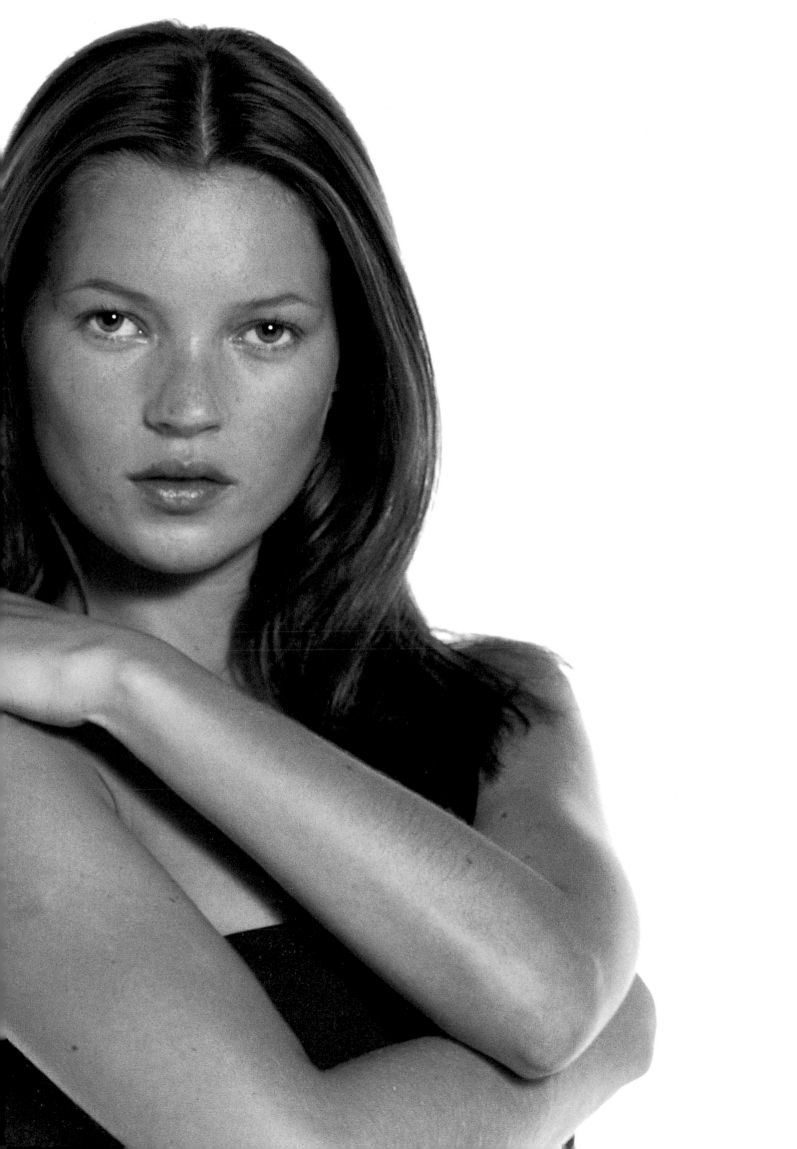

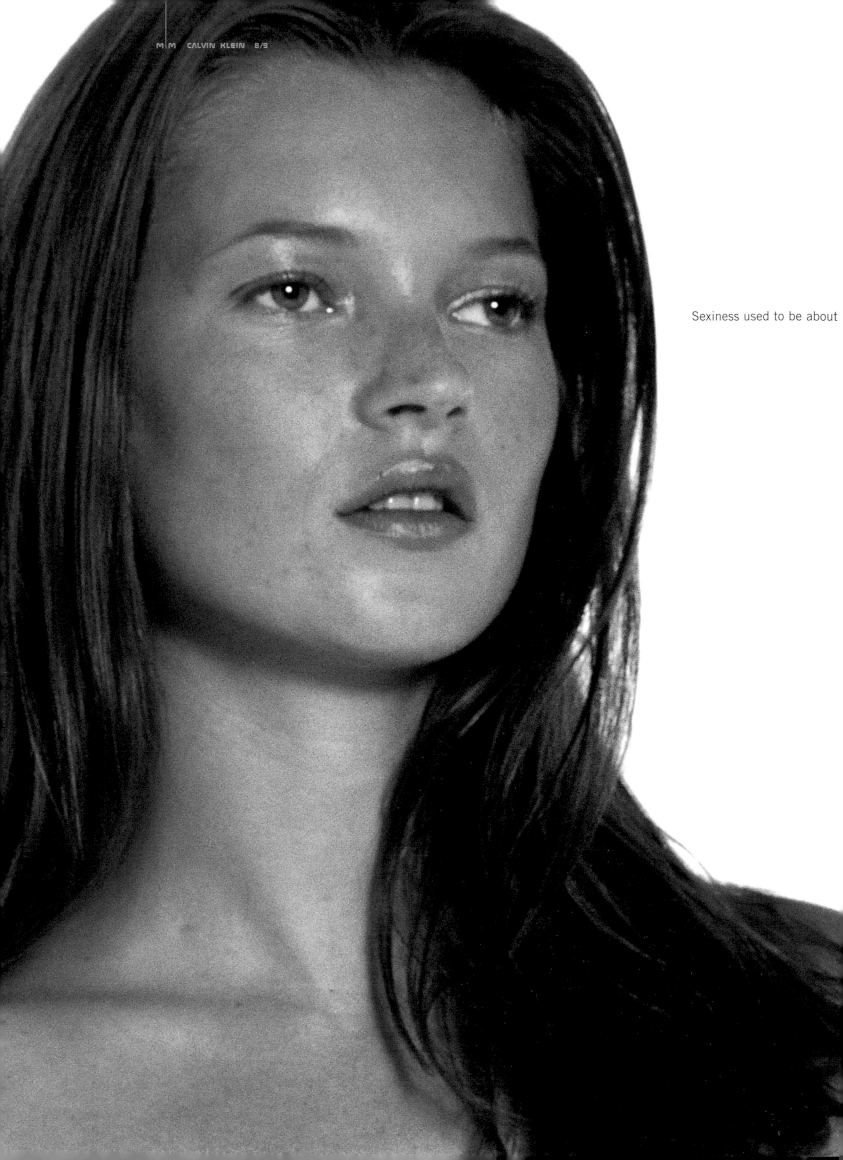

Sexiness used to be about

what you revealed. Now it's about what you choose to put on—and how you wear it. —Calvin Klein

BLACK, SUPERFINE COTTON, STRETCH, STRAPLESS, SIDE-ZIPPERED, PANEL DRESS

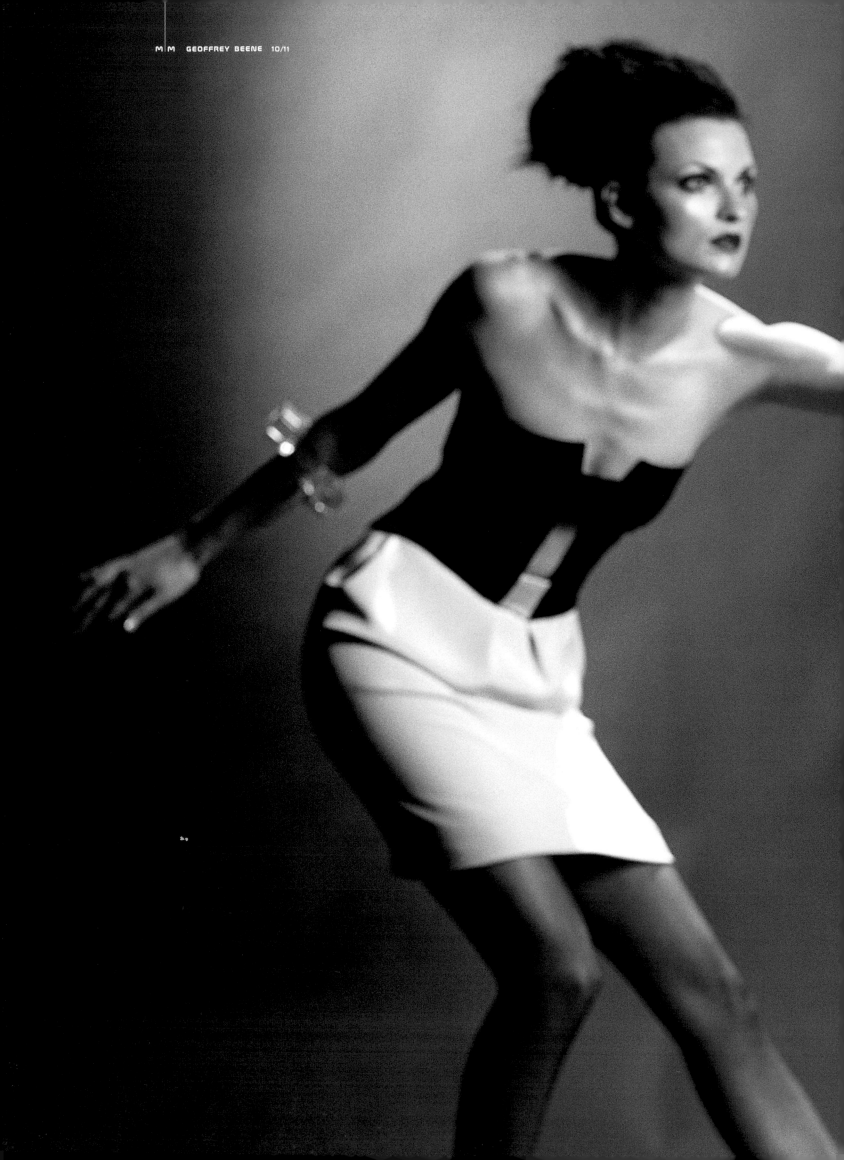

GEOFFREY BEENE

DRESS WITH GEOMETRIC TOP AND PINK TULIP SKIRT

On fashion's role in the future: It will be less demanding as we move more and more quickly toward a working uniform.

What a woman will have in her closet in the next millennium: A jumpsuit with a zippered jacket over it.

On future developments in fabric: About fifteen years ago I felt that revolutions in fashion really had come to an end. Comfort had become our luxury. Now, the revolution is coming from the fabrics made in the test tubes of the chemists and scientists.

On Lycra: Fabrics with stretch (though not those that define the body too perfectly) are valid for they help to eliminate seams, which in the end is more economical. I think we'll see more crossover between men's and women's fabrics.

On color: Designers may still have a relationship with color—but in the future women will reject many "colorful" choices. Fewer colors in prints are already routine.

On new sources of inspiration: Right now, homogenization is happening in clothing. Fabrics should be the great inspiration, as well as the constants of a woman's body and her needs.

On the impact of other media: The media and the Internet will have more and more impact on design of the future—as long as what they offer is both intelligent and credible.

—Geoffrey Beene

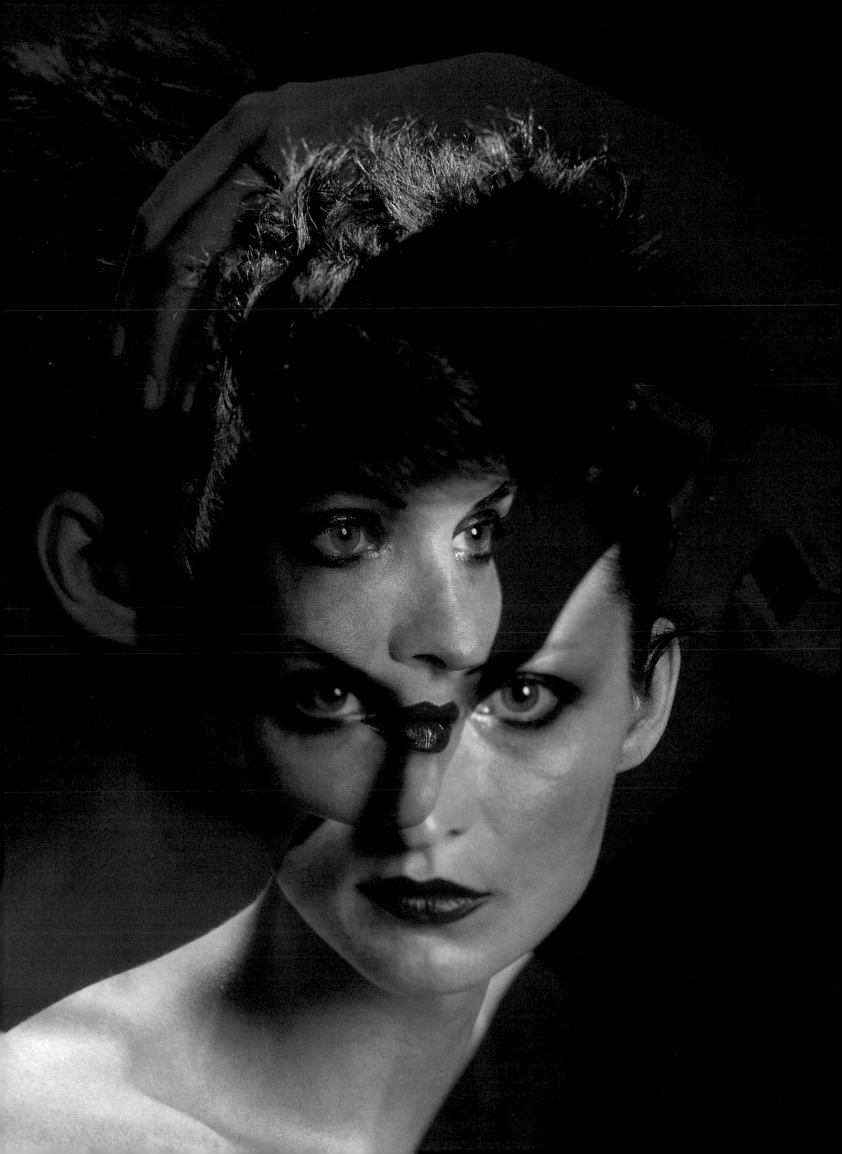

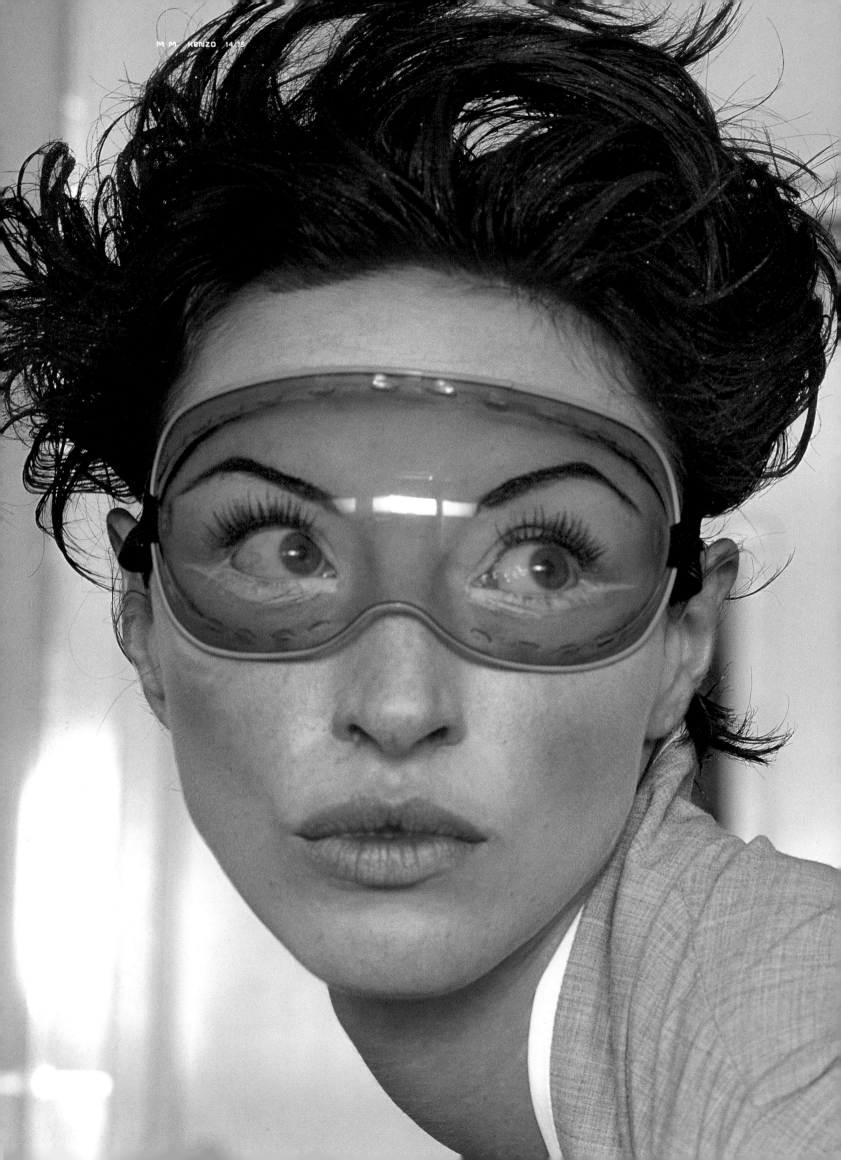

On fashion in the next millennium: In my opinion, fashion in the next century will continue to be very sophisticated, which is a result, I feel, of society's evolution. Already today, we are creating clothes more inspired by the street, like "streetwear" and "easy casual" wear, clothes which adapt to new materials.

On the woman of the future: The woman of the future will need to keep her roots. For me, the allure of her natural elegance, her originality, and her sense of freedom will be critical. She will be also more active, but always feminine, with a sense of humor and independence. There will be nothing decorative or sculptural about her.

On the fabrics of the future: The fabrics of the future will be a mix of technology and noble materials like linen and silk. They will affect the course of design by providing more freedom. When we move more easily, we are more open to others.

On Lycra: Fibers like Lycra already play an important role in fashion and will continue to do so in the future. Lycra brought a "comfortable" mood and a way of being to clothes. When you wear clothes made of Lycra, you adapt to them immediately. It changes your way of moving. Of course, we still need fabrics such as wool, silk, and cotton. Interestingly, the progress of Lycra, even at the first glance, is like that of a noble fabric. Even the touch has evolved. Today it's softer than it used to be.

On new or different sources of inspiration: There will be different sources of inspiration as we adapt and follow new technologies. And fabric is very important in giving direction to a collection. But of course, I will stay with my own vision of a woman.

On spirituality: There will always be a spiritual dimension in the material world of fashion. I think we all need to stay true to our roots and to communicate them. That is an important value.

On art and fashion: Art will continue to influence fashion as much as it does today. It is part of our culture and we can't ignore it.

On the impact of fashion in the next millennium: I truly hope that innovations and inventions in fashion will bring happiness and serenity.

–Kenzo Takada

BI-COLOR, JERSEY STRETCH, KIMONO JUMPSUIT WITH V-NECK |

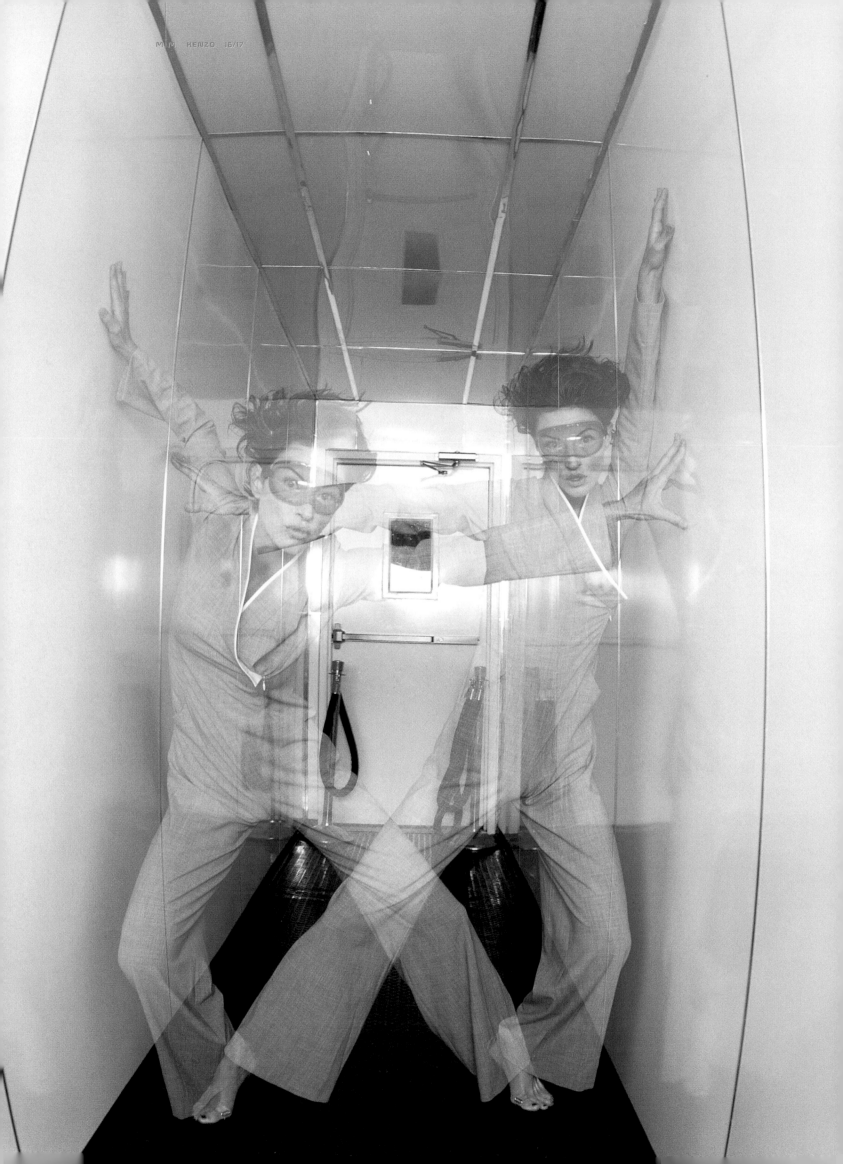

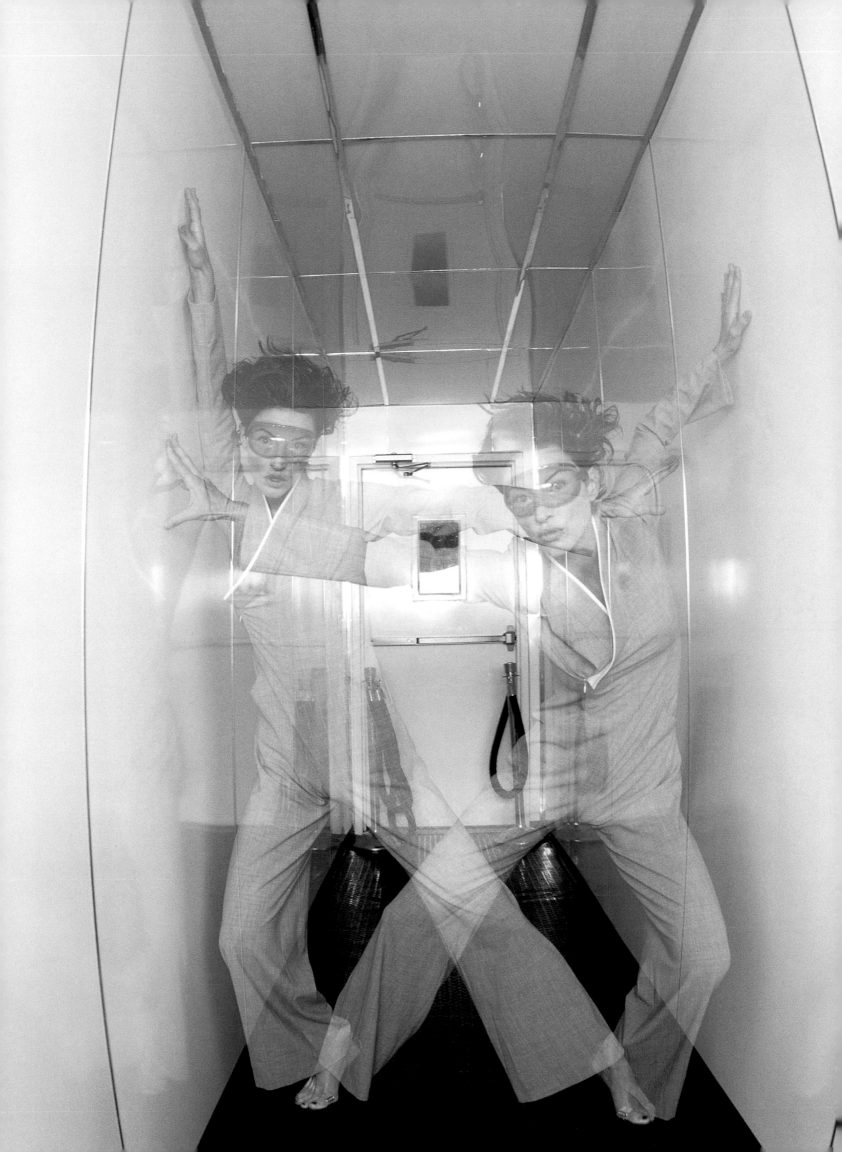

On fashion's role in the next millennium: [It will play] the same role as always: that of making women more beautiful, more attractive, of renewing their fascination and their powers of seduction, of keeping their image in tune with the times. I have total faith in the capacity of women to play a greater role [in the next millennium], to acknowledge their own worth and their own resources. The world is in the hands of women. If we can trust them we shall move toward a time that is less violent, with fewer wars, less injustice, more respect for the environment.

On the effect of globalization in fashion: The same as it is doing now, but multiplied a thousand times. Local and national traditions, whether in the form of style, custom, or craftsmanship, will become rare and more valuable—treasured like protected species in the face of a totally planetary market. Even interplanetary.

On fabrics: Fabrics will be lighter in weight, more tempting, and highly protective. They will be able to protect from cold, heat, and even such harmful agents as radiation, for example, or negative electromagnetic fields. The fabrics (and non-fabric fabrics) of the future will give designers a lot of freedom to invent. They will also make those who wear them very happy. At least, that is what I hope.

On color: Sensitivities regarding color change very fast. There will be new, as-yet-unseen, hypertechnological colors. For example, there will be clothes capable of changing color according to the moods of the wearer. The spectrum of artificial light will change. Let's hope natural light remains the same.

On inspiration: New forms of communication will influence the creativity of designers. These new modes of expression will offer designers a different means of spreading the images of an increasingly global fashion.

On fantasy vs. reality in fashion: That distinction is already passé. A designer must always take reality and the laws of the market into account. However, no one can deprive a creator of fantasy, nor a woman of the desire to dream.

—Mariuccia Mandelli
for Krizia

BLACK DRESS WITH CLEAR PLASTIC TUBES

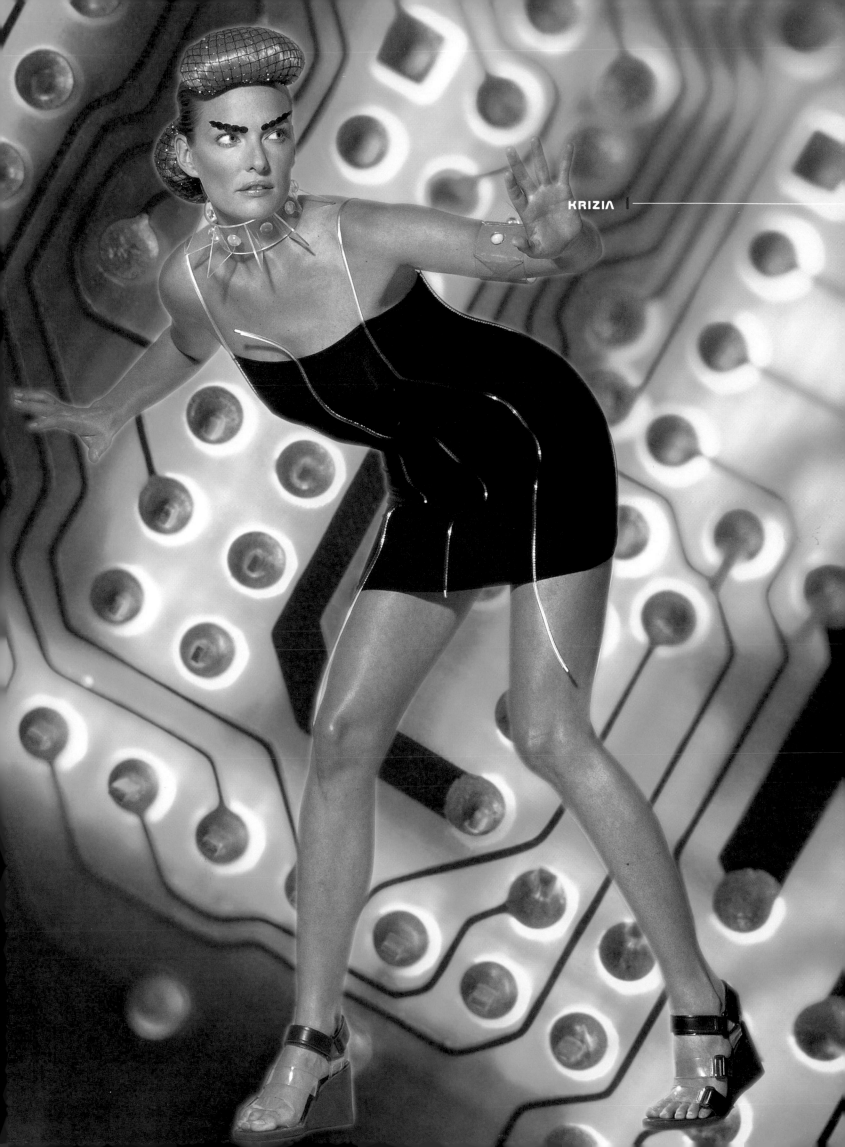

KRIZIA

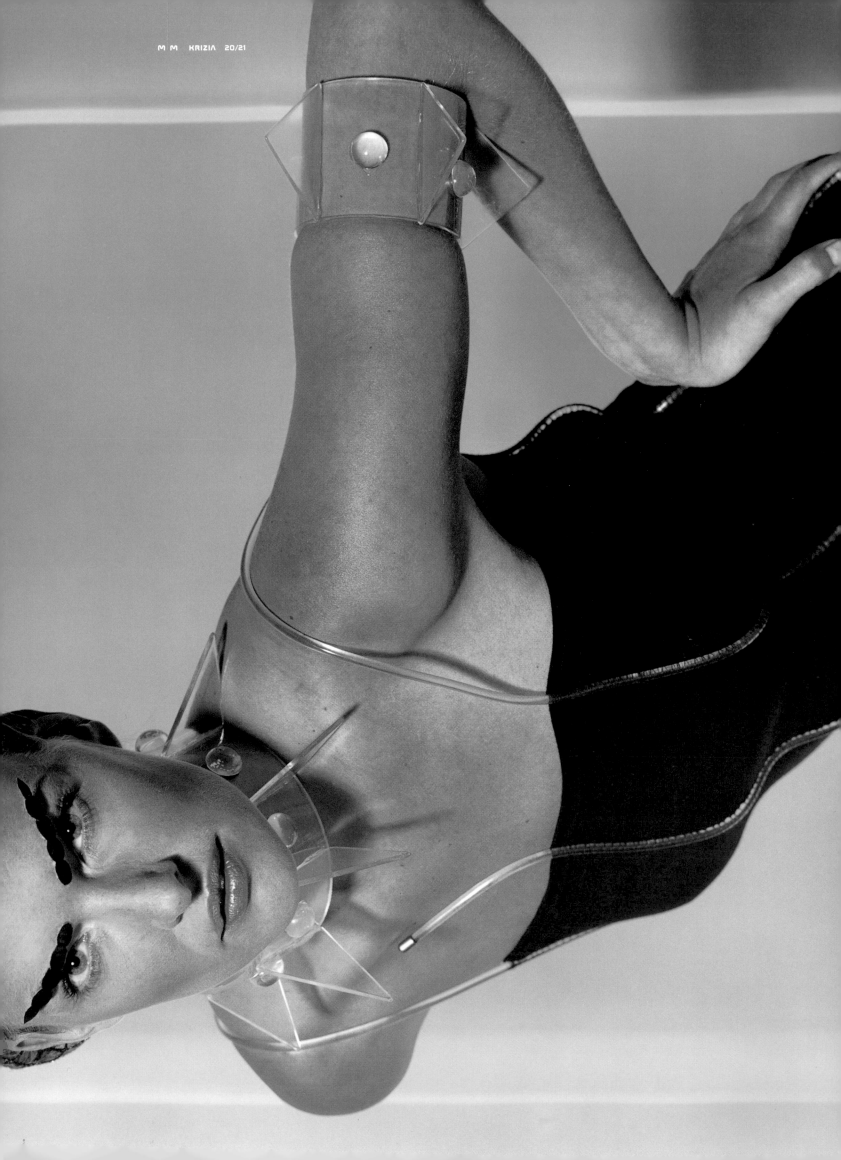

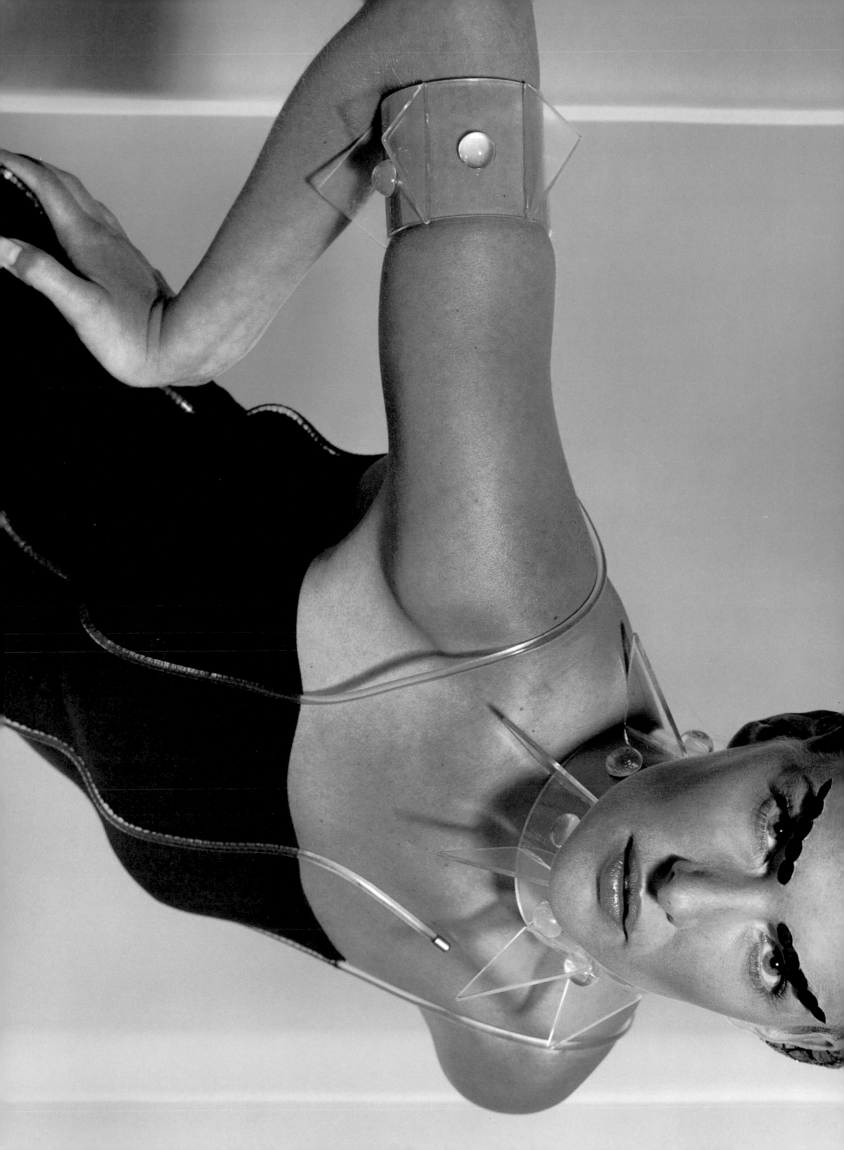

| ESCADA

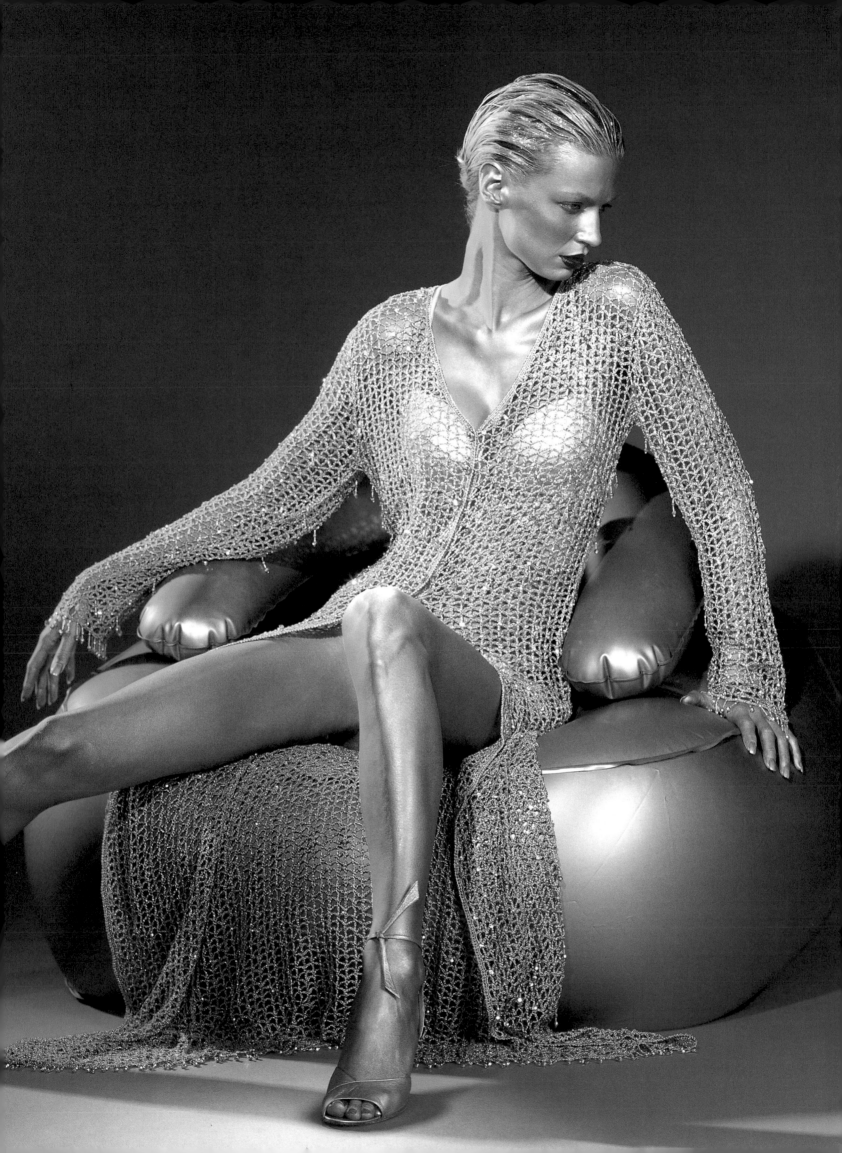

I'm certain that fashion will be very important in the future. In a world in which cloning is a reality and people can create "perfect bodies," fashion will be a critical means of expressing individuality. I think it's possible that the couture will remain important for the same reason— because people will crave something special, something unique. The proliferation of computer-generated fabrics will turn the old handmade crafts into highly priced status symbols.

In the future, work as we know it will be obsolete. Robots and computers will control the work environment, while people devote their time to leisure, home, and travel. Vacation and leisure will be very important in the future. Pleasure will be crucial, so comfortable fabrics will play a major role in fashion. So will materials that cling, the better to show off that perfect body!

The computer offers the possibility of new color developments, of never-seen-before effects, while developments in fabric technology will inspire designers to create totally new looks in which fantasy will be more important. "Reality" as it exists in fashion today will be obsolete—individuality will rule. In fact, it's conceivable that people will create their own fabrics and fashions over the computer. This "computer couture" could make designers obsolete!

—Brian Rennie, chief designer for Escada

SILVER STRETCH BIKINI WITH LONG SILVER HAND-CROCHETED CARDIGAN

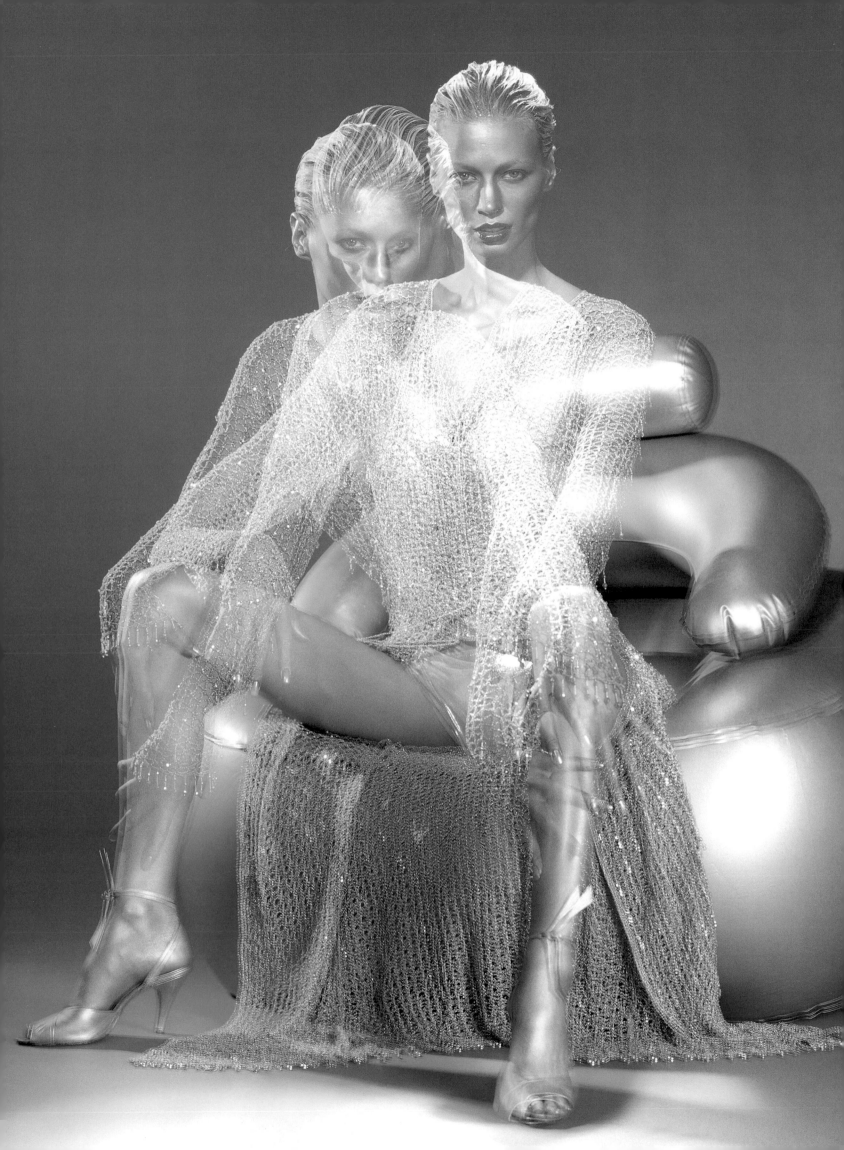

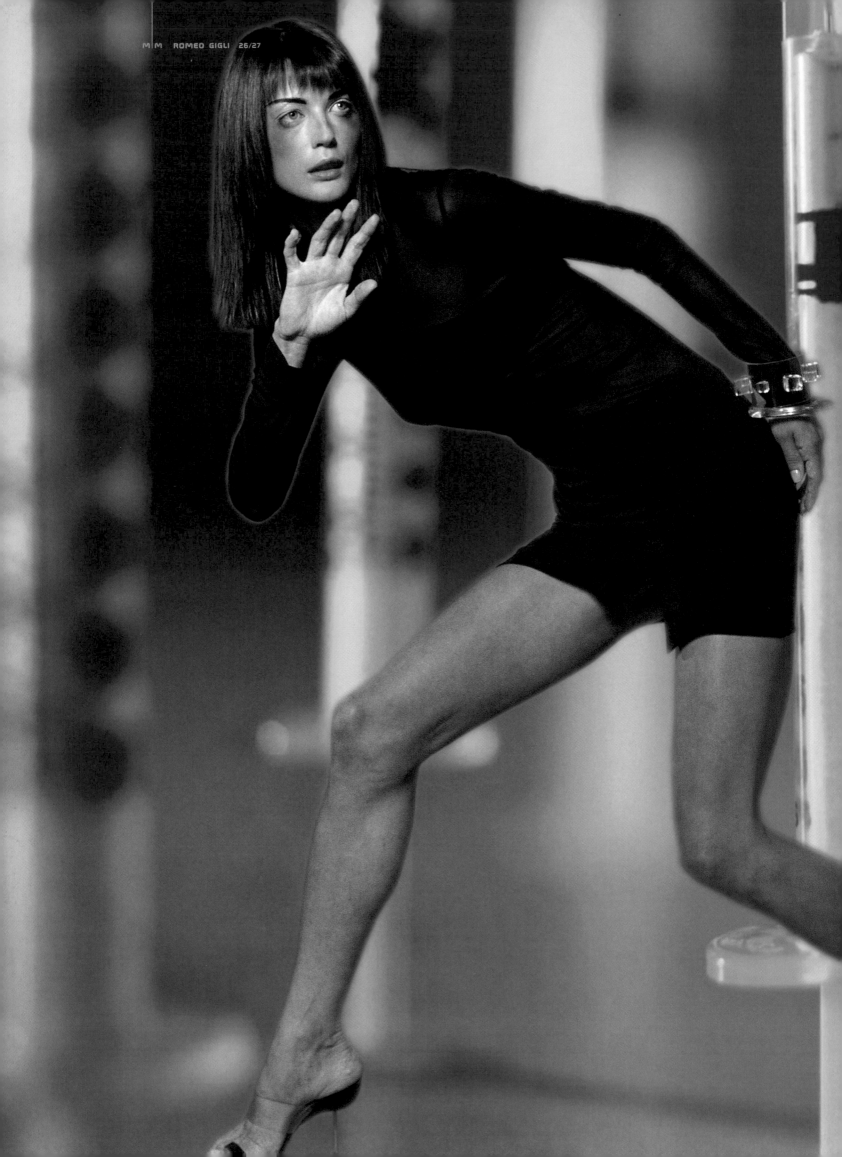

ROMEO GIGLI

Everybody's talking about globalization in the next millennium. But for fashion designers globalization is nothing new—already, in the century now drawing to an end, we have imposed an aesthetic idiom and taste on the entire world. To rewrite Orwell, you could say we've been the Big Brother to Beauty across the planet. I believe fashion must now offer its services to something more intimate. Fashion must aid in the search for identity that men and women are going to be increasingly anxious to find within the mass mentality of globalization.

New inspirations are inevitable. If we end up on Mars, some people will surely get Martian inspirations. I believe, however, that the chief source of inspiration for the designer will always be his or her creative restlessness, the tension of his or her rapport with the actual concept of Beauty. New materials are always a source of fresh creativity. For the future of fashion I see them as being rather like the genie of Aladdin's lamp. Color, on the other hand, will be increasingly relied upon to convey the novelty of lines at a glance. The media, hopefully, will have no impact at all. The media are by definition "means"; they are not the substance of fashion. To be worthy of its name, fashion must stay free to act in its own creativity.

I have never believed in the gap between reality and fantasy in fashion. If fashion was expected to offer practicality alone, we would have designed nothing but overalls. In the end, I see the woman of the future as a second Joan of Arc, fighting back at last to claim not a role, but the most intense, sensual, and poetic femininity, in absolute freedom.

—Romeo Gigli

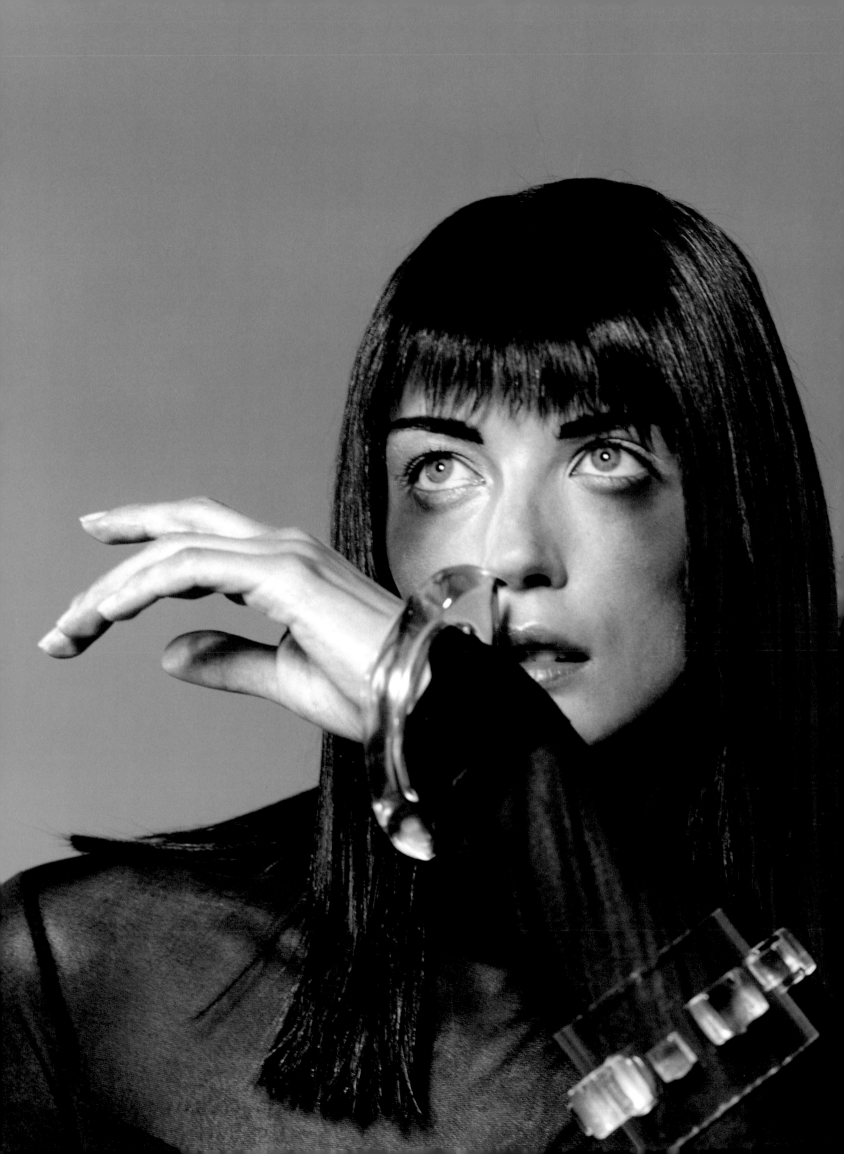

| ETRO

For the woman [dressing in] the new millennium I'm thinking about clothes without precise shapes, an immaterial collection focused mainly on transparency to help a woman face the changes a new era will bring. I envision a dress which softly underlines the body. It is made out of light and recalls the luster of mother-of-pearl, the transparency of a jellyfish. This dress is suitable for many different occasions, perfect for a world in which we don't own more than what is strictly necessary.

Of course, we will also carry into the new millennium a style linked to our heritage. We will draw on things from our past—the shapes and creative energy of the natural world, stones and woods made smooth by water, the memory of primitive objects, natural fibers, atmospheres echoing other countries and cultures.

Fashion will become a group job, an enterprise involving not just tailors and fabric producers but also people who work on the body, following the harmonies and rules of nature.

Finally, fashion in the new millennium will be about color. That is because color represents the strength of our culture, a strength embodied in the bright colors of the Italian art cities.

—Kean Etro

WIRE-CAGE SKIRT WITH COMPUTER CHIPS AND CLEAR PLASTIC DOWN-FILLED JACKET

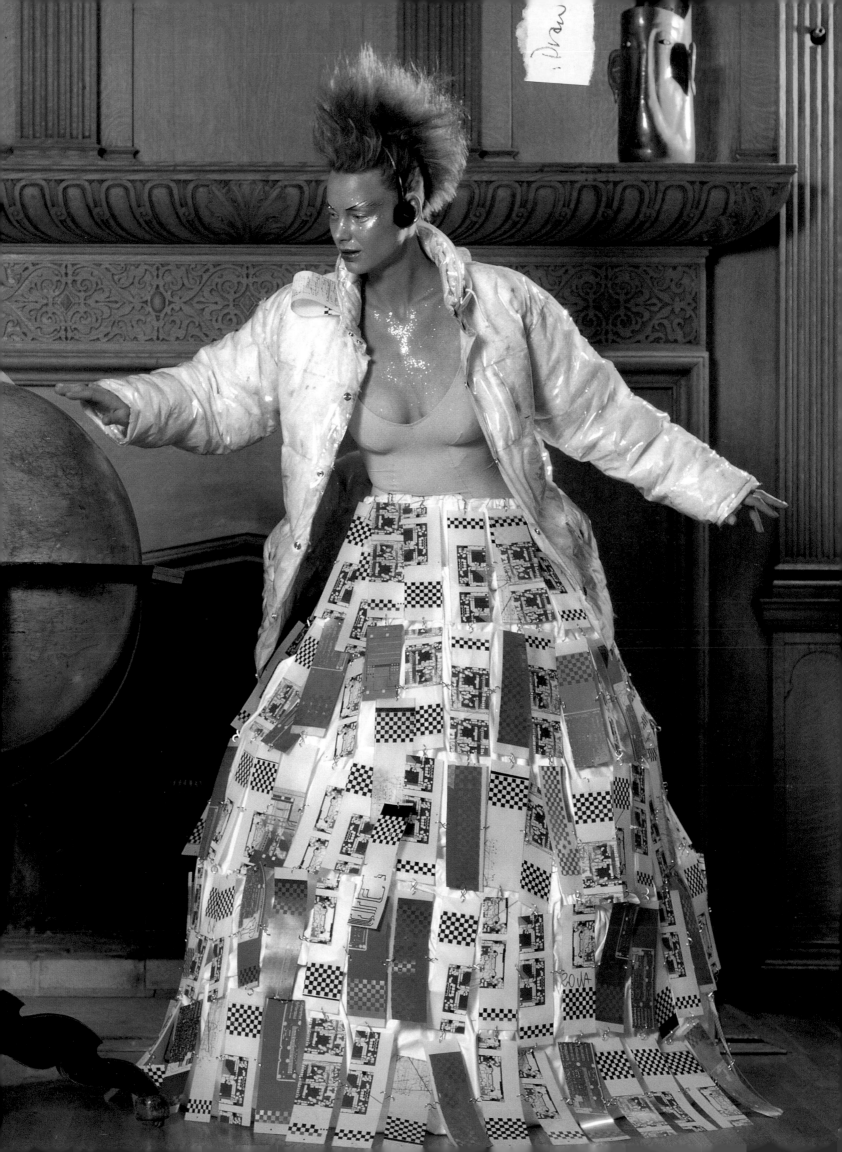

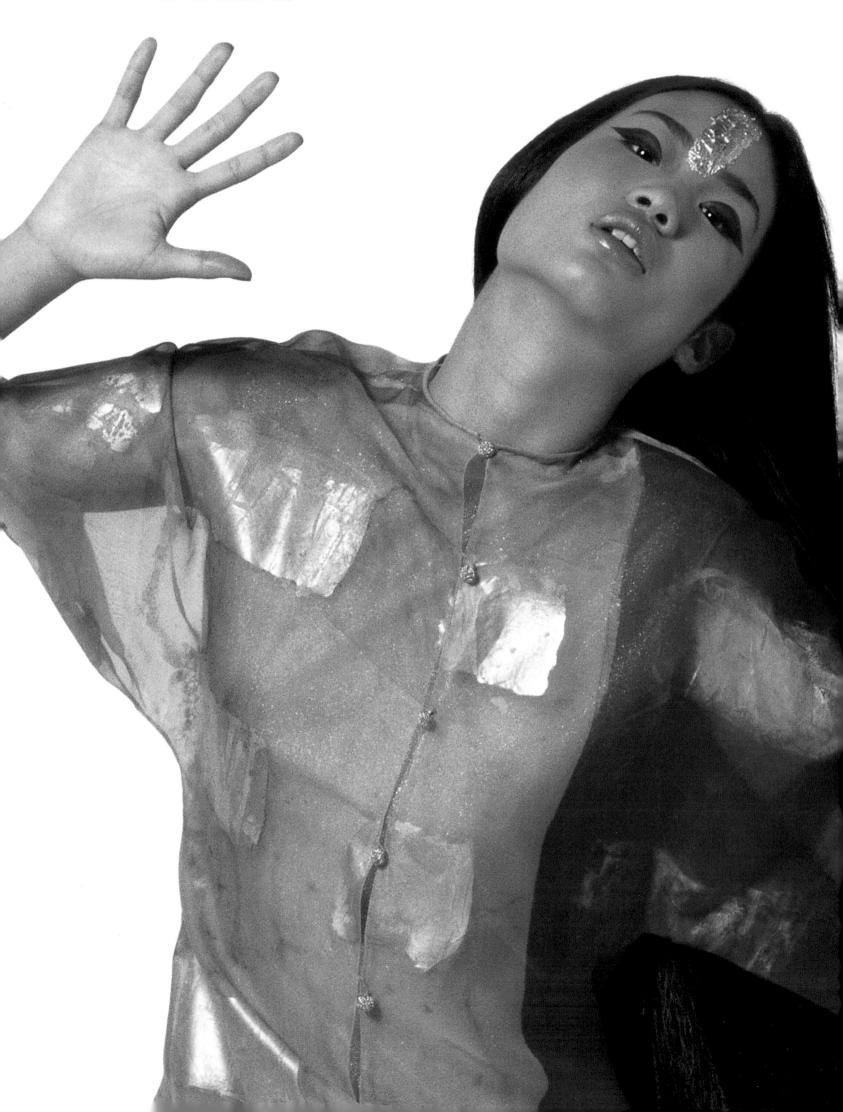

PINK-AND-RED GOWN WITH GOLD UNDERPIECE

The homogenization of world culture will be a leveling force. No matter what part of the globe, there will be signage for McDonald's, Getty Oil, Revlon, Avis, etc.

The Western casual sportswear look will prevail, with blue jeans doing the most damage to wipe out the native costumes of the ancient civilizations.

Africa will be a bloodbath over boundaries and power shifts.

Chemical weapons will proliferate.

A new wave of mystics will challenge the authority of the older religions.

In 2001, Andy Warhol's quote is applicable: "Art is anything you can get away with."

—Mary McFadden

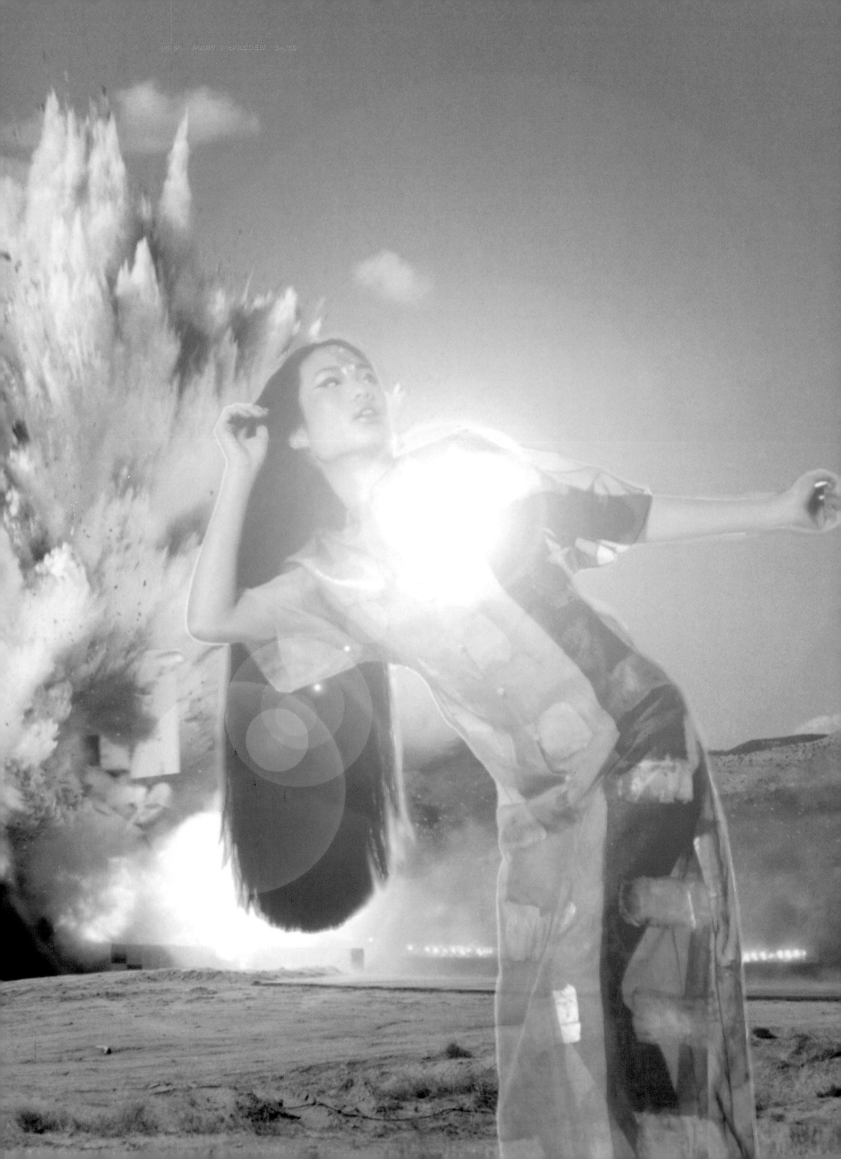

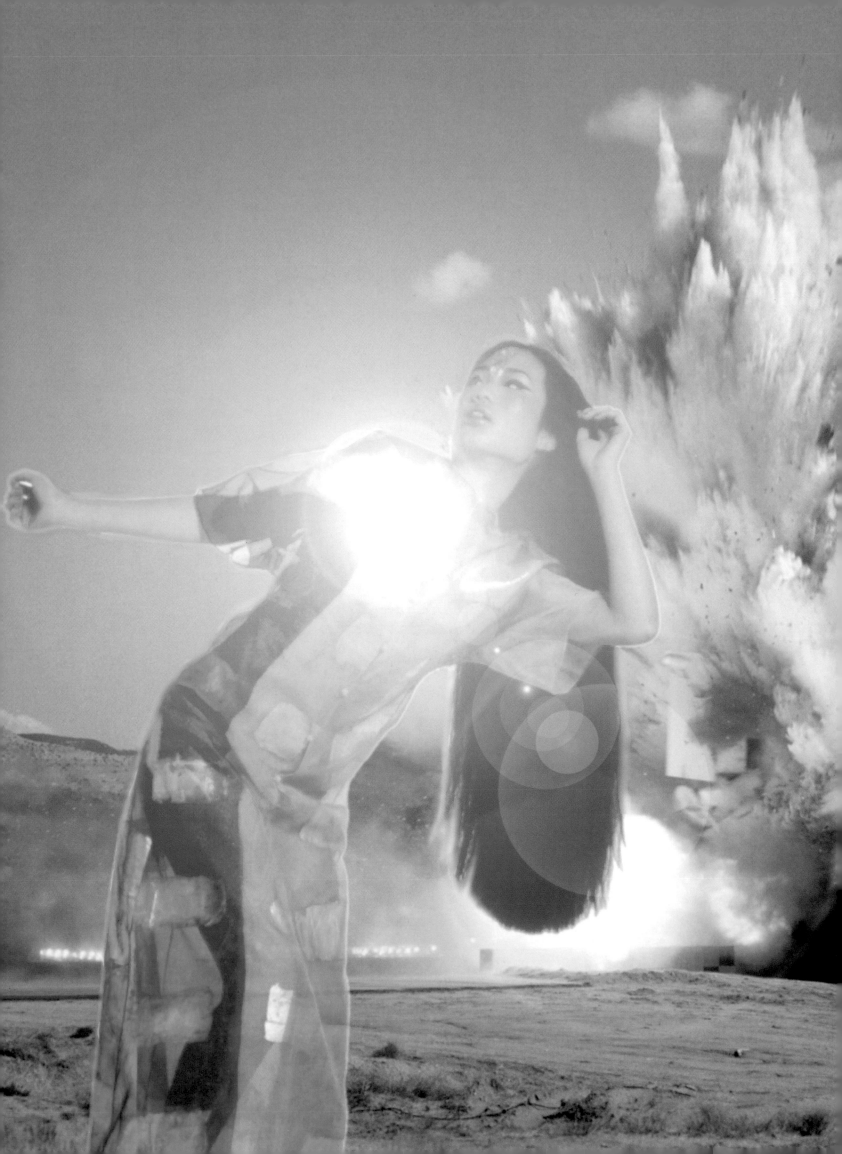

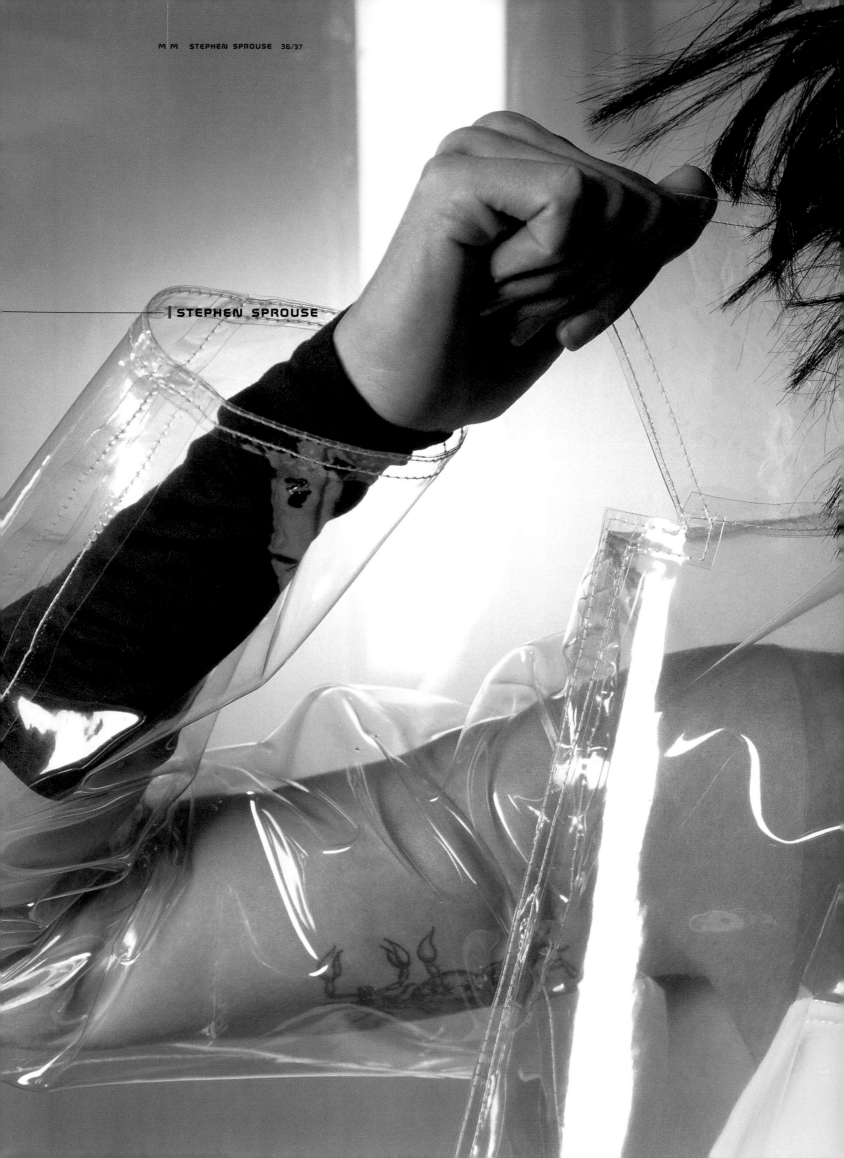

| STEPHEN SPROUSE

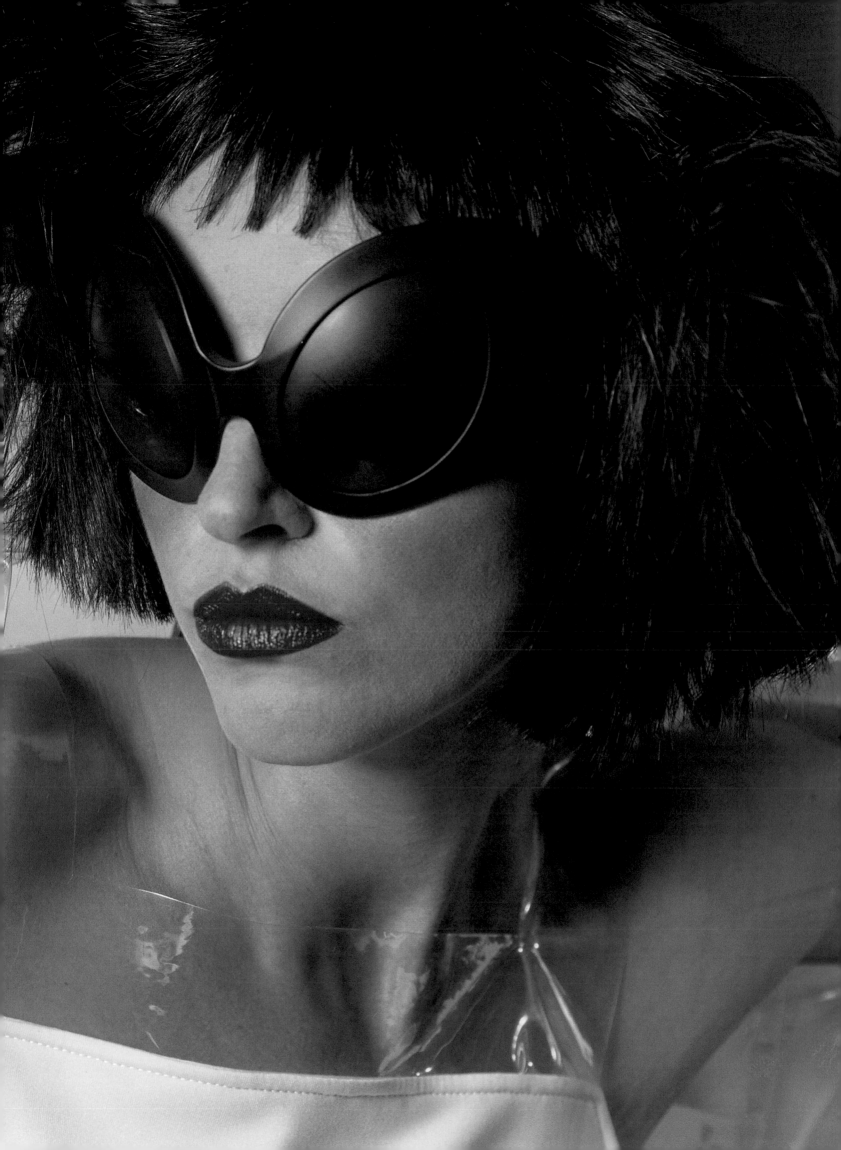

Fashion will always be around, as long as people are wearing clothes. In the future, I'd love to see clothes that you pour on. Just get in the shower and press the clothing sprocket. You dip yourself in the clothes and they're hot-wired to computers to keep you warm or cool, change colors, whatever. Clothes that respond to you. Eventually, you probably won't need designers. You'll just need the right cable company. But that's not going to happen next year. I thought we'd all be in flying cars by now, but we're not.

Essentially, I'm a visualist—I draw first and then go see if the fabric I want is out there. I'd love to find fabrics that turn colors and change temperatures and keep you hot-wired—interactive fabrics that work with computers. Fabrics that grow. If you wanted an ankle-length skirt, your skirt could grow longer. Or if you went out and the weather got cold, you could grow a hood and some sleeves. You'd have to be able to talk to the clothes, though, so we're really talking about robotic fabrics. It's about function— clothes that can really mutate, almost like toys. [Something that will make you exclaim], "wow, look what this T-shirt can do!"

I'm waiting for new forms of color, too. Day-Glo's still the most 21st-century color because it has a life of its own. It glows with an out-side source, which is a black light. Day-Glo is still the last new form of color. I've always liked Day-Glo. So that's what I'm looking for, the next thing after Day-Glo.

Right now, to stay in the fashion business, you have to have someone who will churn money into it because everything costs so much to produce. And then every six months you're supposed to be a genius, so there's a lot of pressure. I'd like to do one show a year: winter, spring, summer, fall, these are the clothes, that's it. But there's this big business system. It's weird to go shopping right after Christmas, when it's freezing, and see spring clothes.

But the globalization of fashion is already changing that. Actually, I think the globalization of fashion is going to lead to the breakdown of the fashion system. When it's winter here and summer in Australia it makes more sense to do one show a year. And when all this video and phone technology really gets working, when you can actually talk to people and see what something really looks like, or see it on your computer, that will completely change the ways things are sold.

I'm very optimistic about the future. As long as we're wise enough not to have any more atomic wars or chemical wars or holocausts, the future is a big, wide, open, great thing.

—Stephen Sprouse

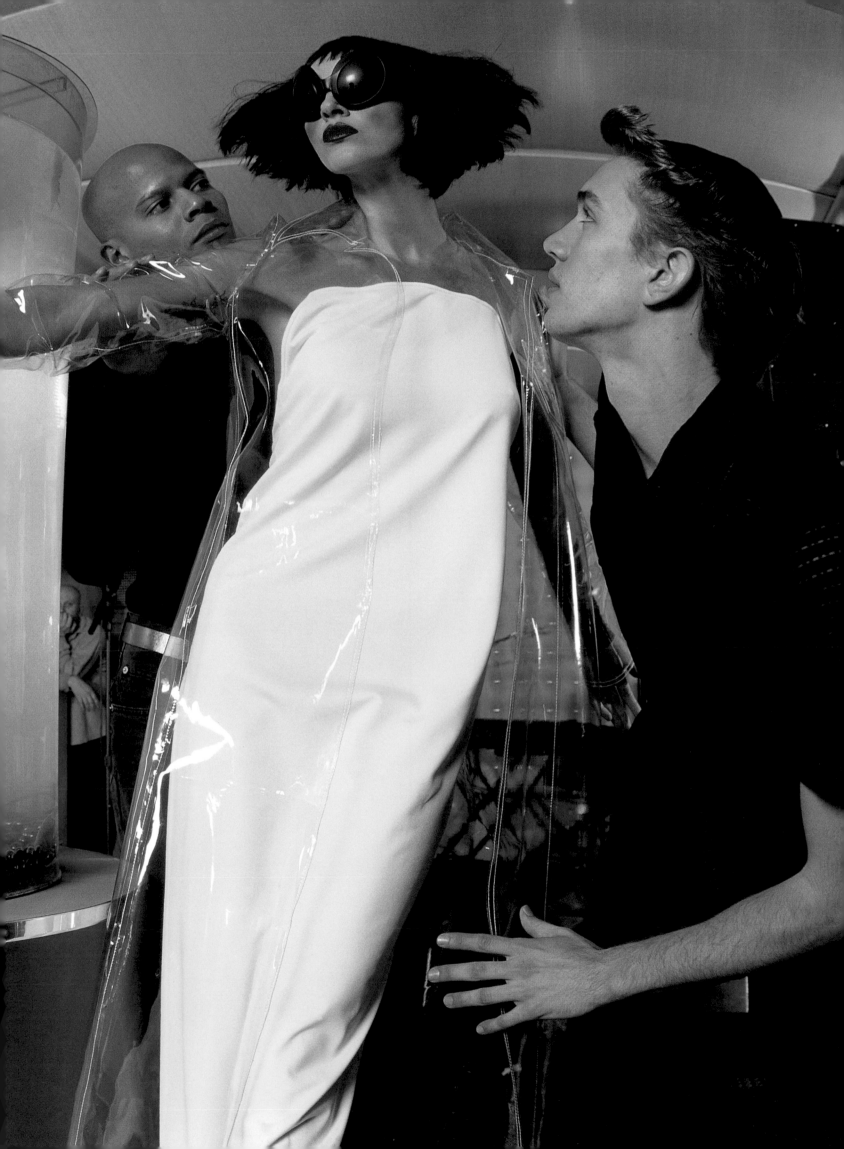

| TODD OLDHAM

In the future, clothes will be desensitized, less fraught with social significance. There needs to be less hype in the world. The more we're able to let clothes function as utilitarian entities, the better off we'll be.

Fabric is the thing that will make [fashion] fresh. [It] is really the only place we've seen any technological breakthroughs in our industry. You can streamline machinery, but in the end, the sewing machine that was invented in the 18th century is pretty much the same one we're using today. In that case, it's going to be the fabric that takes us forward, and we've seen marvelous jumps in synthetics. Synthetics are the wave of the future. For years they were developed to mimic fine fabrics for a lesser-price market, but in the last eight to ten years they've developed [amazing] qualities of their own. They feel luxurious, they hold up in different ways, they travel well—they mean something different than [what] they used to.

Color will always be a wonderful mix of things—it's so much more than we see with our eyes. The energetic vibrations of color are very intense—try to ignore it, you can't. Whether you know it or not, you respond to colors and what your body needs. And thanks to computers, there's already a new generation of colors in existence. I find it's an incredible feeling to synthesize things and come up with something brand new. I also think of it as an homage. Technology so rarely pays tribute to nature, but color reworked by a computer is absolutely that.

Communications technology has already had a huge impact on life. There are no more suburbs—we all get our information at the same time. And the way we get that information, the Internet, has the potential to change the way we think. For instance, people are buying things on the Internet. But the tactile quality of clothes—probably the biggest sales clincher—is missing. You can't feel anything on the Internet except desire for a flat image. This is going to make us think a little more, force us to expand our senses.

That said, I use computers only in the print process. I don't design with a computer. Hands have to do that. We're designing for the human form. It's very instinctive where to place a seam— computers can do it, but it won't be right. The biggest companies on the planet are using computers to design and you can see it in the clothes. In the end, I think people will turn away from that. The success of design is making it look like humans touched it.

—Todd Oldham

LONG HOT PINK JERSEY T-SHIRT WITH TRAIN

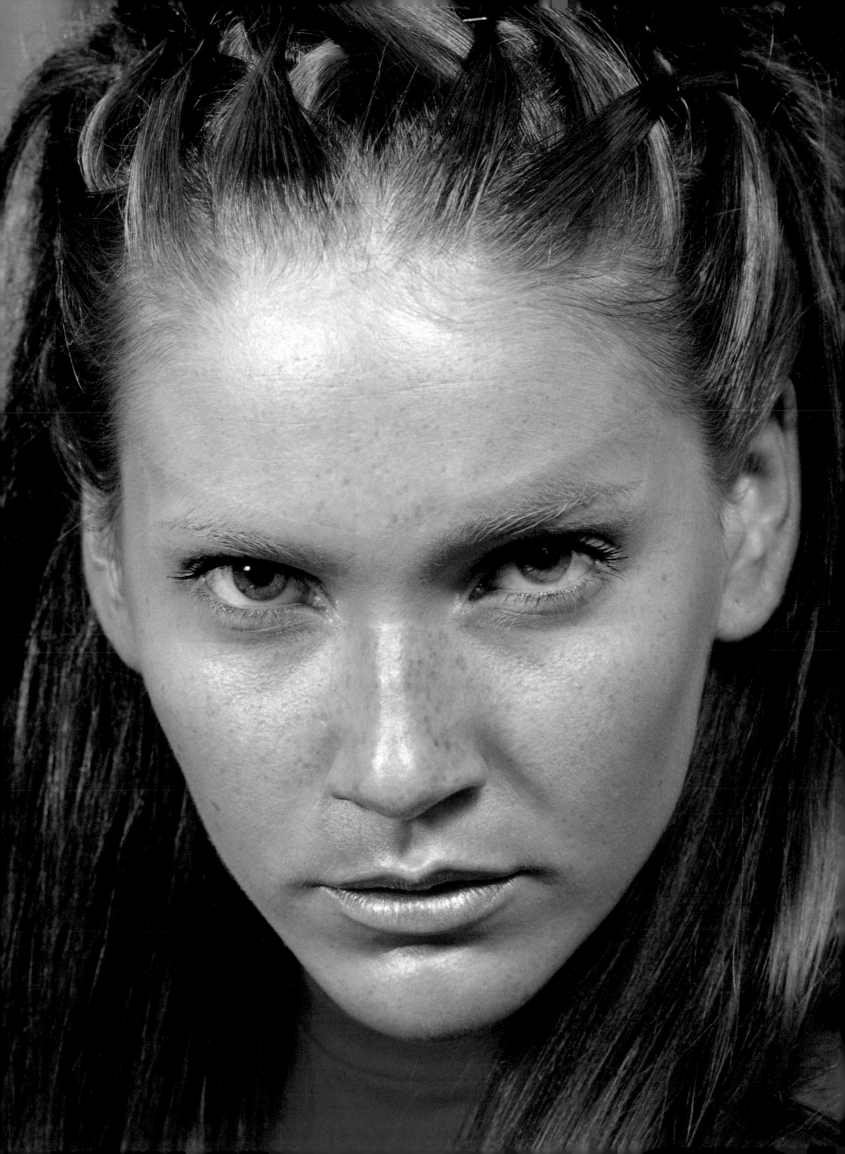

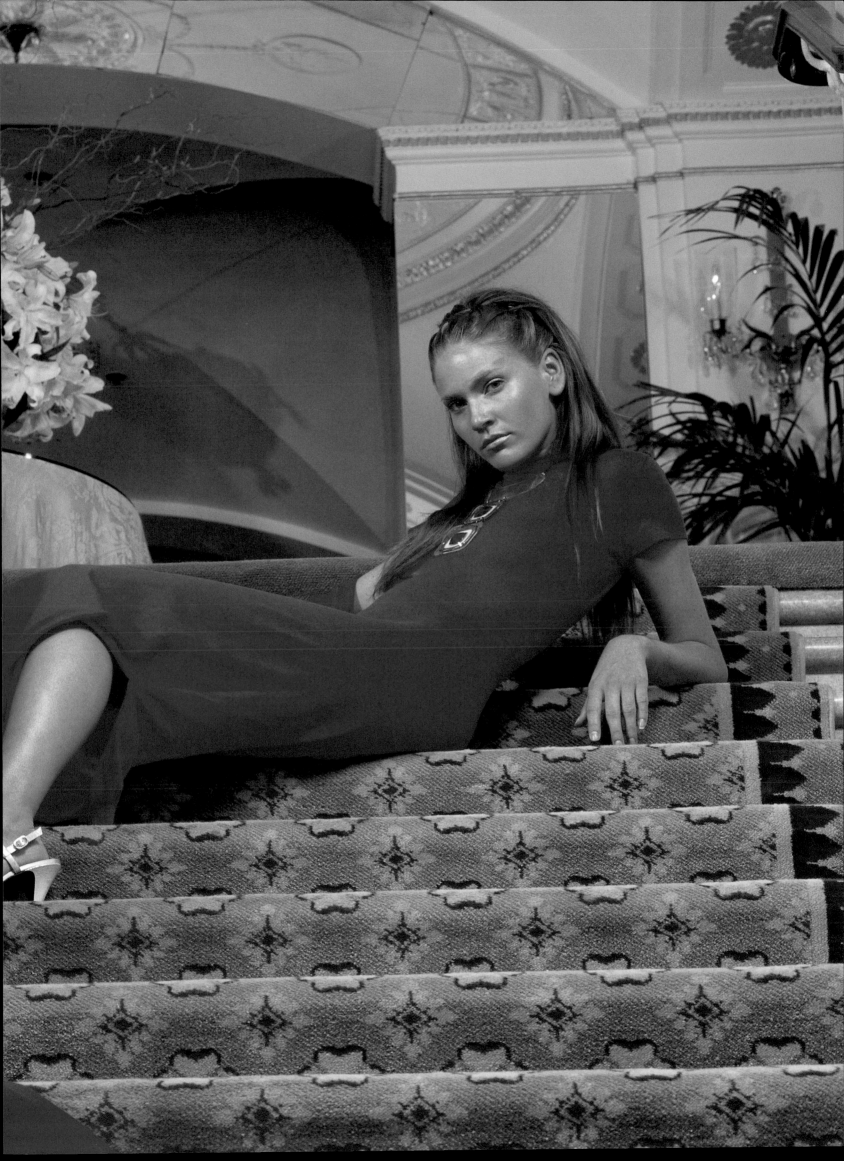

| CAROLINA HERRERA

My clothes are very classic
in the modern way—for the
woman of today—but at the
same time they are very
sophisticated and sensuous.
The women I dress are
admired by men; they look
very sexy and they also look
like real women.

—Carolina Herrera

| BEIGE-AND-WHITE LACE DRESS

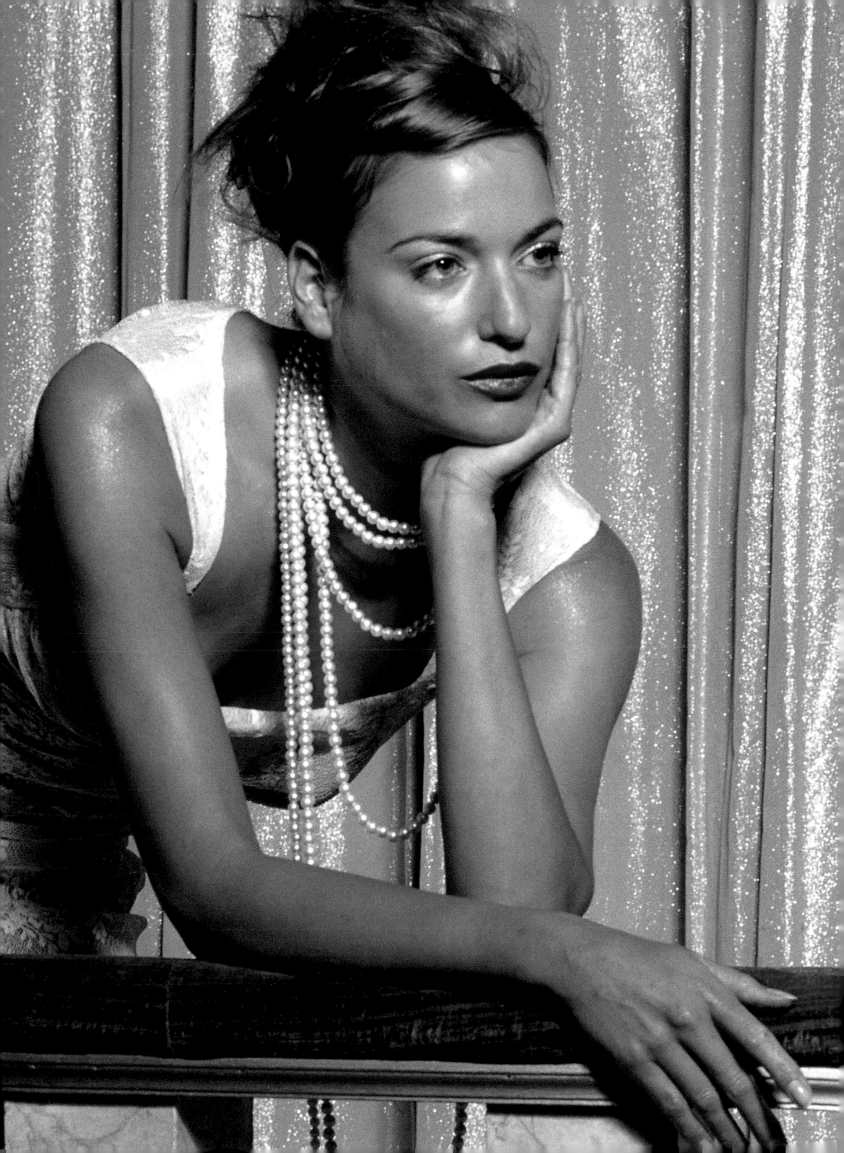

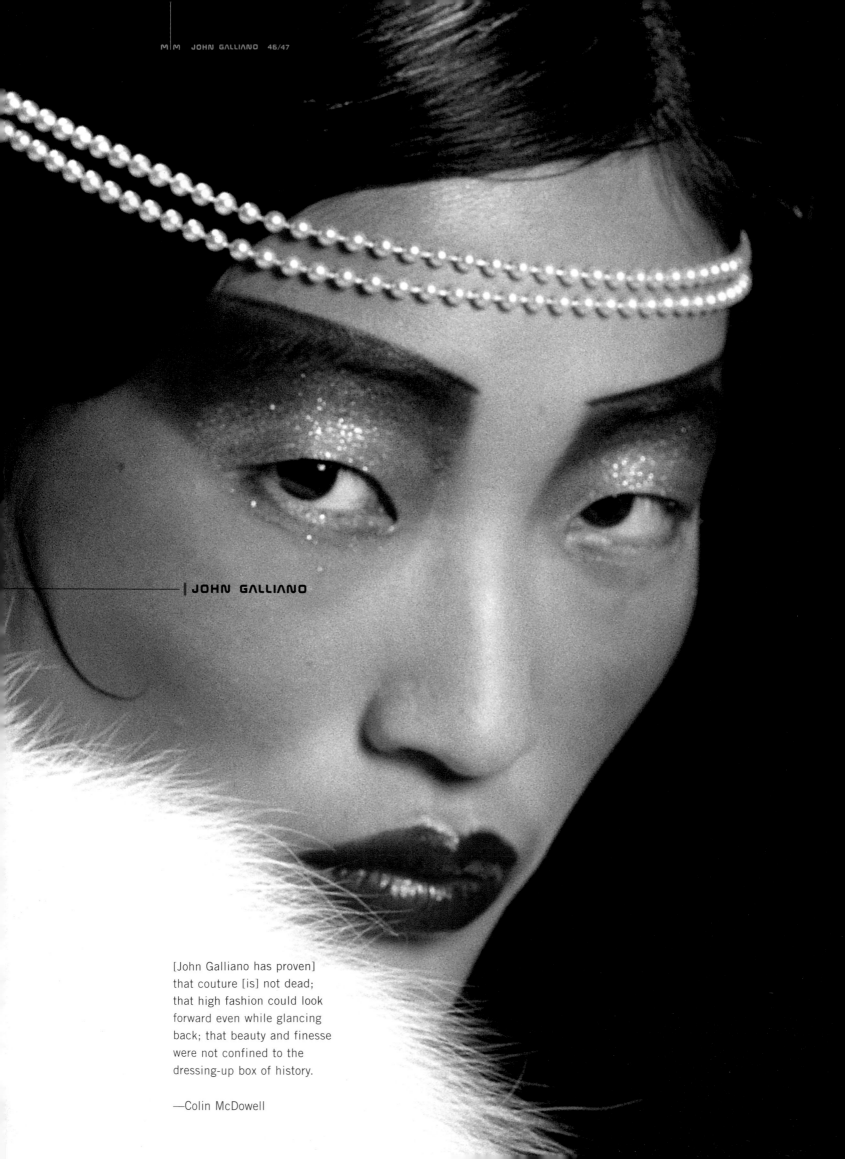

| JOHN GALLIANO

[John Galliano has proven]
that couture [is] not dead;
that high fashion could look
forward even while glancing
back; that beauty and finesse
were not confined to the
dressing-up box of history.

—Colin McDowell

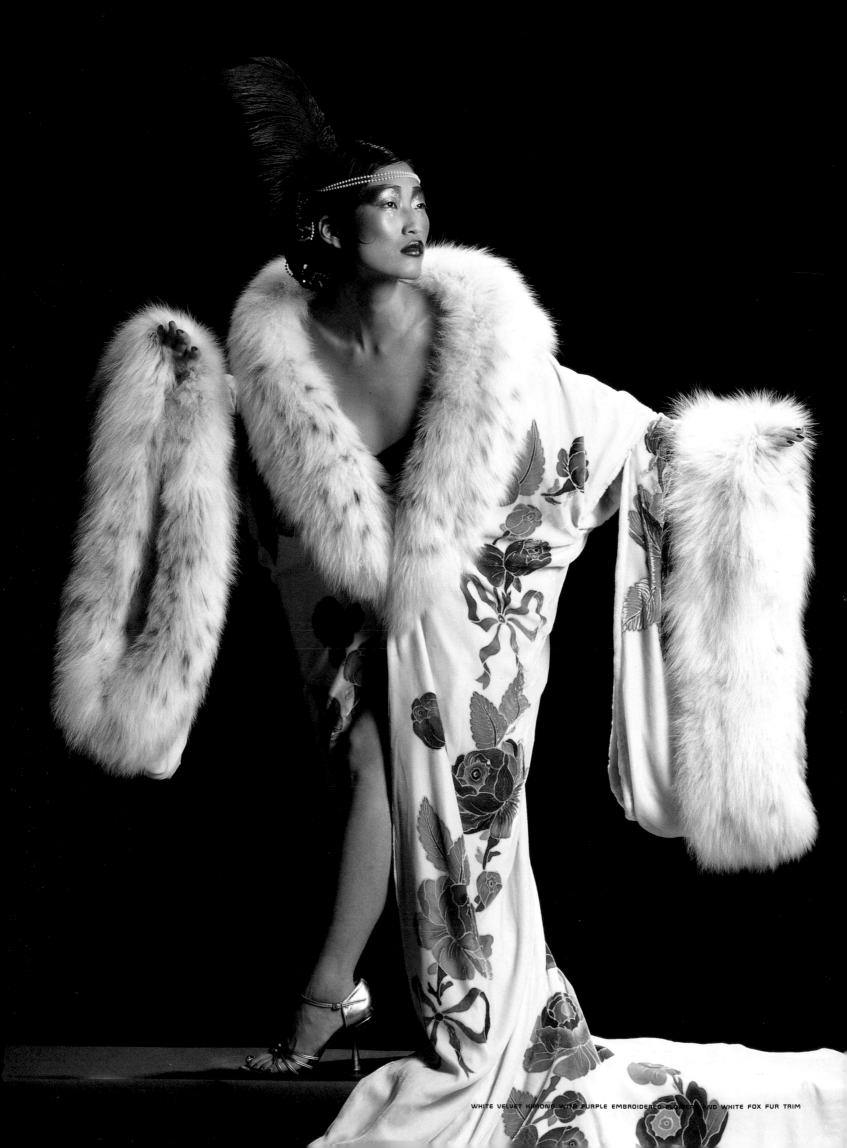

WHITE VELVET KIMONO WITH PURPLE EMBROIDERED FLOWERS AND WHITE FOX FUR TRIM

JOHN GALLIANO

LONG GOLD BROCADE KIMONO WITH SABLE COLLAR AND LEOPARD FUR TRIM

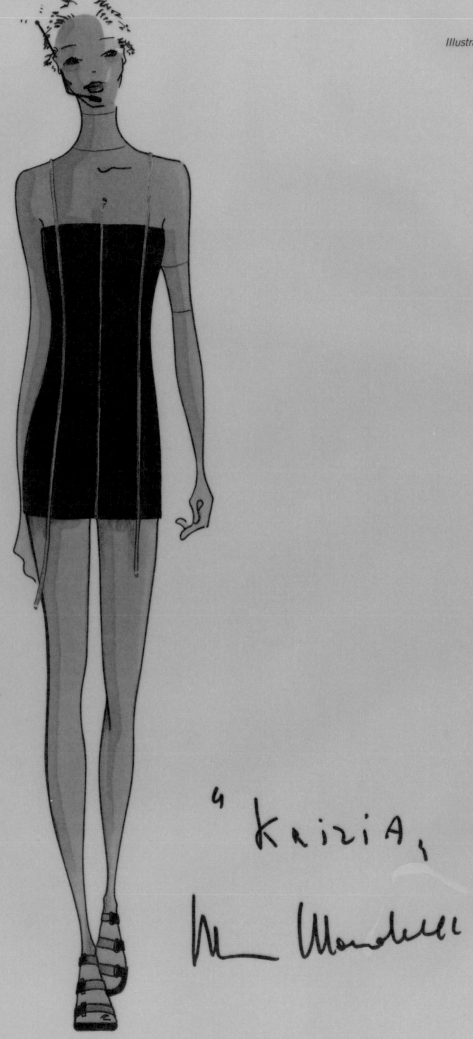

"Krizia,

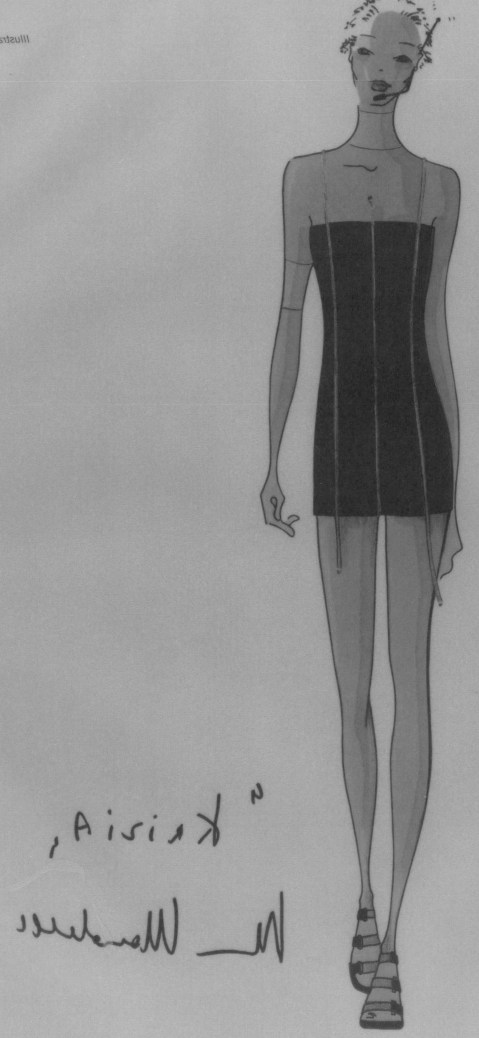

"Krizia,"

ETRO®

ETRO®

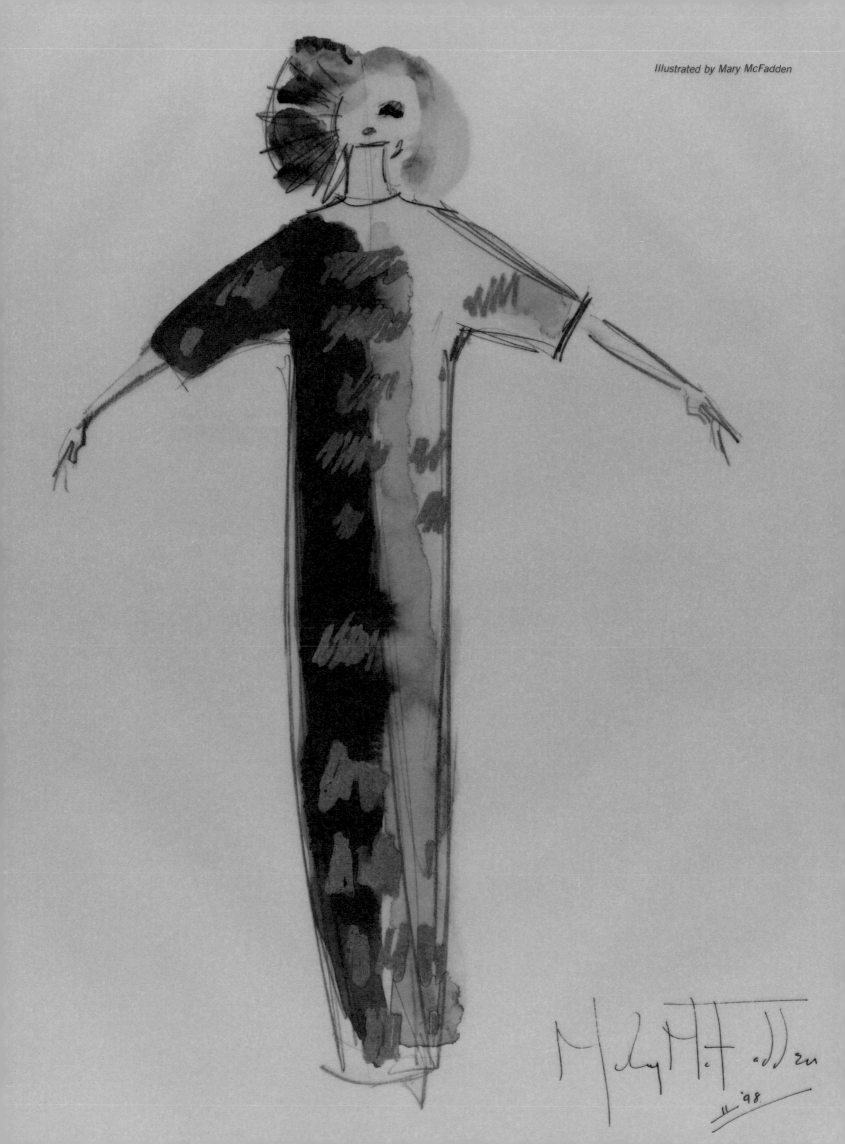

Illustrated by Mary McFadden

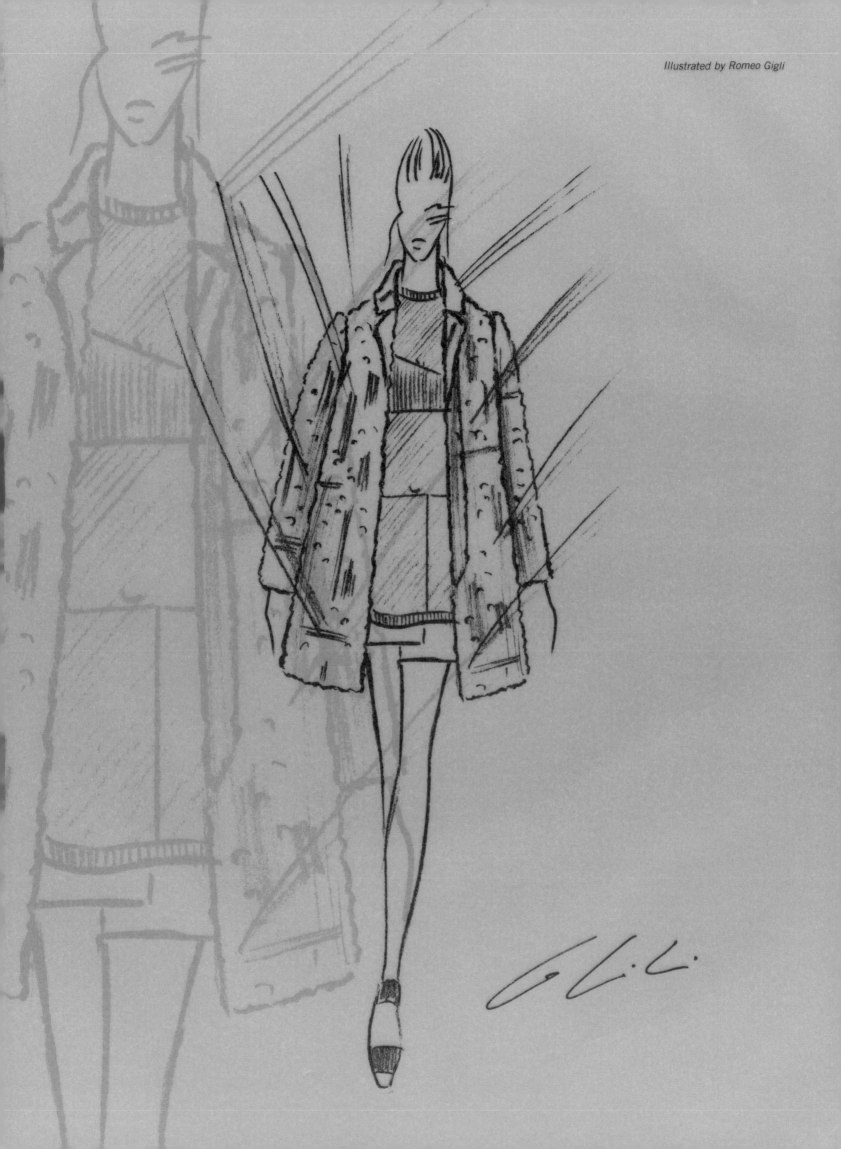

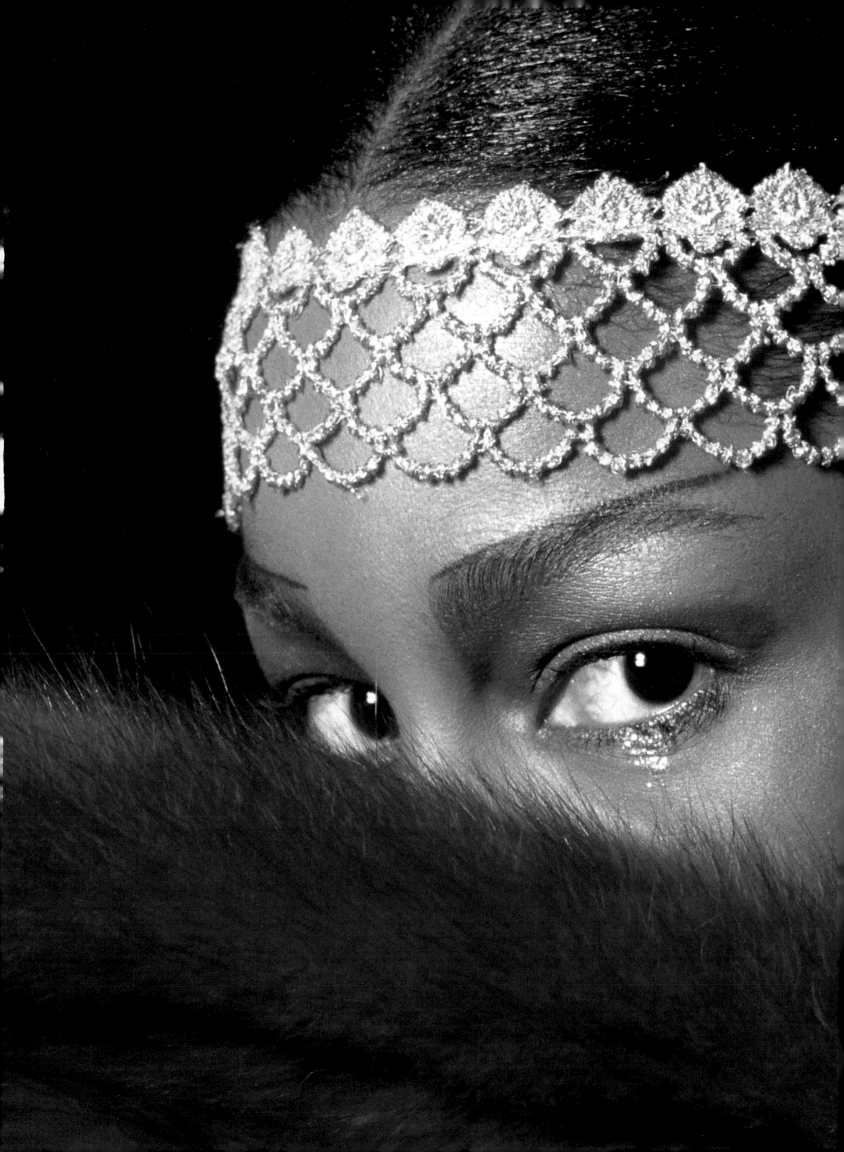

OSCAR DE LA RENTA

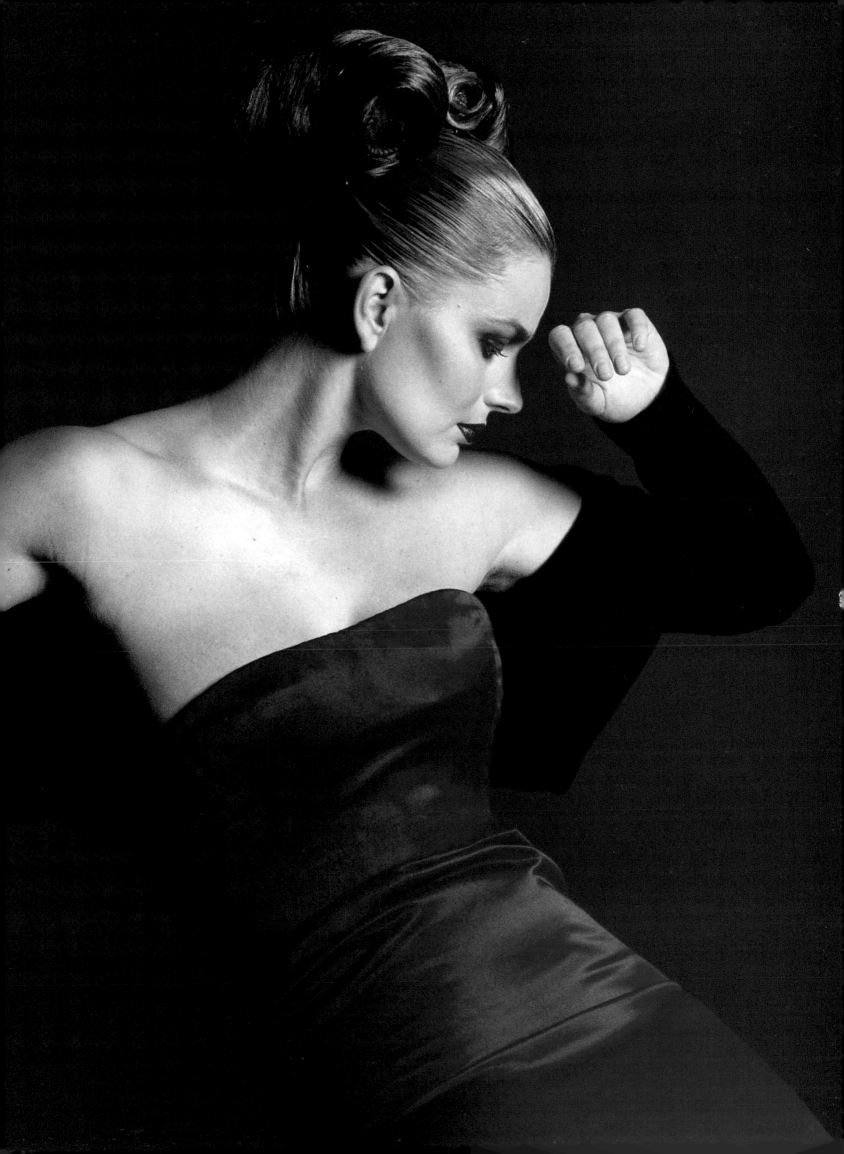

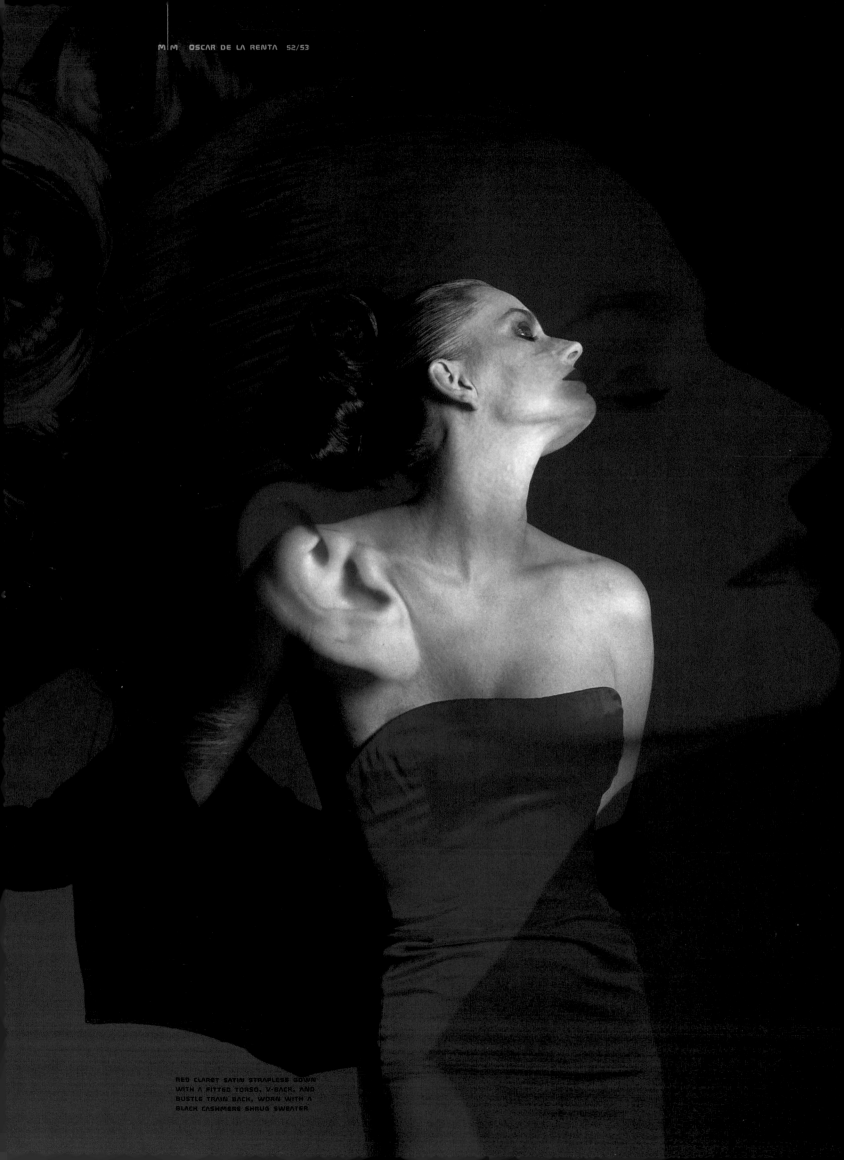

RED CLARET SATIN STRAPLESS GOWN
WITH A FITTED TORSO, V-BACK, AND
BUSTLE TRAIN BACK, WORN WITH A
BLACK CASHMERE SHRUG SWEATER

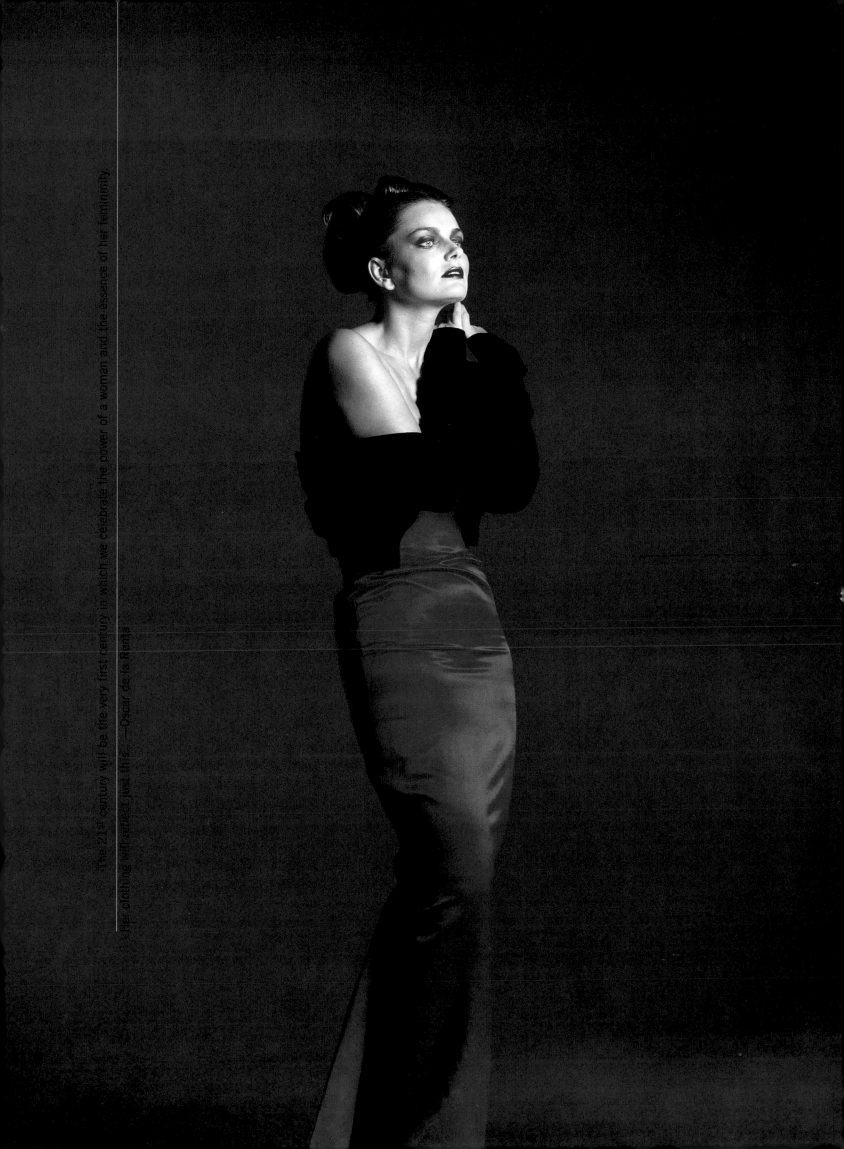

The 21st century will be the very first century in which we celebrate the power of a woman and the essence of her femininity. Her clothing will reflect just this. —Oscar de la Renta

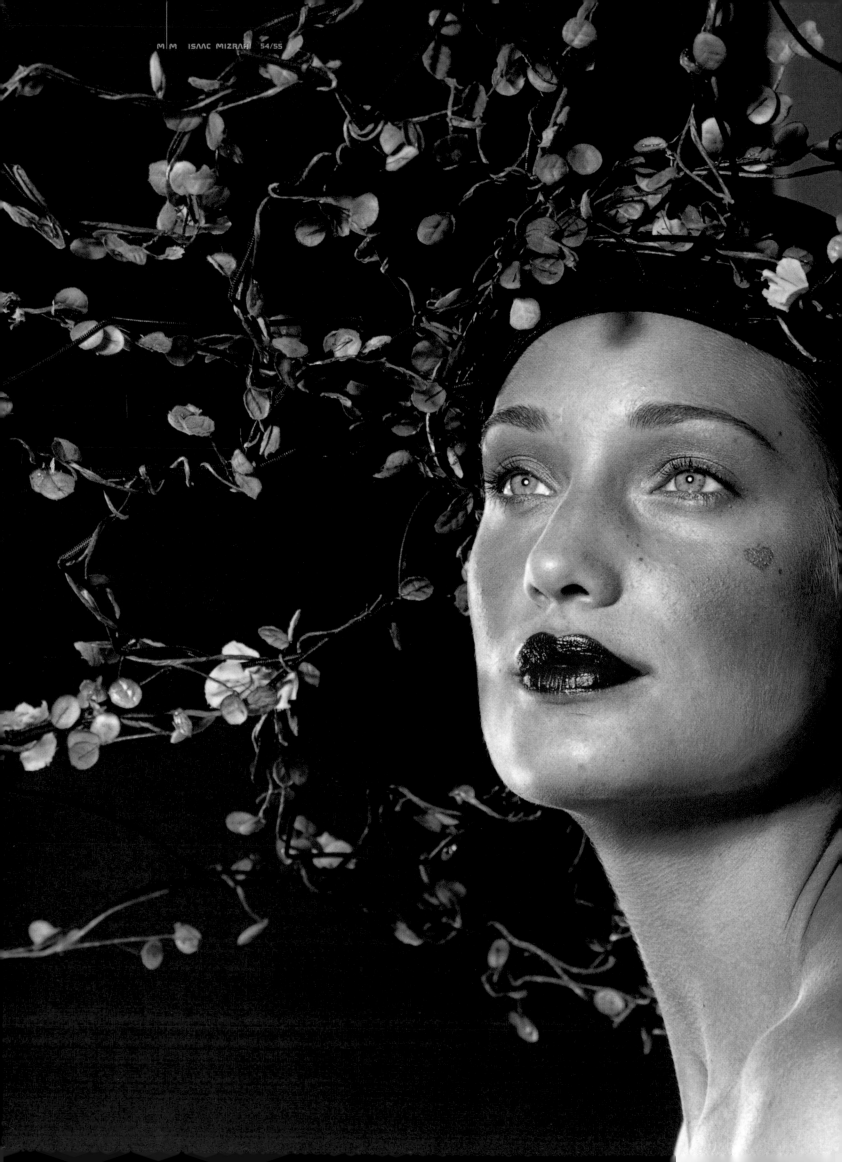

ISAAC MIZRAHI

SILK GOWN WITH TULLE

Authors' Note: *Even though Isaac Mizrahi no longer produces a retail line, for the past eleven years, he has been a formative force in the fashion world and continues to play an important role through his film work. We are proud to include his visionary ideas in* Millennium Mode.

In the next 100 years people are going to be into all sorts of different things. For executives and working people, I think it's going to be about cleanliness. It will be pared down. Very few details. There will be few colors and few things going on. It's going to be like a jumpsuit of one color or something. It's going to be made of some incredible knit, something that breathes. Outside of the office, it will be very eclectic and very mixed up and artful and beautiful. It will be an event. I think we'll see an extreme version of what's going on now.

—Isaac Mizrahi

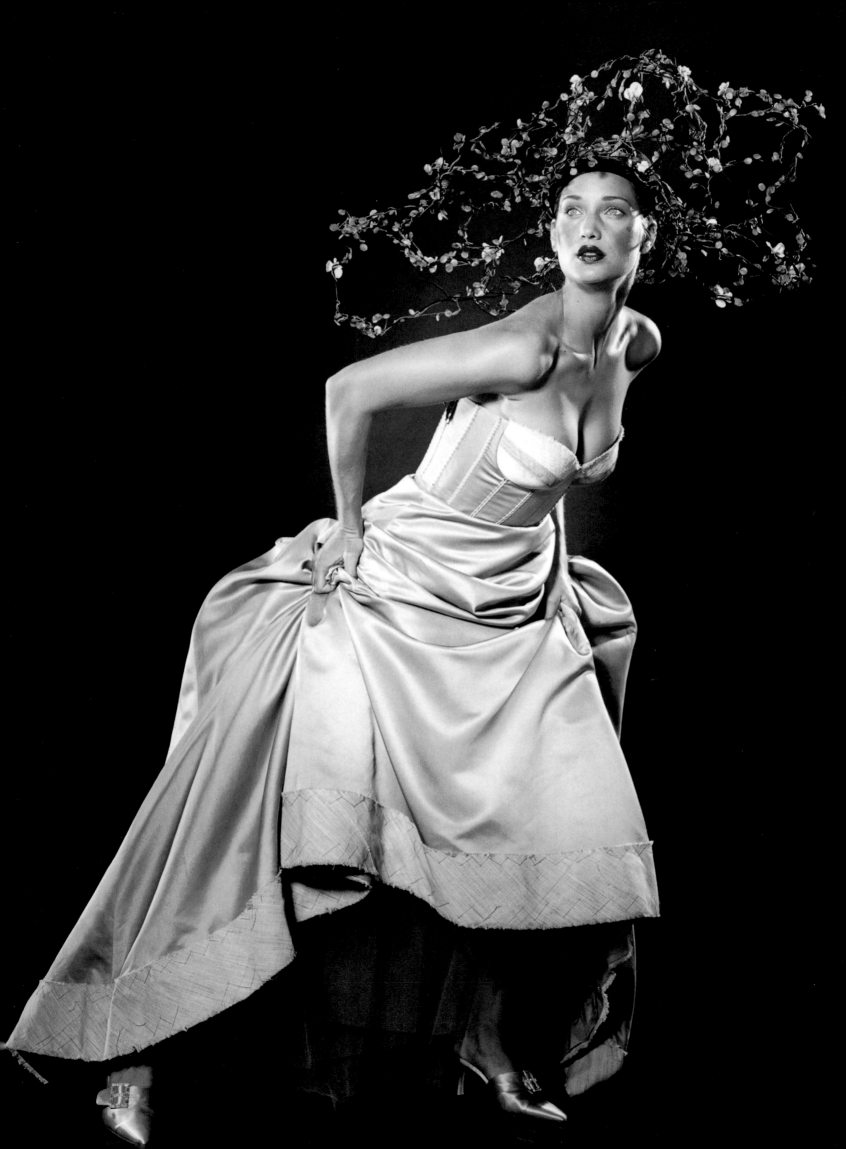

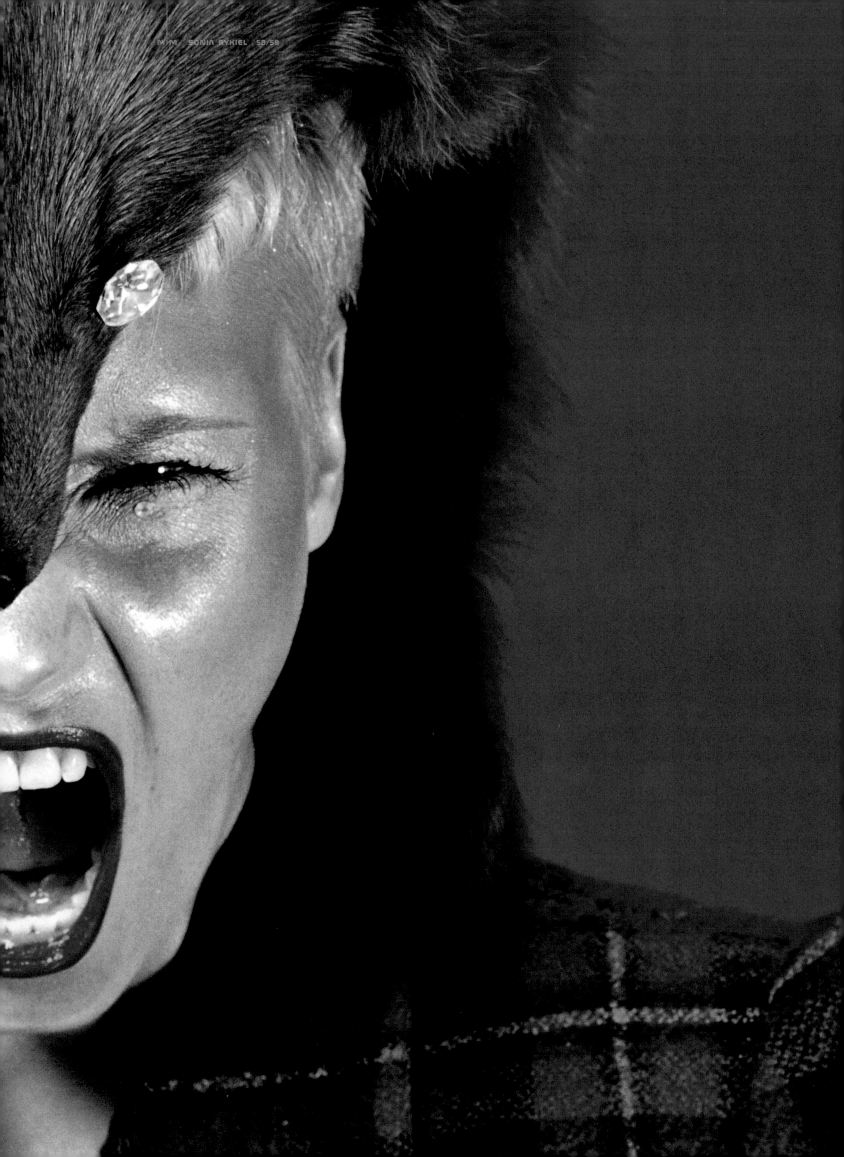

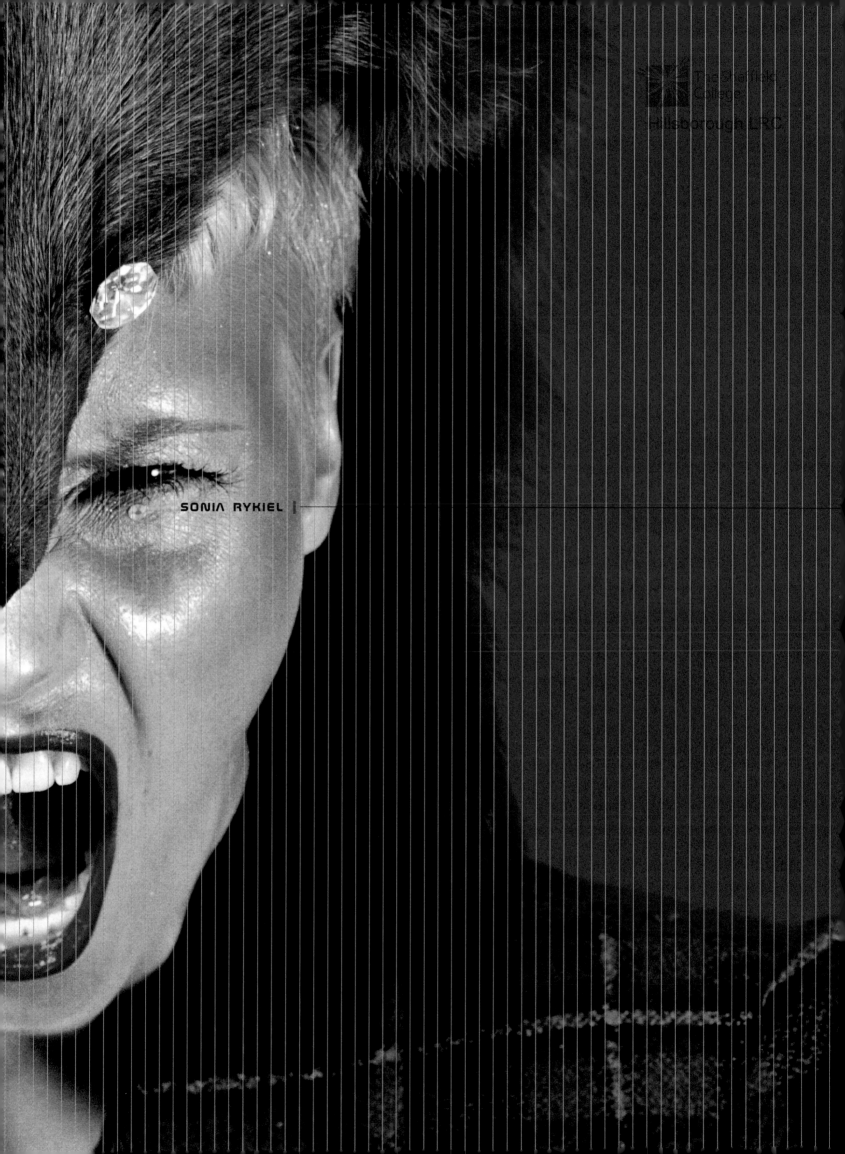

SONIA RYKIEL |

The year 2000 will begin the century of availability, of the fragment, of mobility, of a bewildering technical nature. It will also be the century of a certain uniformity. One can therefore be delirious, but at the same time remain levelheaded; [one can] forget previous experience in order to better experiment, [yet still] take time to contemplate, to self-interrogate, to make up for lost time, to get a real understanding before filing it all away in a corner of one's mind.

To be troubled, to allow oneself to be disturbed, to doubt because being doubtful is essential in order to create [are all mindsets we will find in the next millennium].... There [will be] no confusion but a kind of misbalance which displaces and forces one to face contradictory feelings, opposed ideas [that] introduce new mysteries. One must play with chance, as chance means adventure. [One must] bring together all types and then make a choice.

The year 2000 will be—I think—new fabrics, vibrant materials [that] breathe, which brighten, which allow air to pass through but retain warmth, [and] perfumed materials that excite one's sensuality [and] one's tenderness.

—Sonia Rykiel

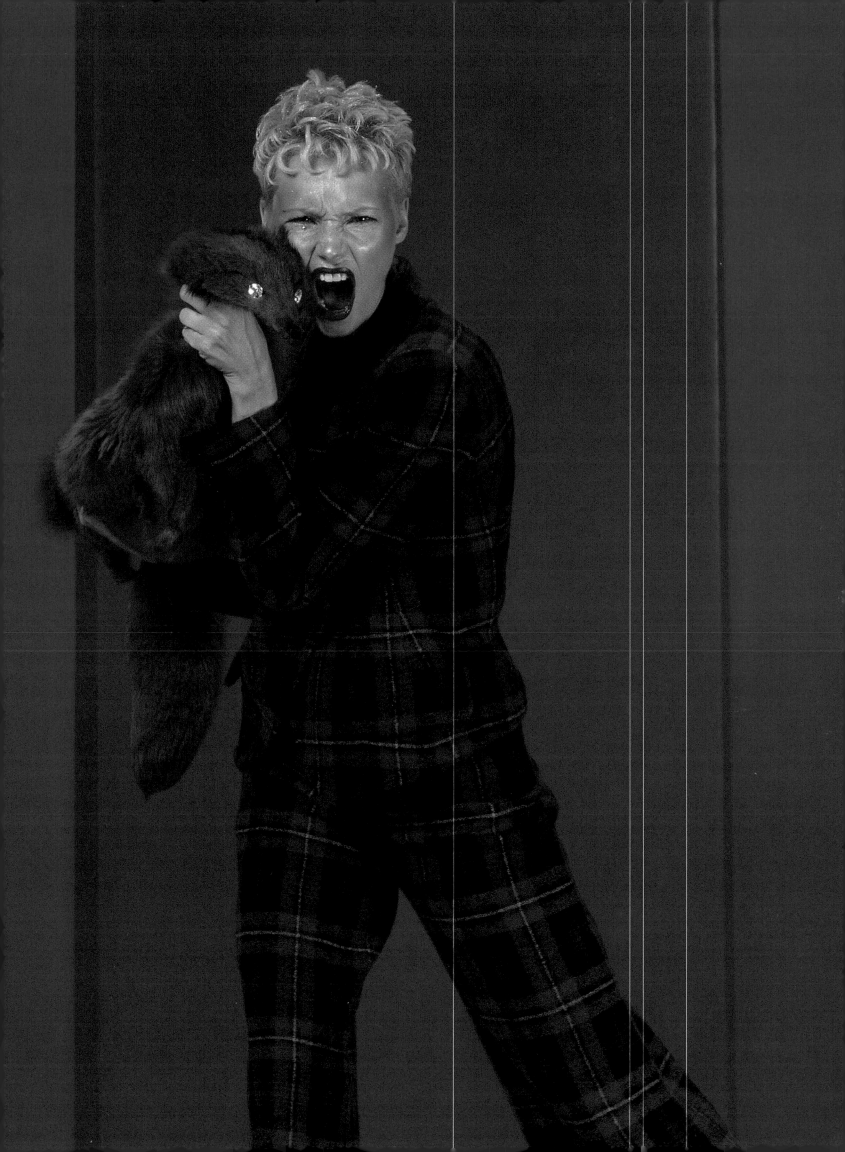

Fashion has always played a significant role in women's lives; however, where it once was a confining factor in a woman's life, it is now a liberating one. Today's woman demands collections that are both beautiful and comfortable, demands [that] reflect her ever-emerging assertiveness, confidence, and strength.

As it will in all aspects of life, technology will play an enormous role in the fashion field as we move into the next century. New technology has enabled the creation of fabrics, such as Lycra, that are not only strong and durable, but pliable and touchable as well. Of course, the impact of technology extends far beyond the creation of fabrics; the elaborate presentations of fashion via the multimedia [that] we have seen in the latter half of this century will inevitably continue into the next.

There is no doubt that the 20th century has been of one of globalism, with the unparalleled opportunities to visit and see all the corners of the earth. Designers have been able to draw from cultures and styles from around the world. As the cultures of the world become more accessible to everyone, the great challenge facing designers in the coming century will be that of drawing inspiration from within to complement those inspirations which are drawn from without.

—Han Feng

CRUSHED RED VELVET CAPE

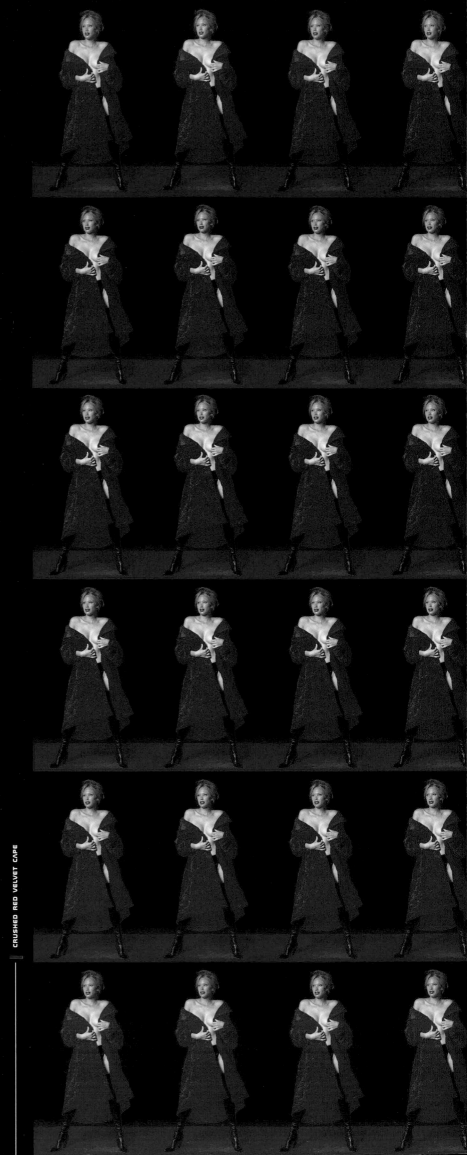

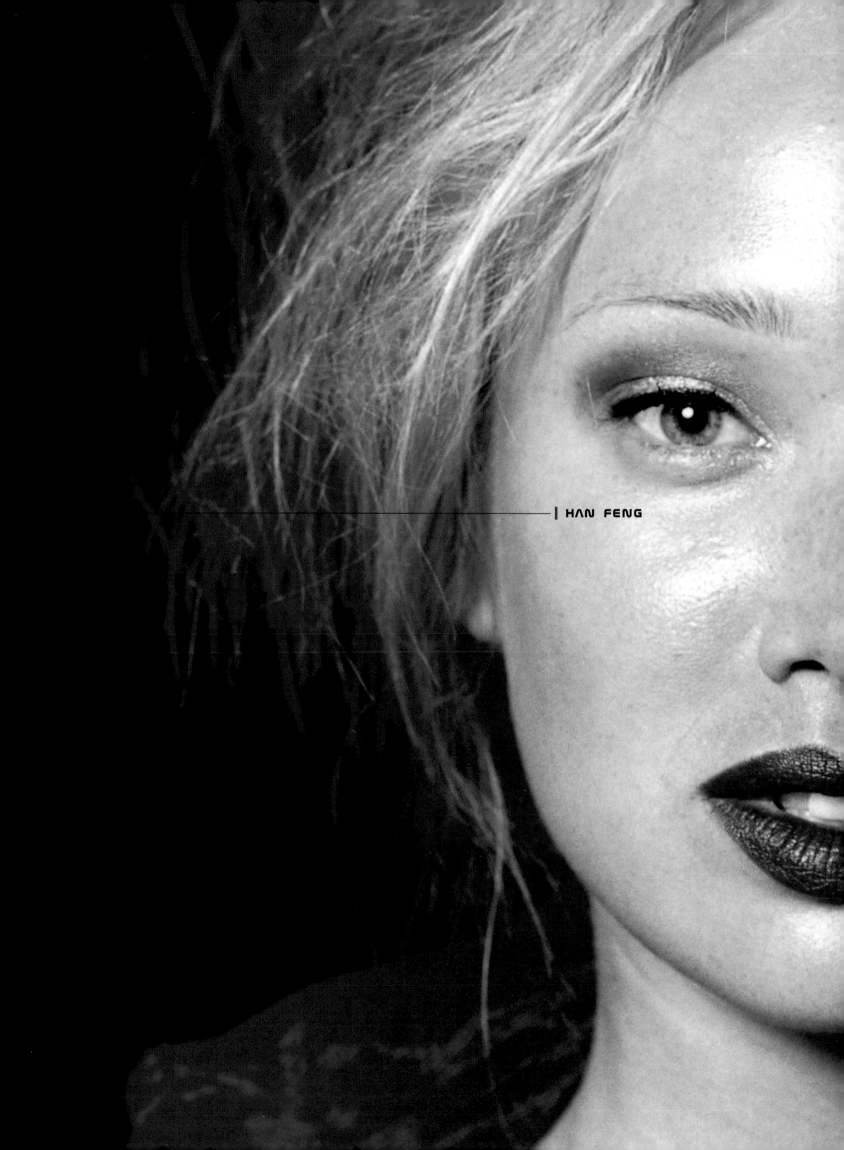

HAN FENG

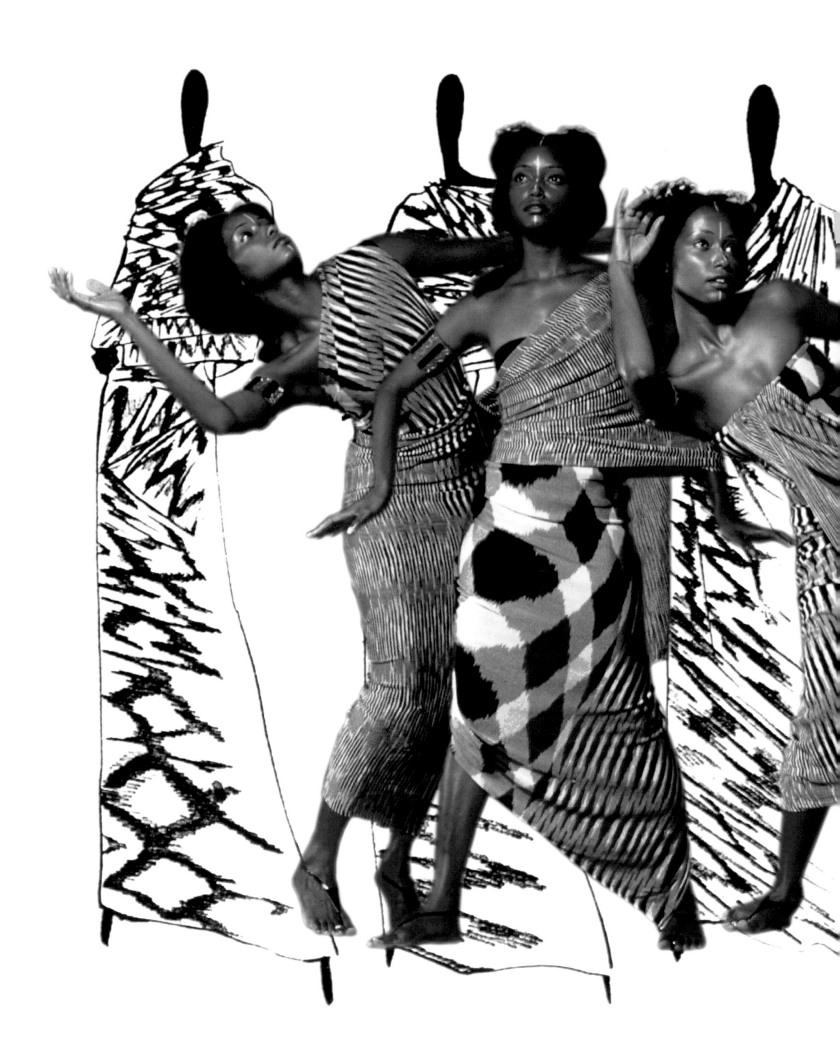

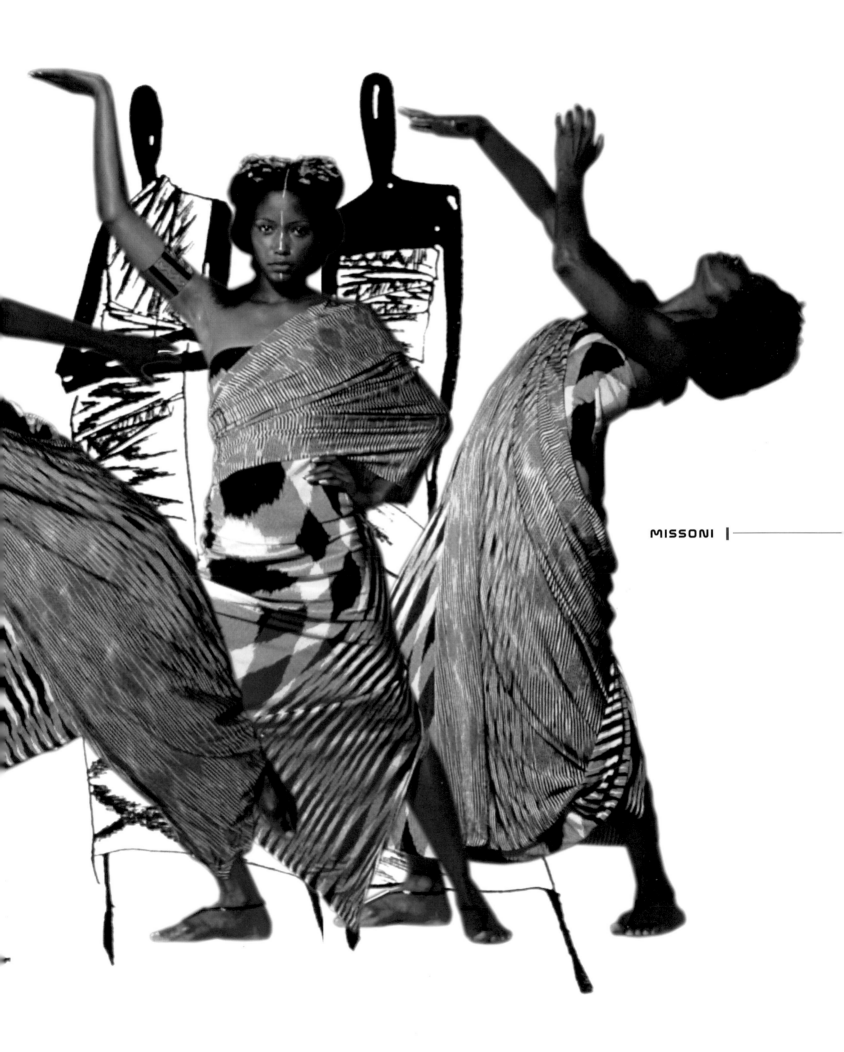

MISSONI |

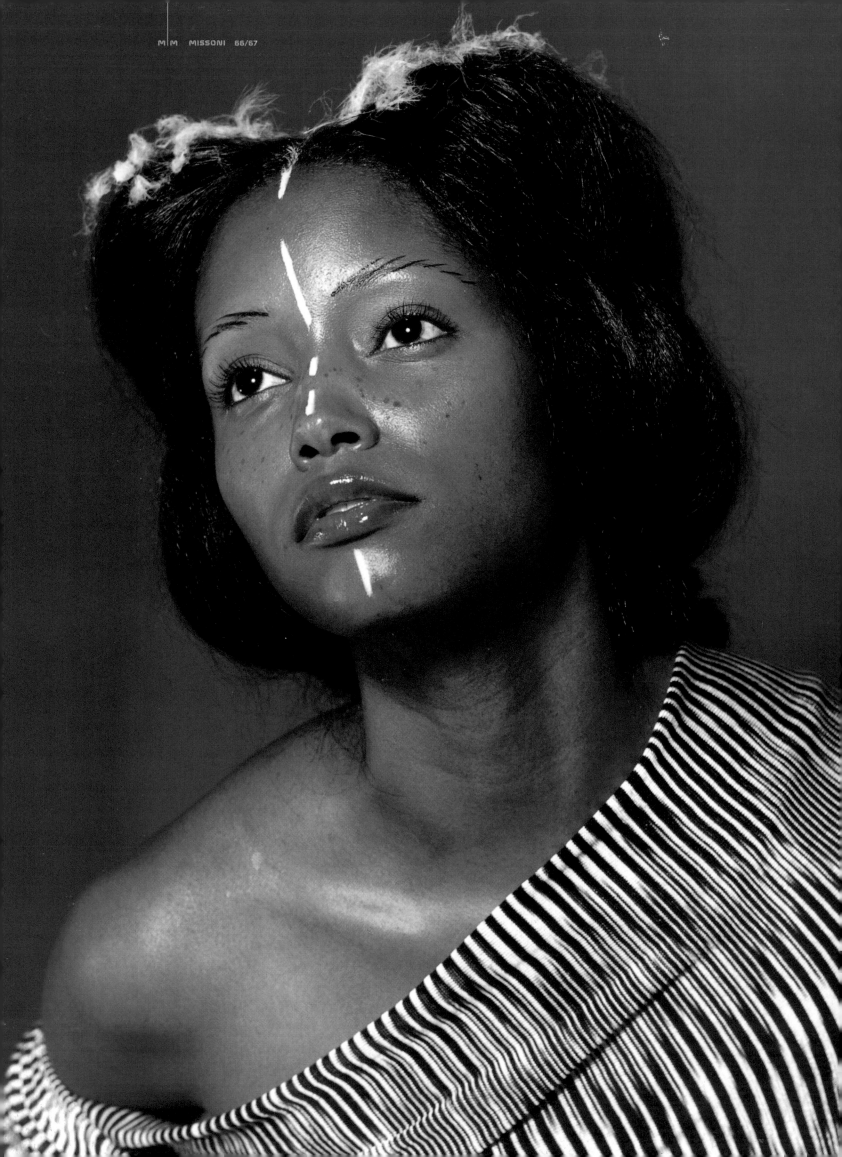

On fashion in the next millennium: Women today are free to enjoy fashion for their own pleasure. I envision for the future a further liberation from the dictates of fashion "rules." Choice is free. In order to be competitive, the established fashion houses are concentrating on evolving their own style and image by offering variety on the fashion market. Because of cultural globalization, fashion has become similar all over the world. Maybe this will generate a desire for personalization and individuality.

On fabrics: In creating clothes, fabric is the primary choice of both the designer and the customer. I have created a single rectangular piece of fabric—high in versatility—which can be wrapped and draped differently to make a variety of looks. Fabrics will be continually researched and developed. Textures, surfaces, new weights, aspects, and yarn composition and mixes will surely inspire new designs and ideas. Technology will play an important role in design inspiration.

On color in the 21st century: Wearing color expresses a certain state of mind, just as color can influence the well-being of a person. Color will always be used to express changes in life and society. I feel that generally we have become more color-therapy conscious.

On reality vs. fantasy in fashion: "Fantasy designers" could become important again as a reaction against fashion's recent tendency toward simplicity and the concept of the "real" woman's easy-to-wear wardrobe. At present, "fantasy in details" has become the important issue in design and will continue to be relevant.

—Angela Missoni

On fashion's role in the next millennium: Fashion is becoming increasingly more functional, comfortable, and adaptable to climate and situation. All of these traits combined contribute to the ongoing ability of fashion to charm and excite.

On fashion and the workplace: Ultimately, it will no longer be necessary for people to go to the traditional "office" as we know it today. The idea of working from any location will break down barriers of what is appropriate where and when. As computer technology grows, these changes will become more and more apparent.

On the woman of the future: Through progress in plastic surgery and exercise, women in the future will be categorized less by age and more by attitude. I believe they will also become more confident and independent in their approach to the world.

On the real woman vs. the fantasy: There will always be a balance between pragmatism and fantasy. The two need to coincide for fashion to remain interesting and to offer a choice to the customer.

On fabrics: More and more fabrics are being developed that appear to be one thing but are in fact something else—they look woven but are knitted, or they look heavy but are light to the touch. Fabrics will soon be developed where sewing with a needle and thread will not be required at all.

—Michael Kors

CASHMERE VOILE T-SHIRT WITH MATCHING PAREO AND CHOCOLATE BROWN THONGS

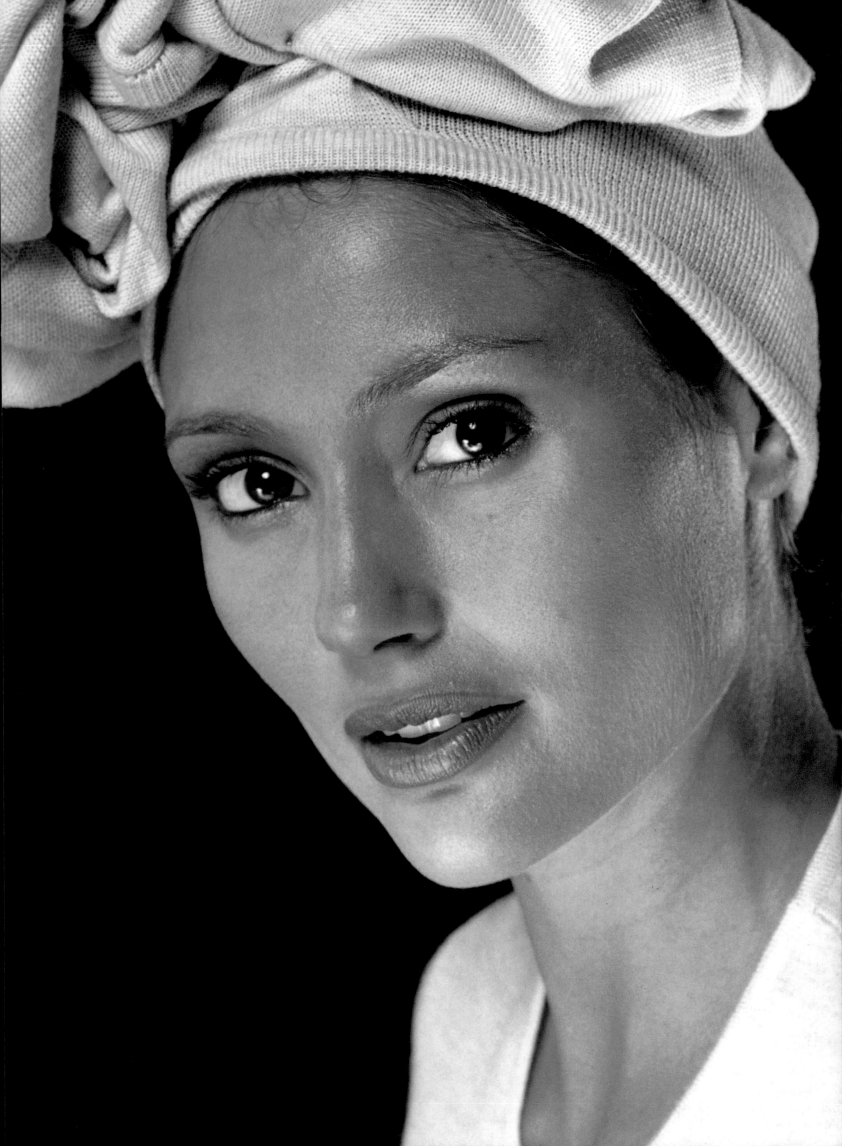

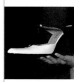
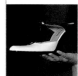
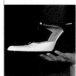
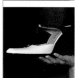
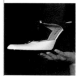
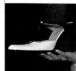
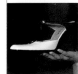
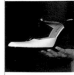

In the next millennium: I think that a woman's sense of fashion has always been connected with her sexual appeal, her social awareness, with expressing herself or part of her aesthetic vision (like her home, etc.). I think that this will never change. Probably what will change and improve will be women's awareness of these...[issues], with a more clever and more flexible use of them.

Art and fashion are both connected with what is visual and aesthetic, each in a different way. I do not think that one influences the other, but that art can help you better understand today's life, problems, and needs. Nor is there such a thing as the "world of fashion." Fashion is one of the many interests and points in life: I have never seen any contradiction between spirituality and the way someone dresses. One probably dresses accordingly with his or her social, religious, and political ideas.

In the meantime, research on fabrics in fashion will continue to have a growing importance—research is fundamental in any field.

—Miuccia Prada

WHITE PLASTIC TANK WITH MATCHING REFLECTIVE PLEATED SKIRT AND RED-AND-WHITE PATENT ANKLE-STRAP PLATFORMS

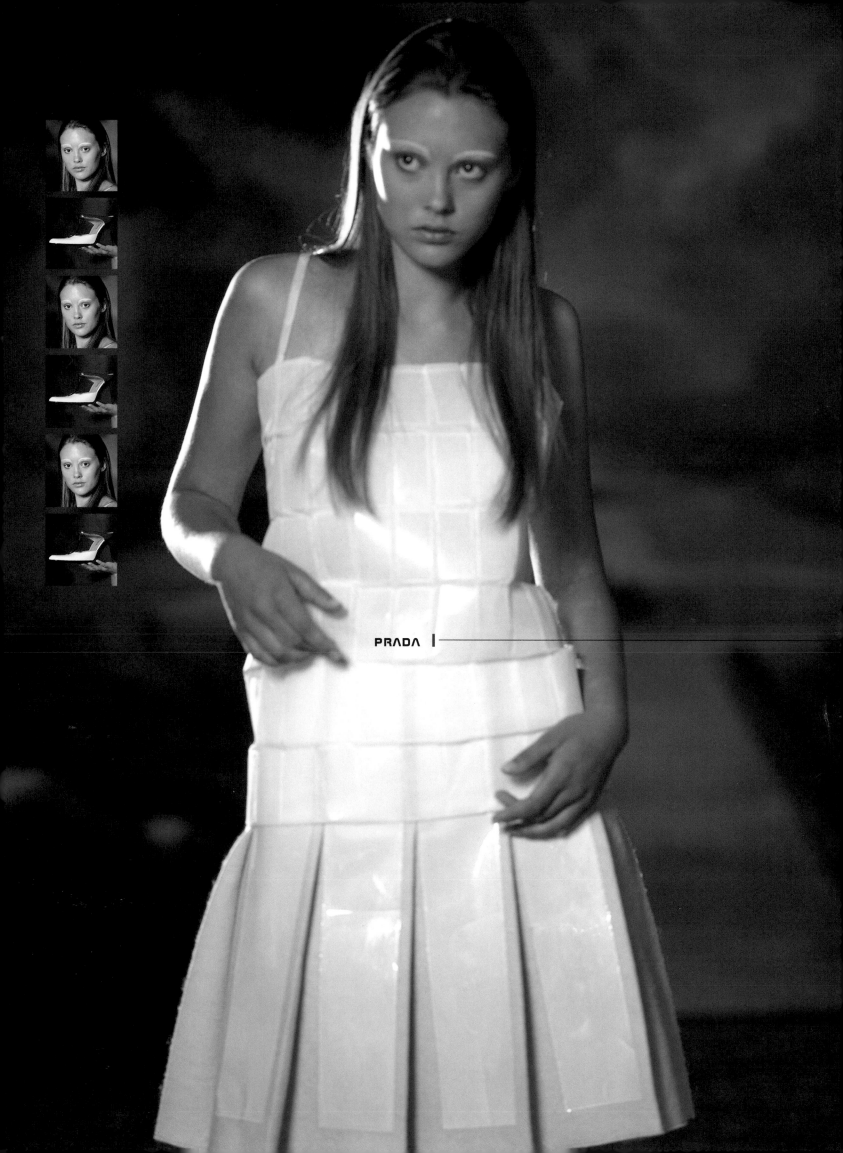

PRADA

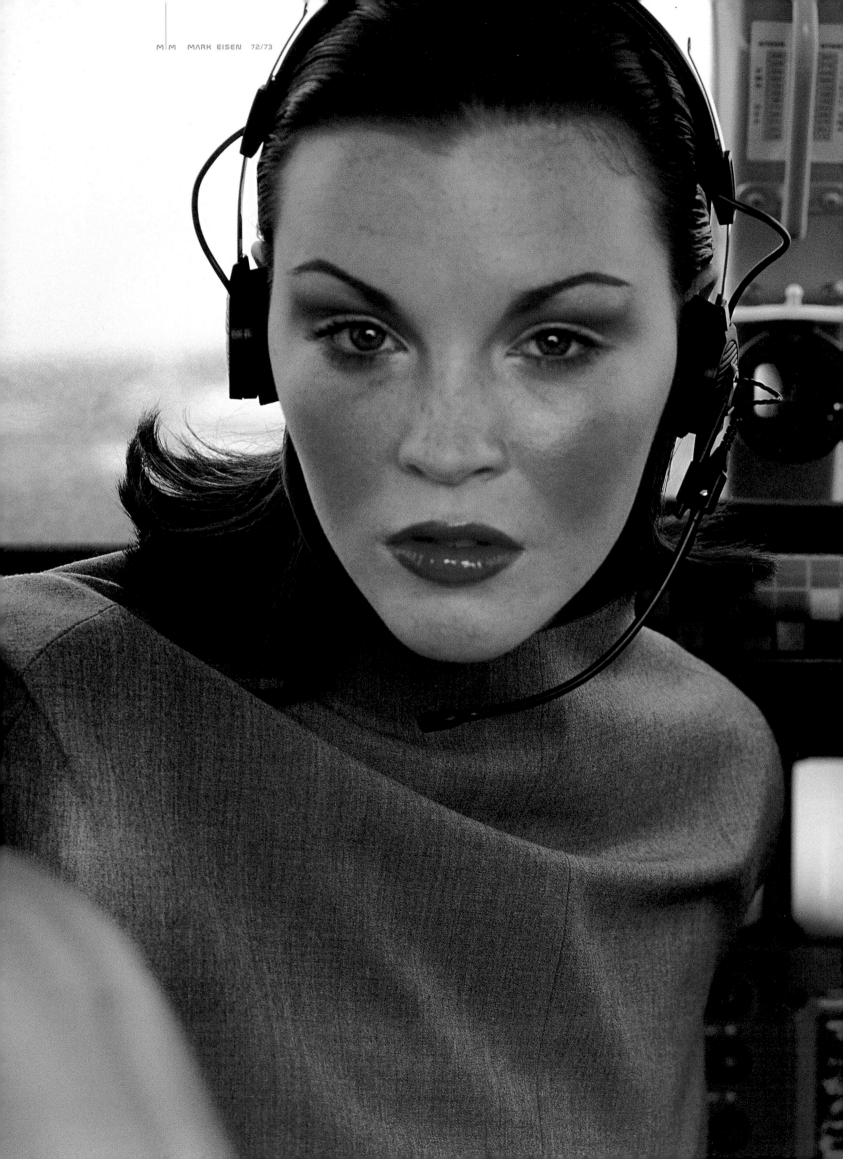

MARK EISEN |

I deal in non-referential fashion—fashion that does not reference the past. It's essentially post-minimalism. That's what's happening in culture and society today, and in my opinion will be the prevailing aesthetic in the future. We've been through minimalism, which is white, stark, and austere. Post-minimalism, while still pure and clean, is softer, warmer, with heart and flavor.

Ultimately, clothes have to reflect what's happening in society or they become costumes. What's happening in culture now is about geometry, not decoration. Take for instance the Paris Opera, which is old and was built by extraordinary artisans, and take Frank Gehry's recent museum in Bilboa. Someone dressed in very decorative clothes looks great standing in front of the Paris Opera, but they look out of date in front of [the] Bilboa [Guggenheim]. As we evolve, our clothes have to develop within an aesthetic context. At the same time, the...[expansion] of global communications means that wearing a Japanese print today looks modern, where forty years ago it would have looked like a costume. The opening up of individual cultures is going to create more cross-cultural realities.

One of the main components of non-referential fashion is the use of technology, modern methods applied to traditional fabrics and luxury yarns. So you create cashmere that's finer than it's ever been, for example. Or cashmere laminated with Lycra. You take traditional fabrics and treat them in a modern way, so they're stretchy or waterproof or feel like paper. Rather than assume that technology will bring mass-production, I look at it as the ability to have total customization. You can have a pair of jeans made for your particular shape, or model an outfit on a computer screen. I can communicate with someone in New York or Hong Kong on a big screen—be physically in that room at that moment.

There's no doubt that in the future, fashion will be all about the individual. There will be no rules. As fashion designers, we will contribute to people's lives by offering them choices. As people learn to express themselves and their individuality through color and shape and confidence, it will be the designer's role to put the pieces together. Because we're not leaving anything behind. We're expanding.

—Mark Eisen

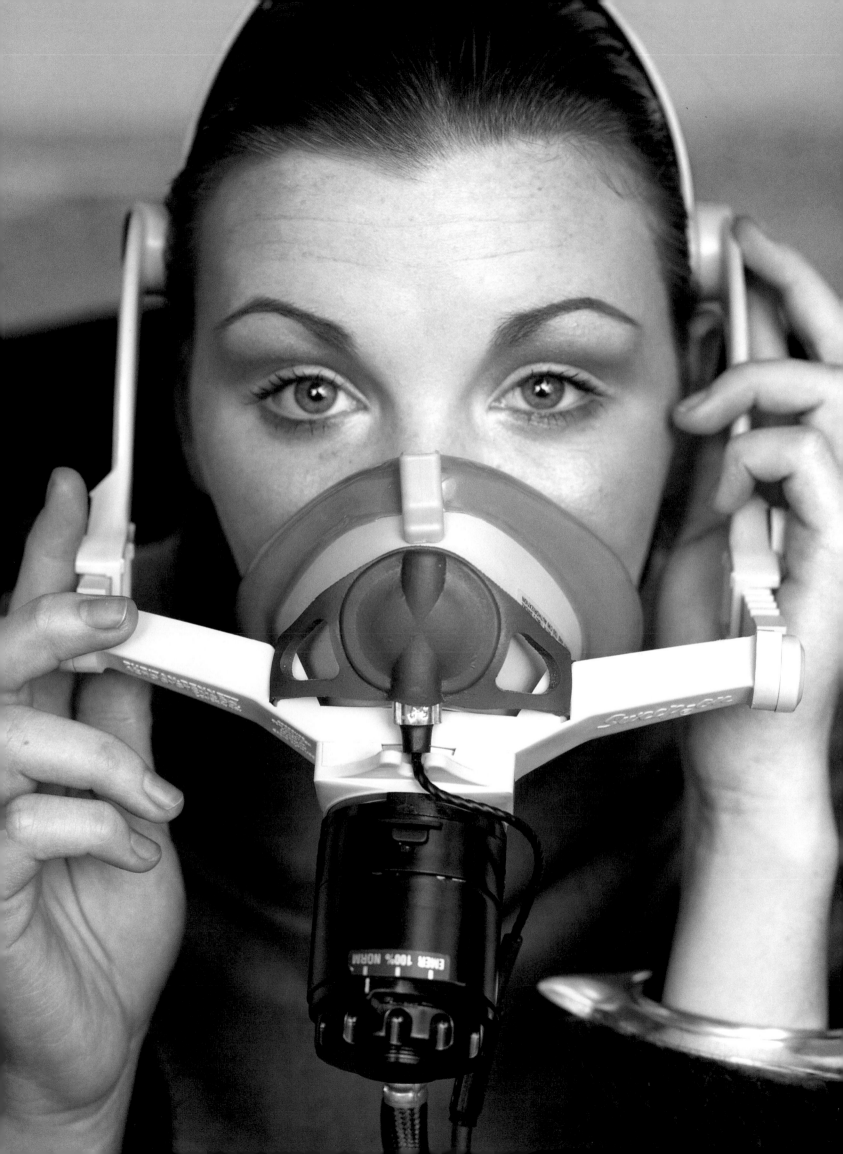

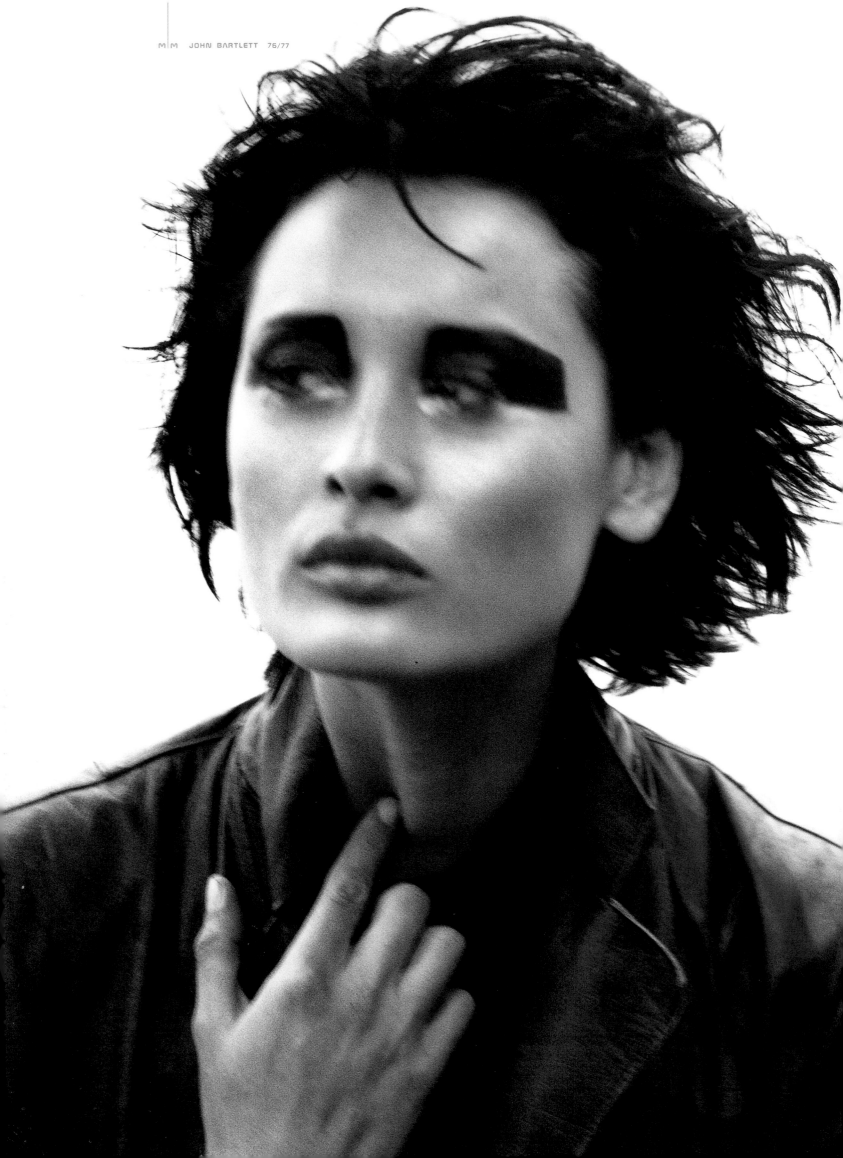

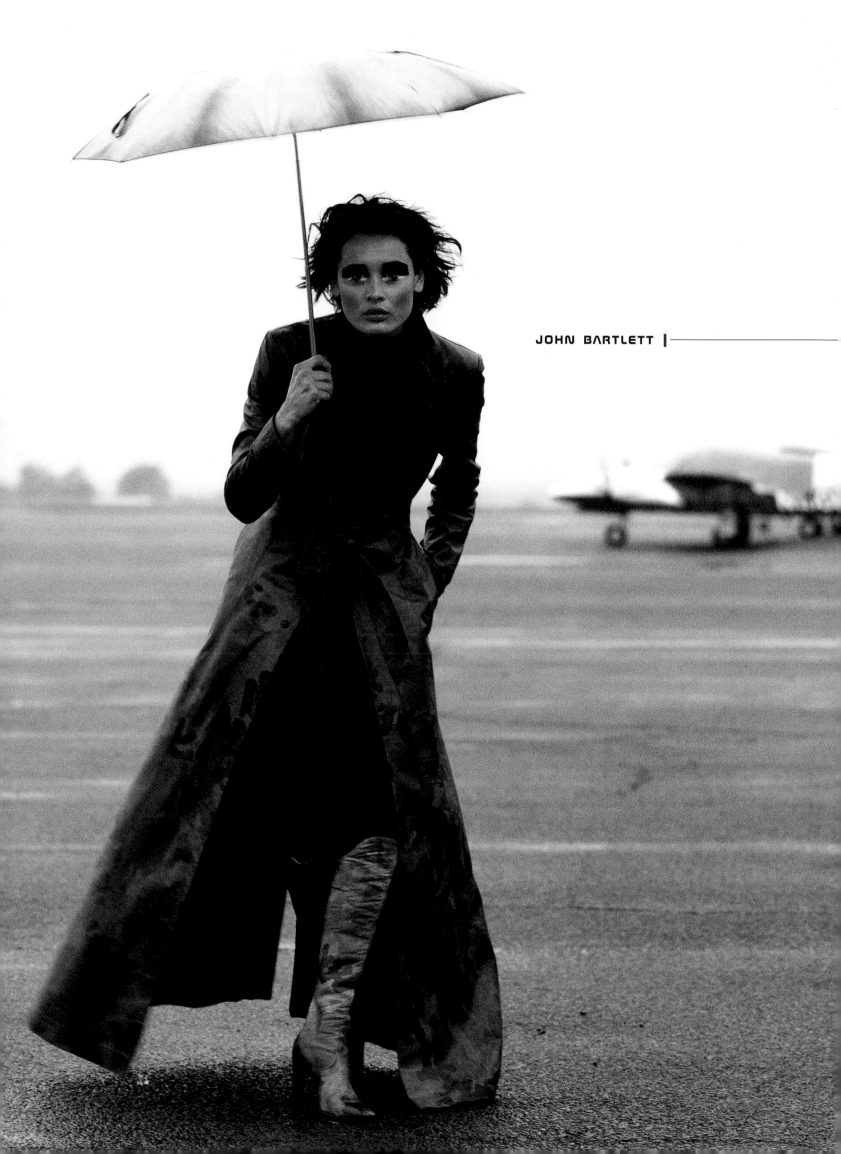

JOHN BARTLETT |

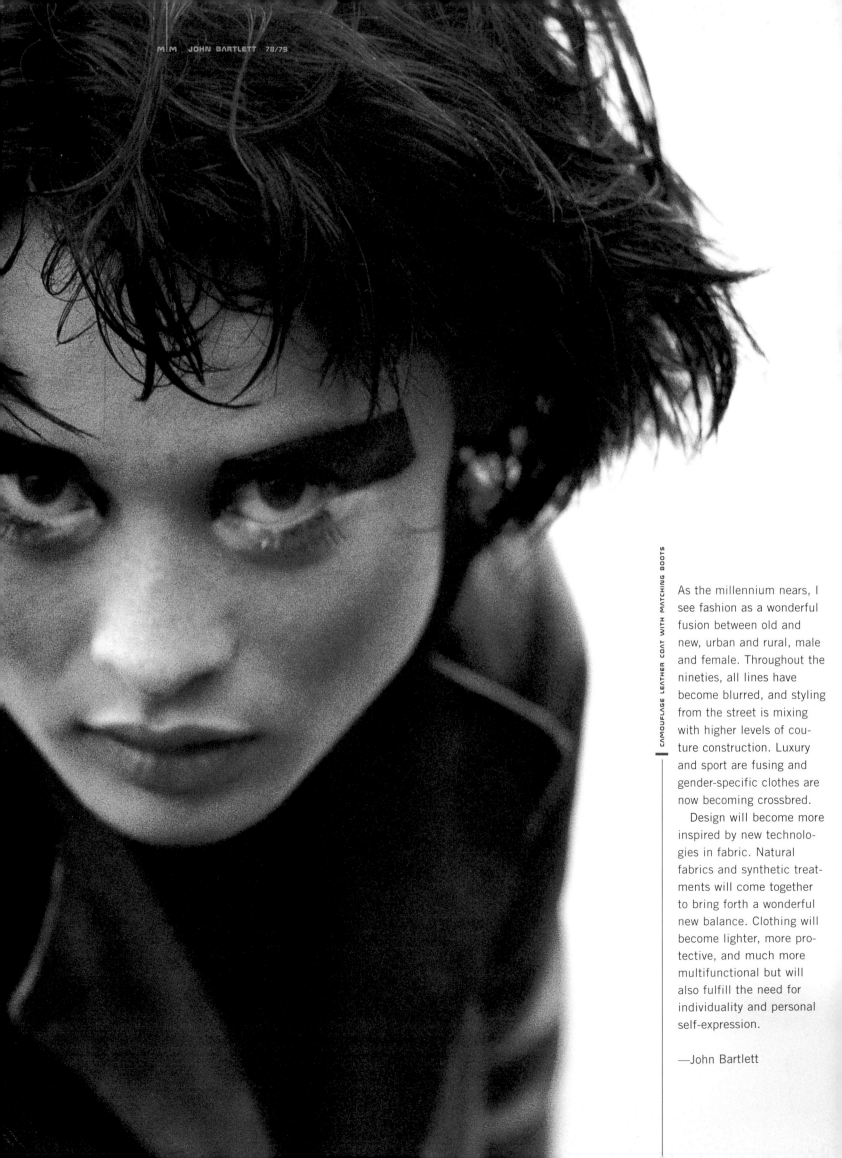

CAMOUFLAGE LEATHER COAT WITH MATCHING BOOTS

As the millennium nears, I see fashion as a wonderful fusion between old and new, urban and rural, male and female. Throughout the nineties, all lines have become blurred, and styling from the street is mixing with higher levels of couture construction. Luxury and sport are fusing and gender-specific clothes are now becoming crossbred.

Design will become more inspired by new technologies in fabric. Natural fabrics and synthetic treatments will come together to bring forth a wonderful new balance. Clothing will become lighter, more protective, and much more multifunctional but will also fulfill the need for individuality and personal self-expression.

—John Bartlett

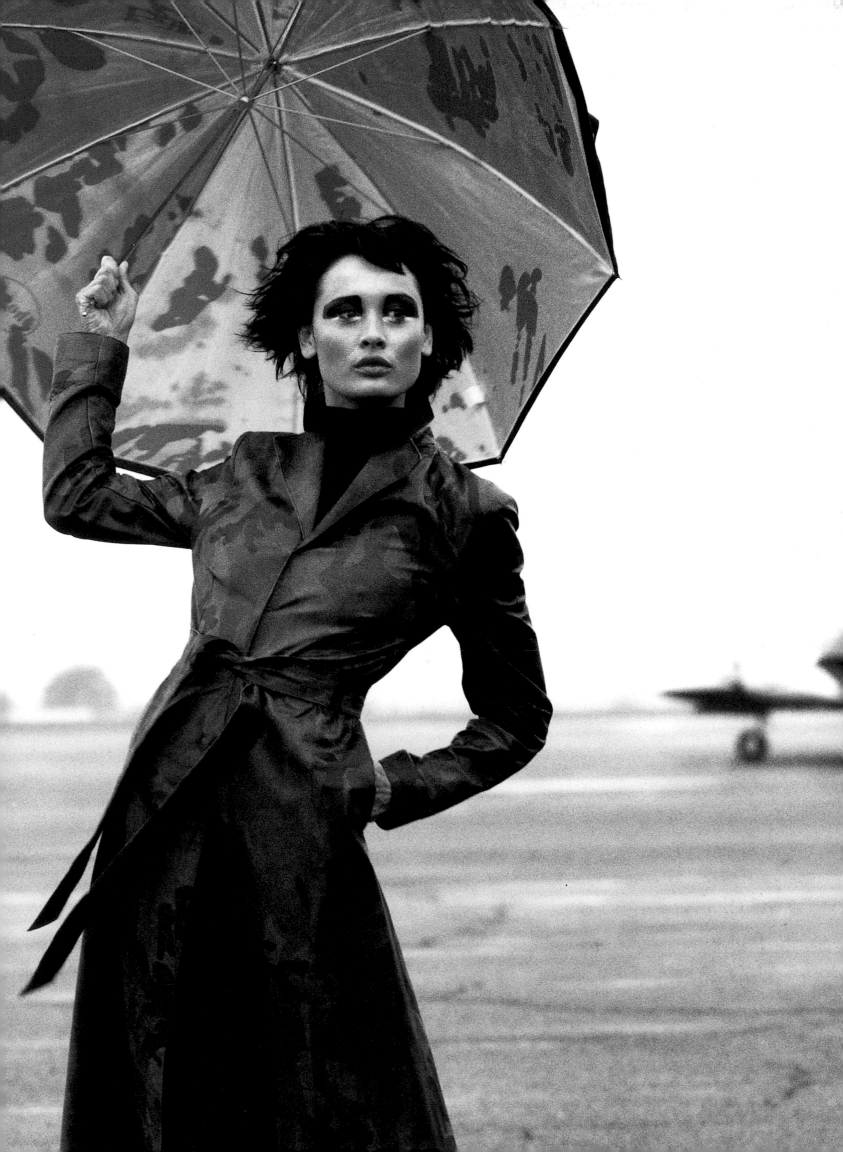

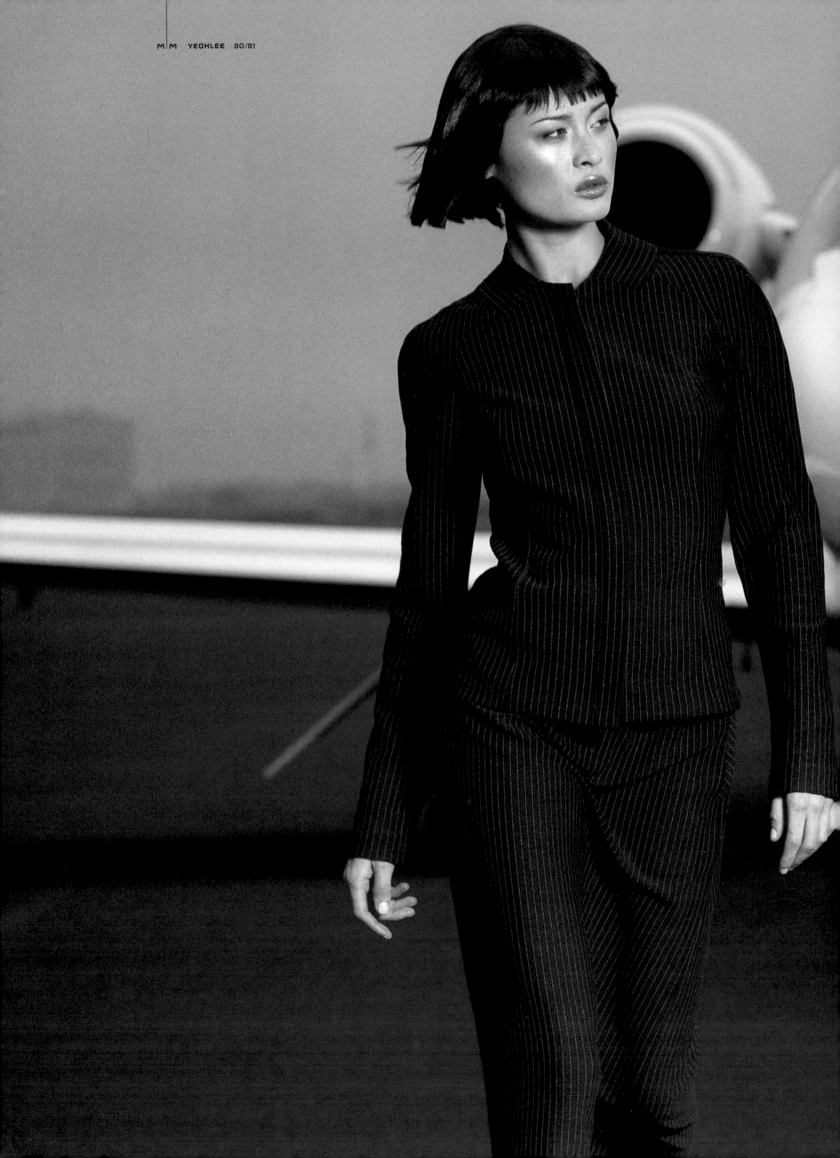

YEOHLEE |

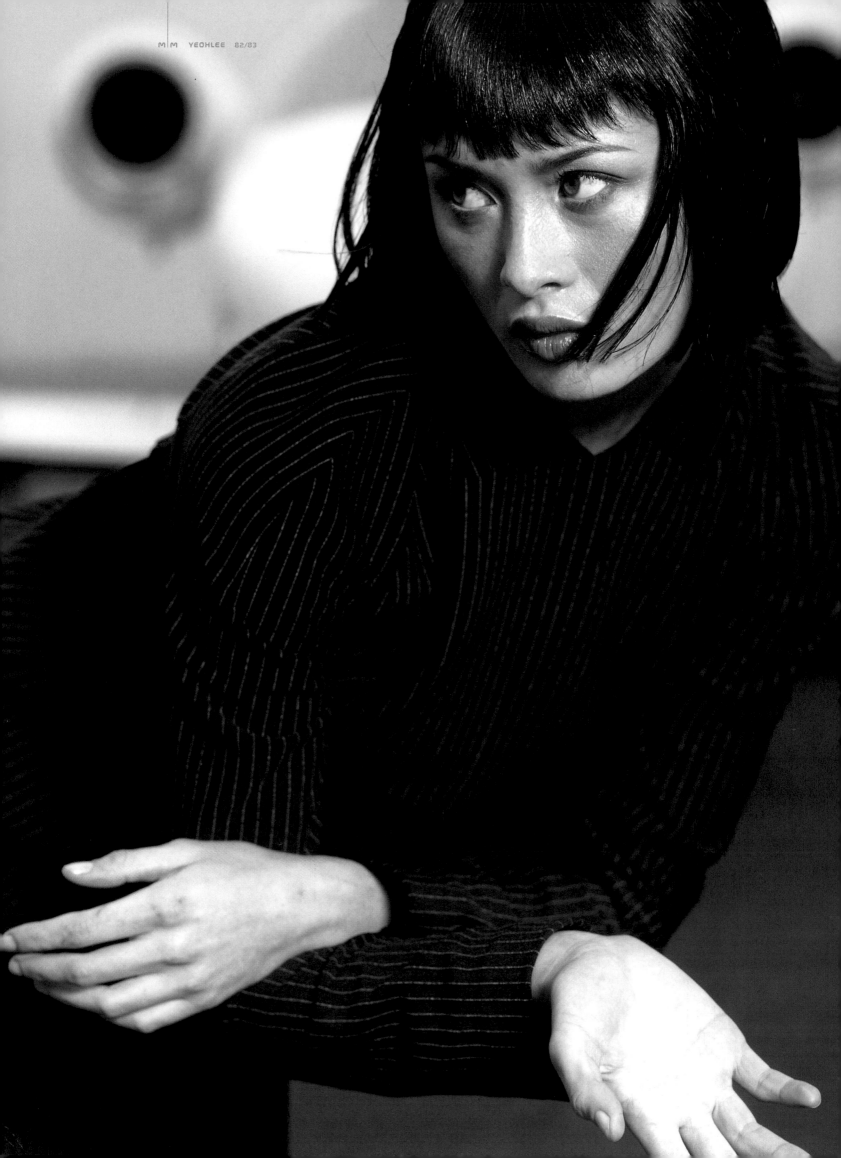

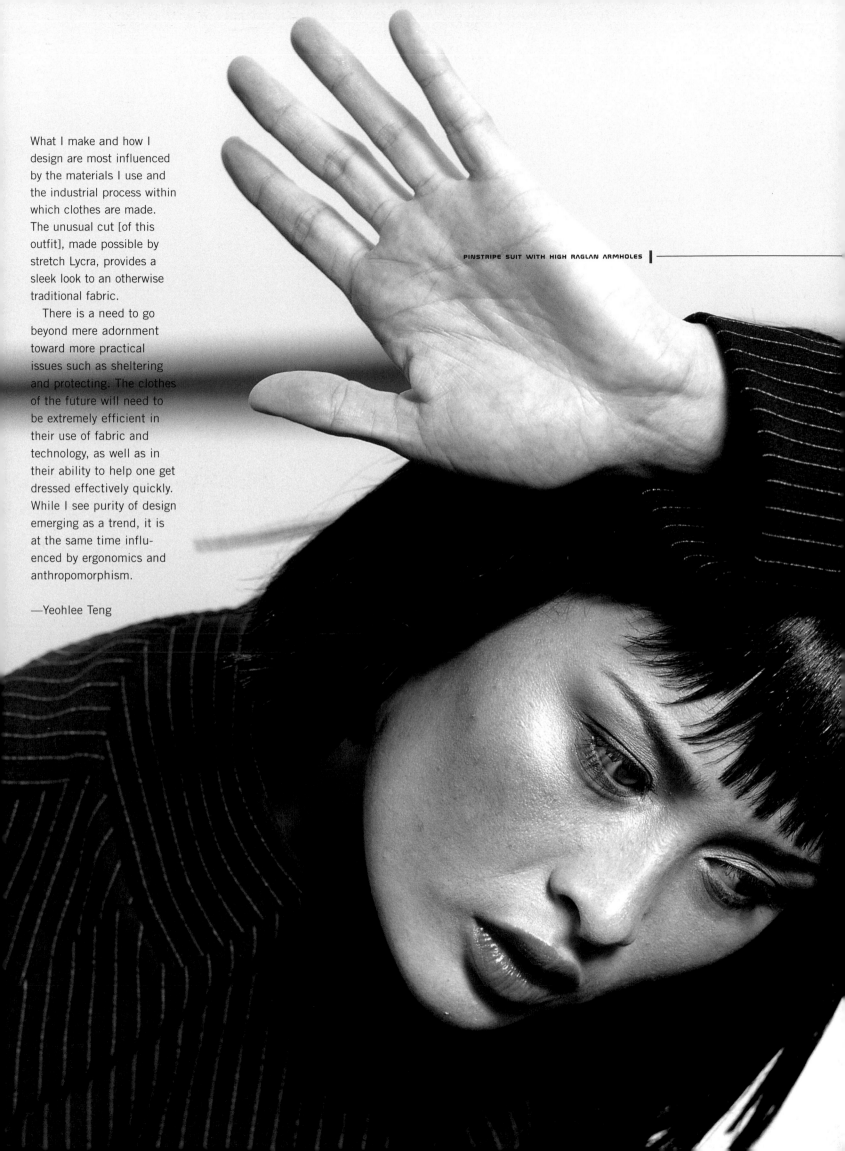

What I make and how I design are most influenced by the materials I use and the industrial process within which clothes are made. The unusual cut [of this outfit], made possible by stretch Lycra, provides a sleek look to an otherwise traditional fabric.

There is a need to go beyond mere adornment toward more practical issues such as sheltering and protecting. The clothes of the future will need to be extremely efficient in their use of fabric and technology, as well as in their ability to help one get dressed effectively quickly. While I see purity of design emerging as a trend, it is at the same time influenced by ergonomics and anthropomorphism.

—Yeohlee Teng

PINSTRIPE SUIT WITH HIGH RAGLAN ARMHOLES

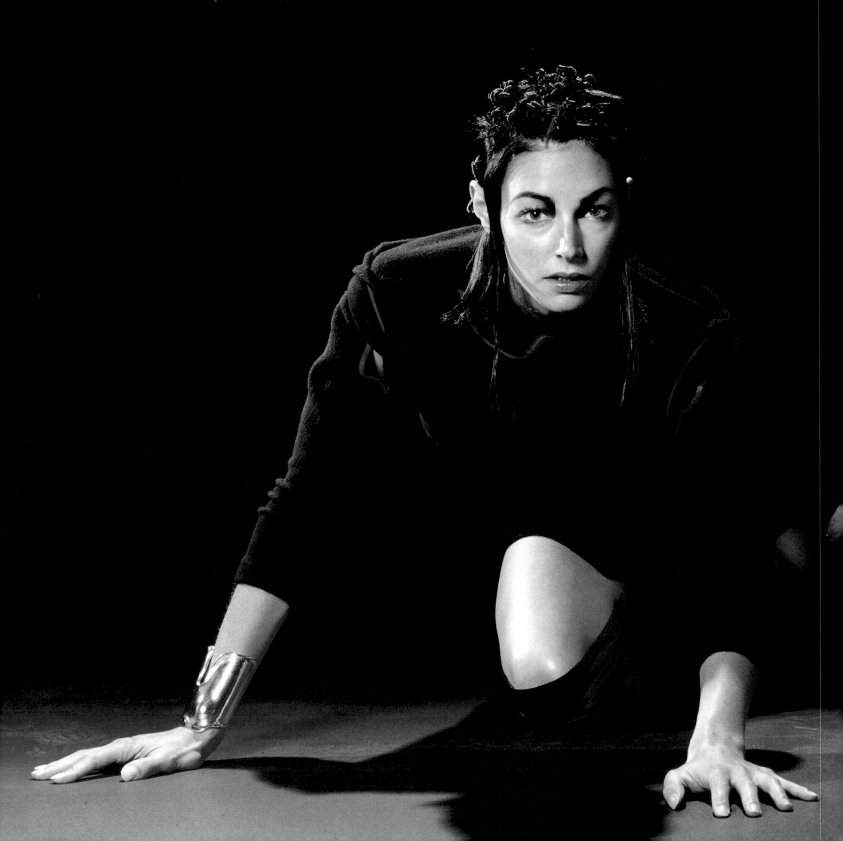

Fashion is a continuous progression of ideas. It may seem to jump forward erratically, but in fact it always turns back and retraces its steps. In about the year 2050 we should see some interesting new developments in fashion that will be conveyed through the use of stretchable fabrics. These new developments will draw even more attention to detail and form, widening the scope of what is thought to be fashionable.

Generally, people have become more conscious of their bodies through physical fitness and a greater knowledge of health issues. Attitudes...[regarding] dressing reflect this increasing awareness, suggesting what could be the ultimate fashion statement—to be naked (or virtually naked). While this concept is obviously not widely accepted right now, it's possible that society could embrace such an idea in the future.

As always, fashion will continue to play an important role in all our lives. It may not be fashion as we know it today, but rather people dressing according to their personal styles and tastes. The more free time and money available to people, the more room there is for the exploration of clothing as an expressive art form. Of course, as long as financial worth is one of our society's top priorities, fashion will continue to be treated as a status symbol. But there are those who use fashion for other means, such as expressing tastes in music, art, and lifestyles. That need for self-expression will always be a part of human nature. And so the history of fashion is sure to continue for that reason, throughout the next millennium and for the rest of time.

—Daryl Kerrigan

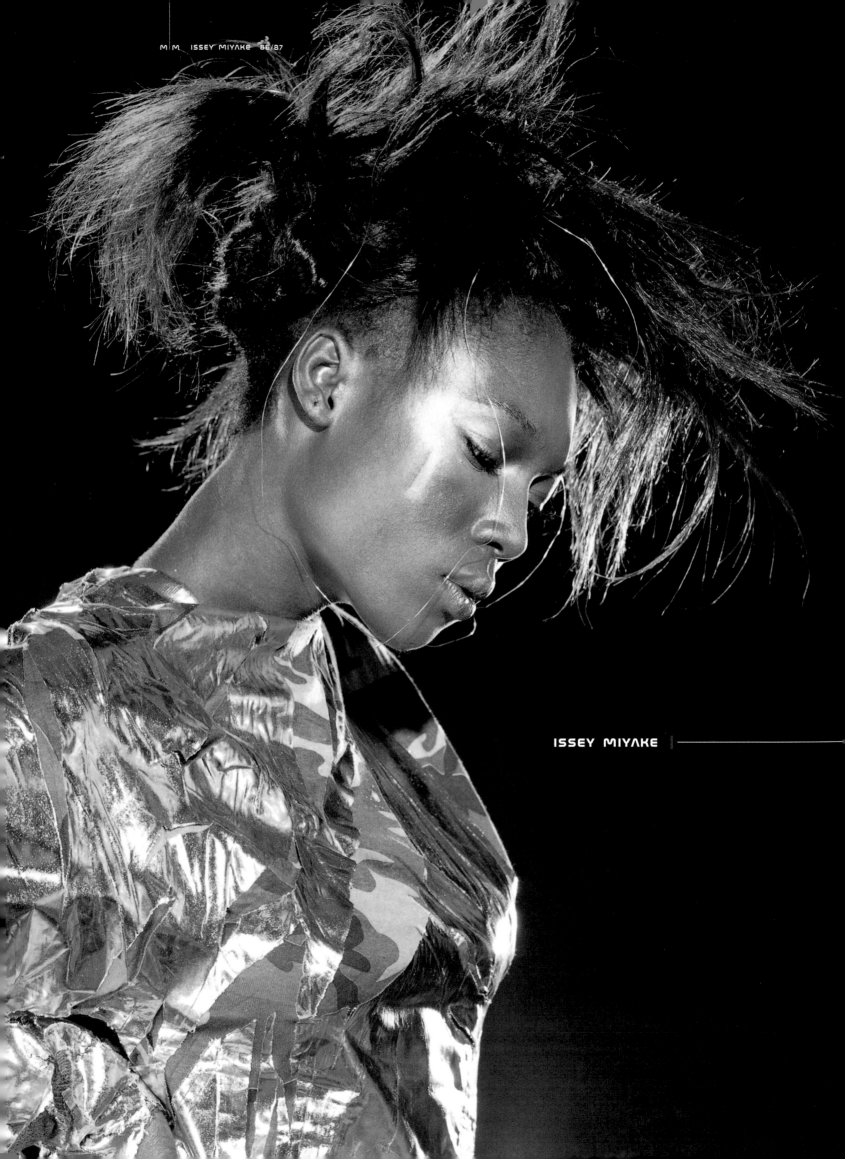

ISSEY MIYAKE

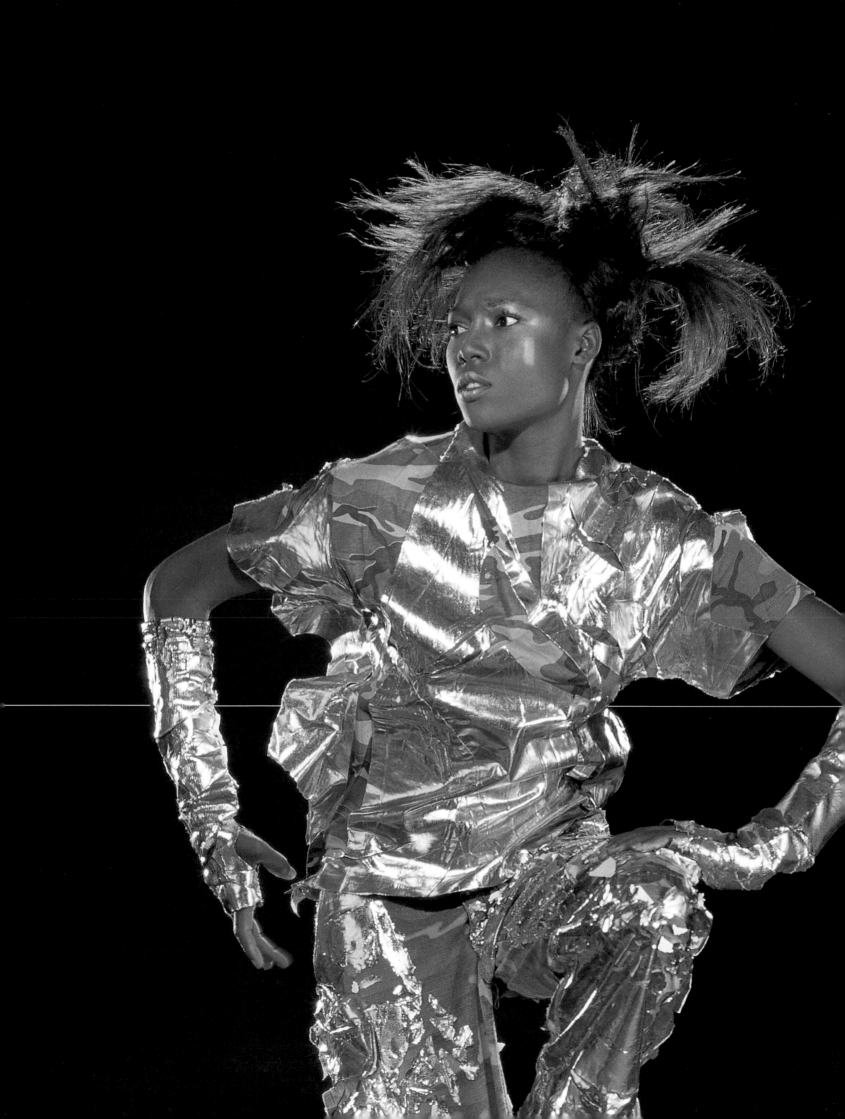

in the twentieth century, the aesthetics of design finally met and allied with technology and science. This marriage has produced textiles and clothing that are both beautiful and functional. As we move into the next century, one hopes that the fruits of this union will only continue to evolve and flourish.

At the same time, we are finally becoming universally aware of the shameful state of our planet's resources. The more we engage in new techniques to create clothing, the more we must take responsibility for the types of materials we use to make them. And we must try to use our knowledge to create clothing that better suits the needs of its wearers.

What happens to the immense infusion of clothing every season? As with all other aspects of increased globalization, we are flooded with information and material objects. As our world continues to decrease in size, we must try not to crowd it with the superfluous, but rather protect that which is unique. One means of conserving resources, as well as reducing the amount of space taken up by our clothing reserves, is to recycle.

Each season I have attempted to experiment with solutions to our recycling needs. For the autumn/winter 1998 season, I created a group called Starburst. I took several weights of fabric, from cotton lawn to flannel, fleece, and jersey, as representative of clothing we might already have. I then pressed sheets of foil onto the clothes. When the folded cloth was opened, the foil tore naturally to reveal new and unique garments. This is but one method by which basic clothing can undergo a dramatic metamorphosis through the use of creative manipulation. It is just a step along the path in the search for ways to reuse materials and preserve our planet, as well as to harness the skills we have acquired to keep design fun and interesting.

—Issey Miyake

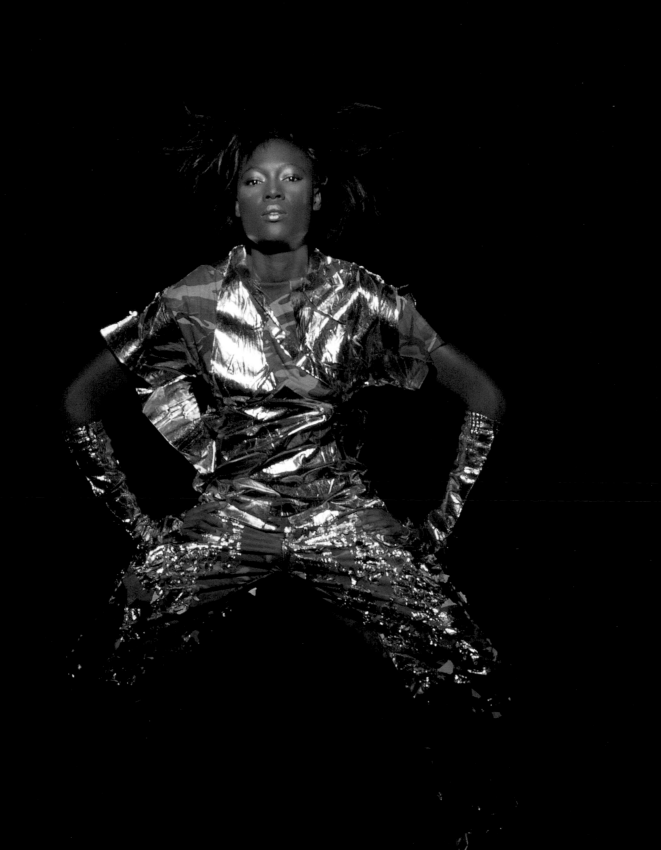

GIANFRANCO FERRE

LONG SILK TULLE DRESS WITH SILVER PAILLETTES ON THE SHOULDER AND FISHTAIL

The future has begun. The challenges of the new millennium have already been set down. Traced out on today's horizons are the coordinates that will orient the sensibilities and visions of men and women far beyond the year 2000.

Awareness of the future: it takes concrete shape in my work in the form of an intense and everlasting love of experimentation and research. For fashion, too, the future has begun; nowadays, creating clothes means evaluating the urges and needs leading into tomorrow. It means, for example, acknowledging the importance of freedom, comfort, functionality, maximum use. And it means grasping the significance of textile research, using evolving and innovative fibers, which grant my style new horizons and new spheres of reference on the market level.

—Gianfranco Ferre

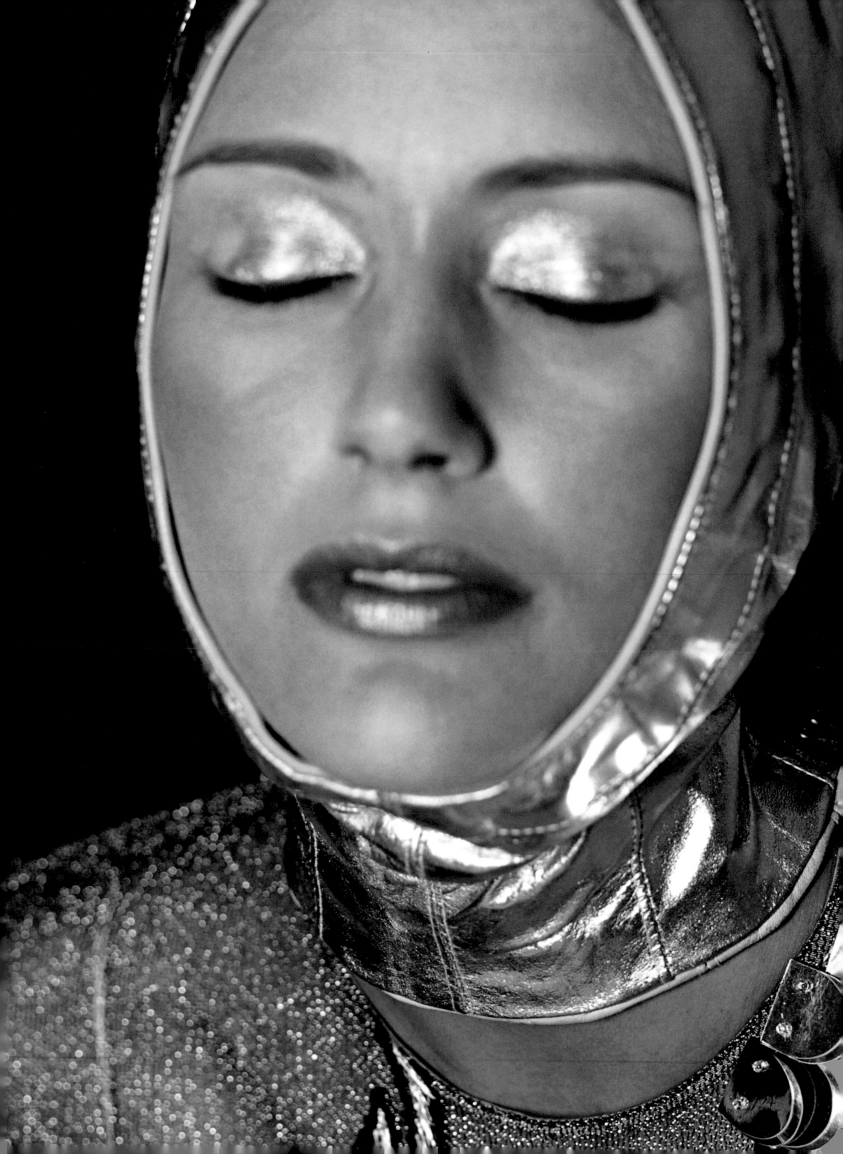

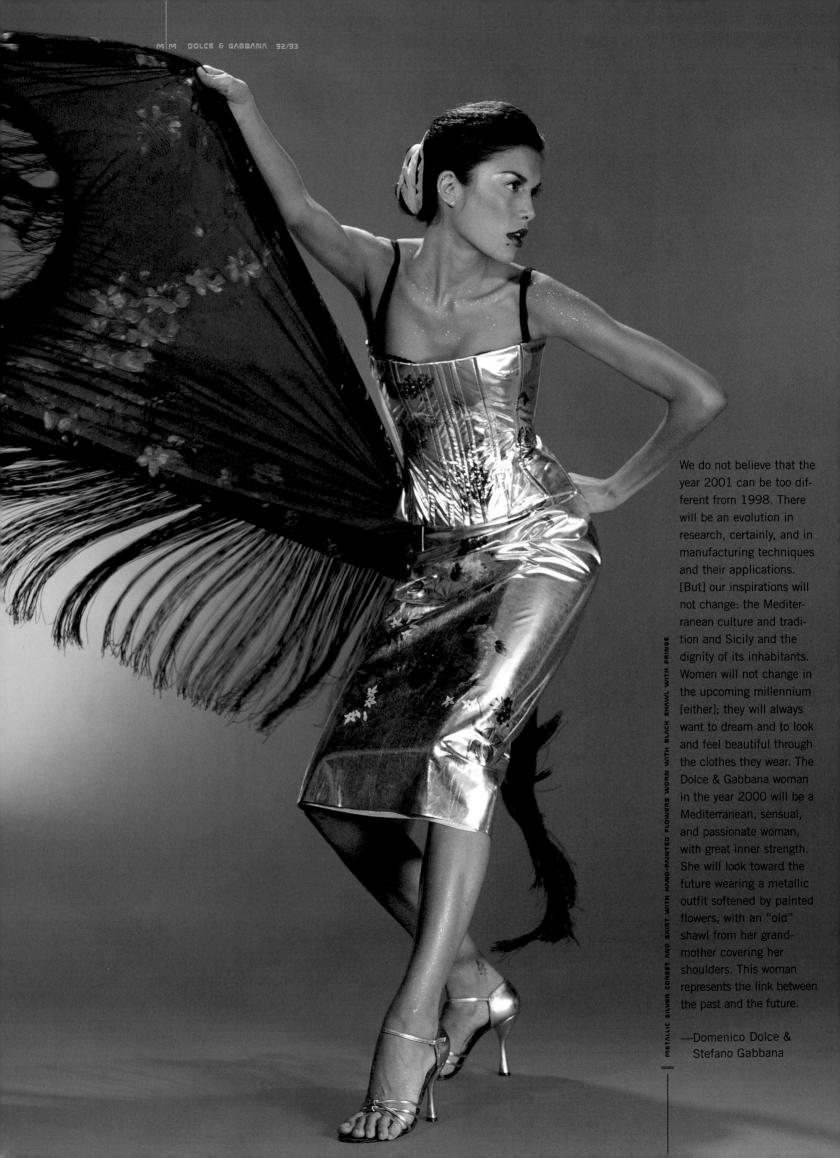

We do not believe that the year 2001 can be too different from 1998. There will be an evolution in research, certainly, and in manufacturing techniques and their applications. [But] our inspirations will not change: the Mediterranean culture and tradition and Sicily and the dignity of its inhabitants. Women will not change in the upcoming millennium [either]; they will always want to dream and to look and feel beautiful through the clothes they wear. The Dolce & Gabbana woman in the year 2000 will be a Mediterranean, sensual, and passionate woman, with great inner strength. She will look toward the future wearing a metallic outfit softened by painted flowers, with an "old" shawl from her grandmother covering her shoulders. This woman represents the link between the past and the future.

—Domenico Dolce & Stefano Gabbana

METALLIC SILVER CORSET AND SKIRT WITH HAND-PAINTED FLOWERS WORN WITH BLACK SHAWL WITH FRINGE

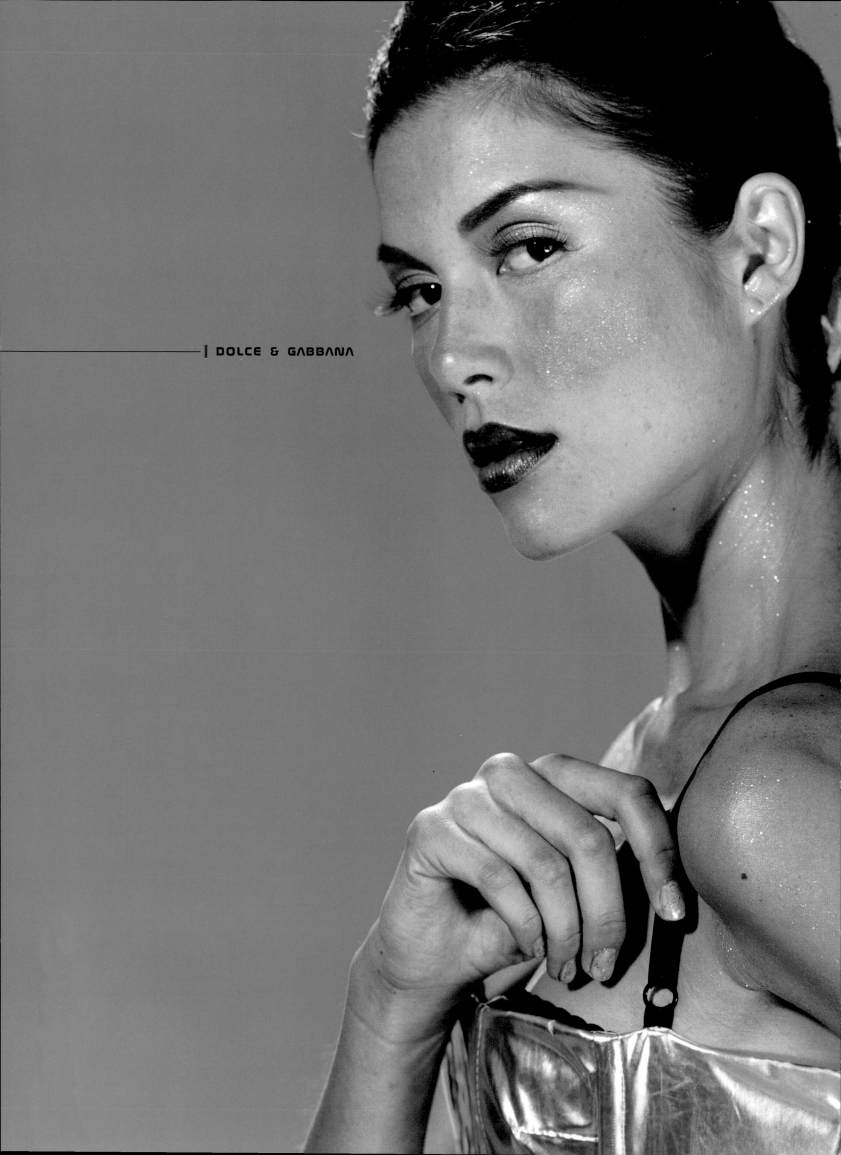

DOLCE & GABBANA

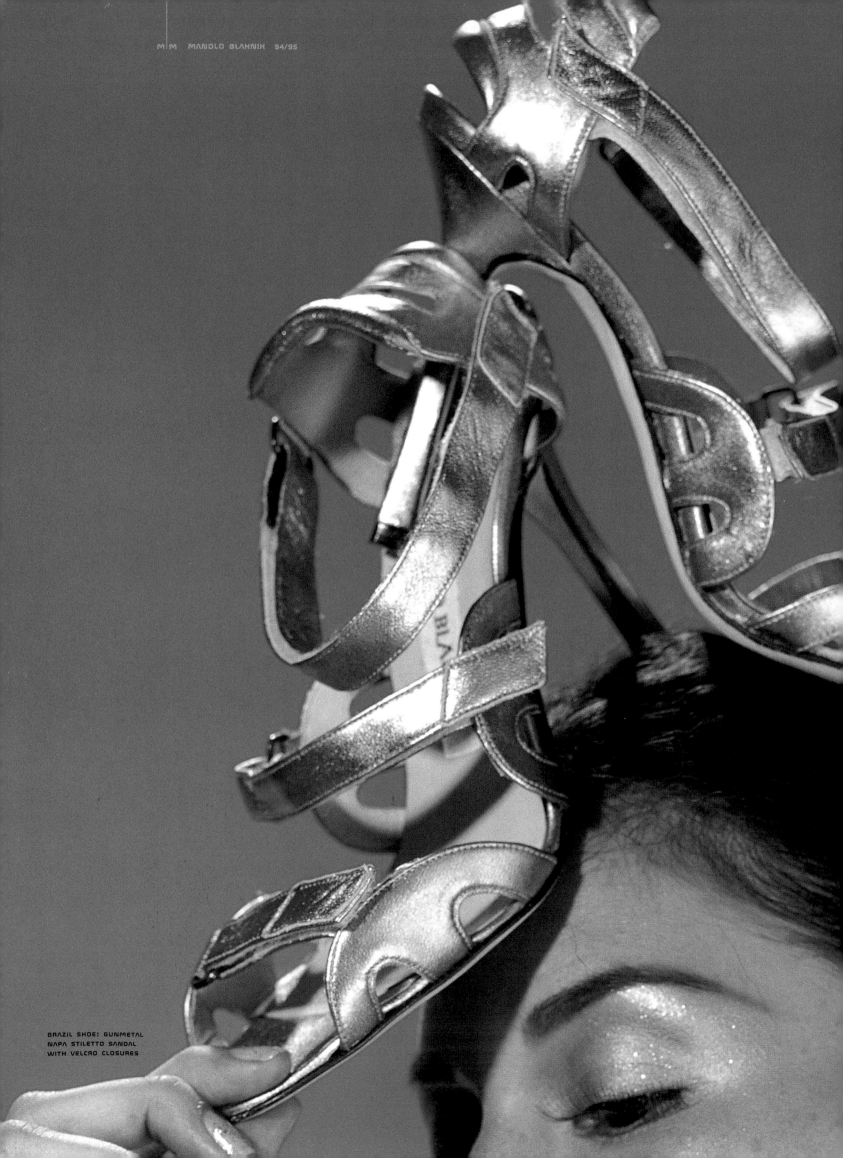

BRAZIL SHOE: GUNMETAL
NAPA STILETTO SANDAL
WITH VELCRO CLOSURES

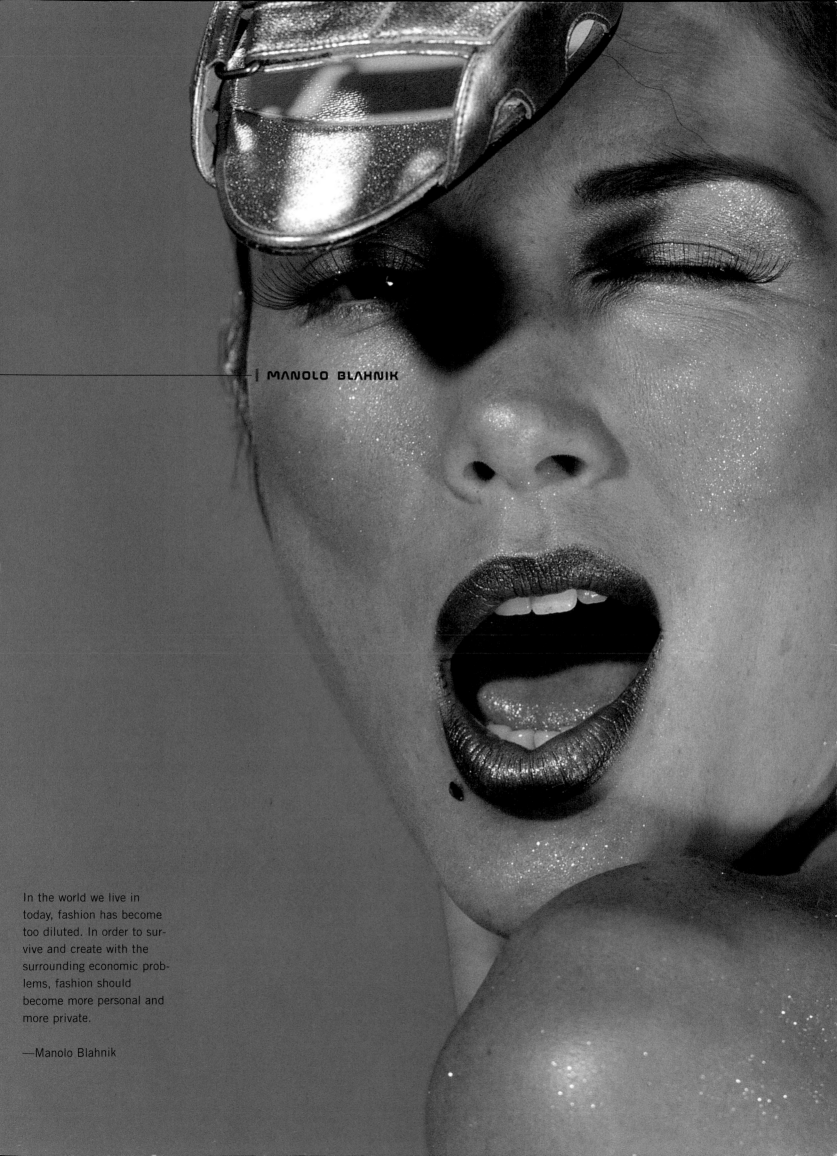

MANOLO BLAHNIK

In the world we live in today, fashion has become too diluted. In order to survive and create with the surrounding economic problems, fashion should become more personal and more private.

—Manolo Blahnik

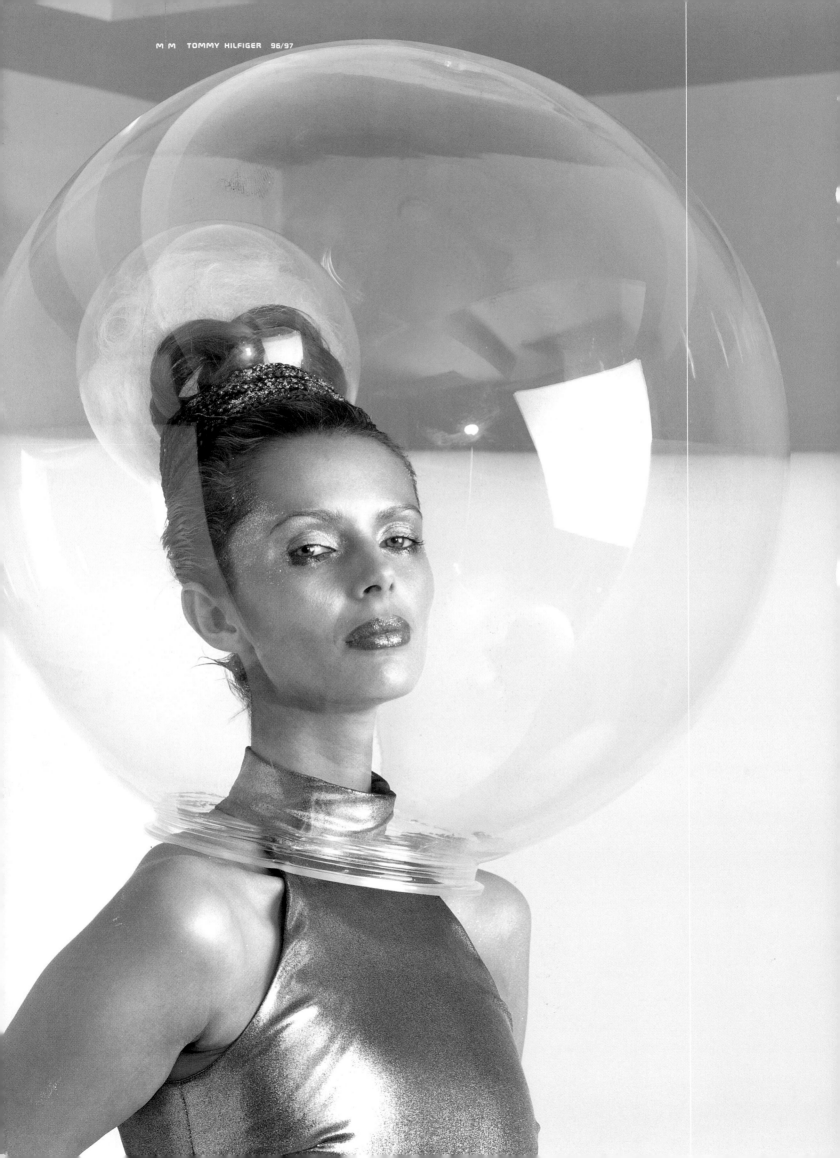

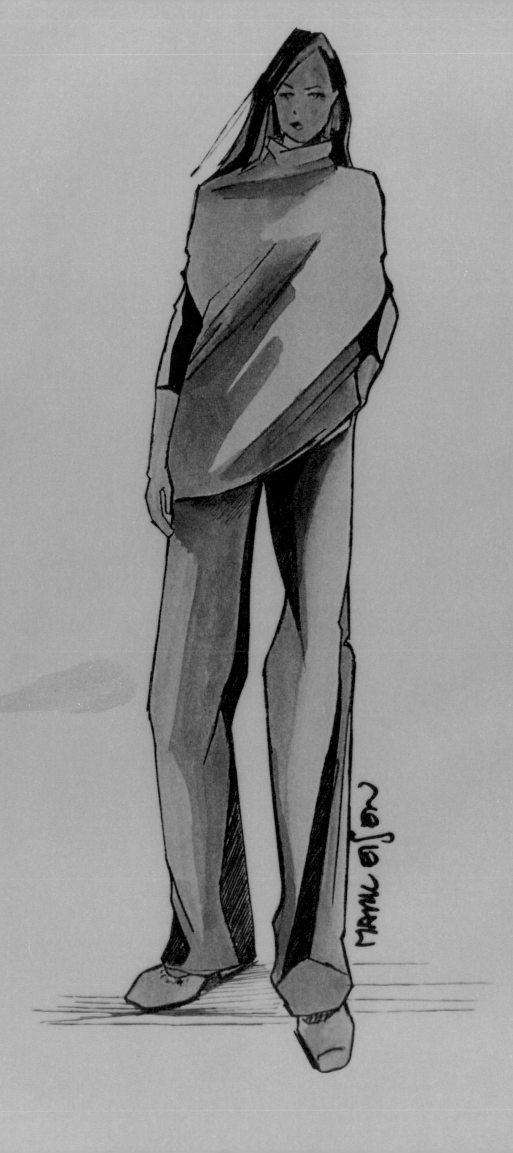

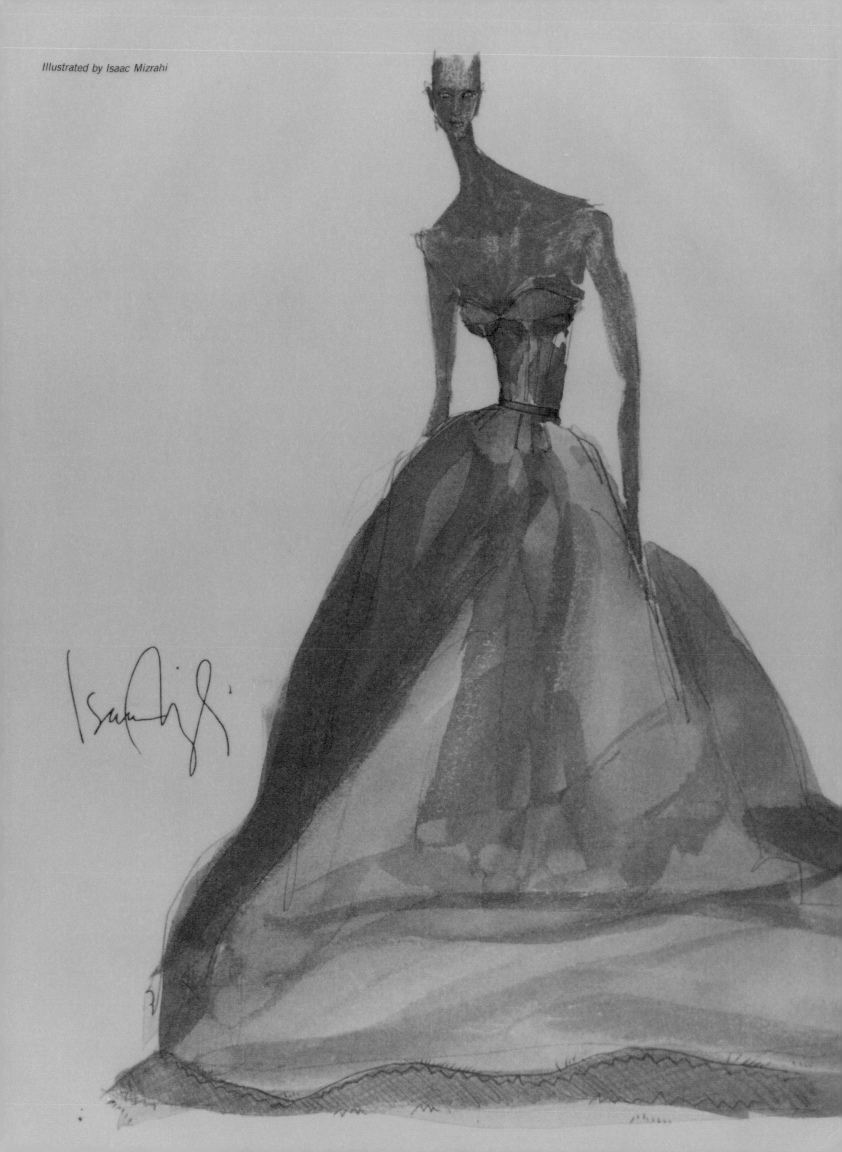

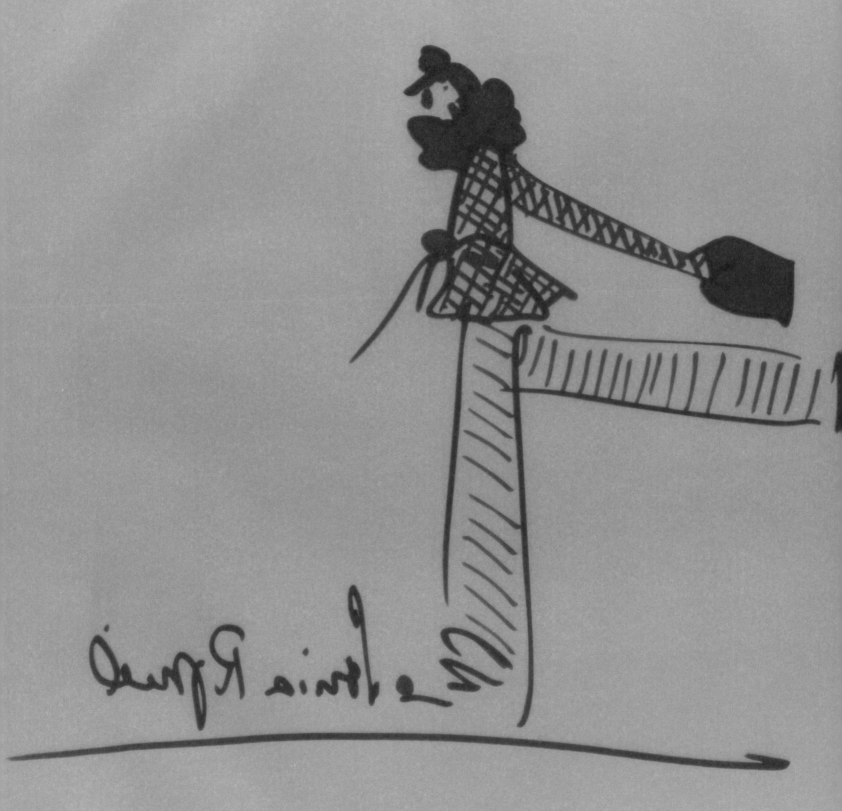

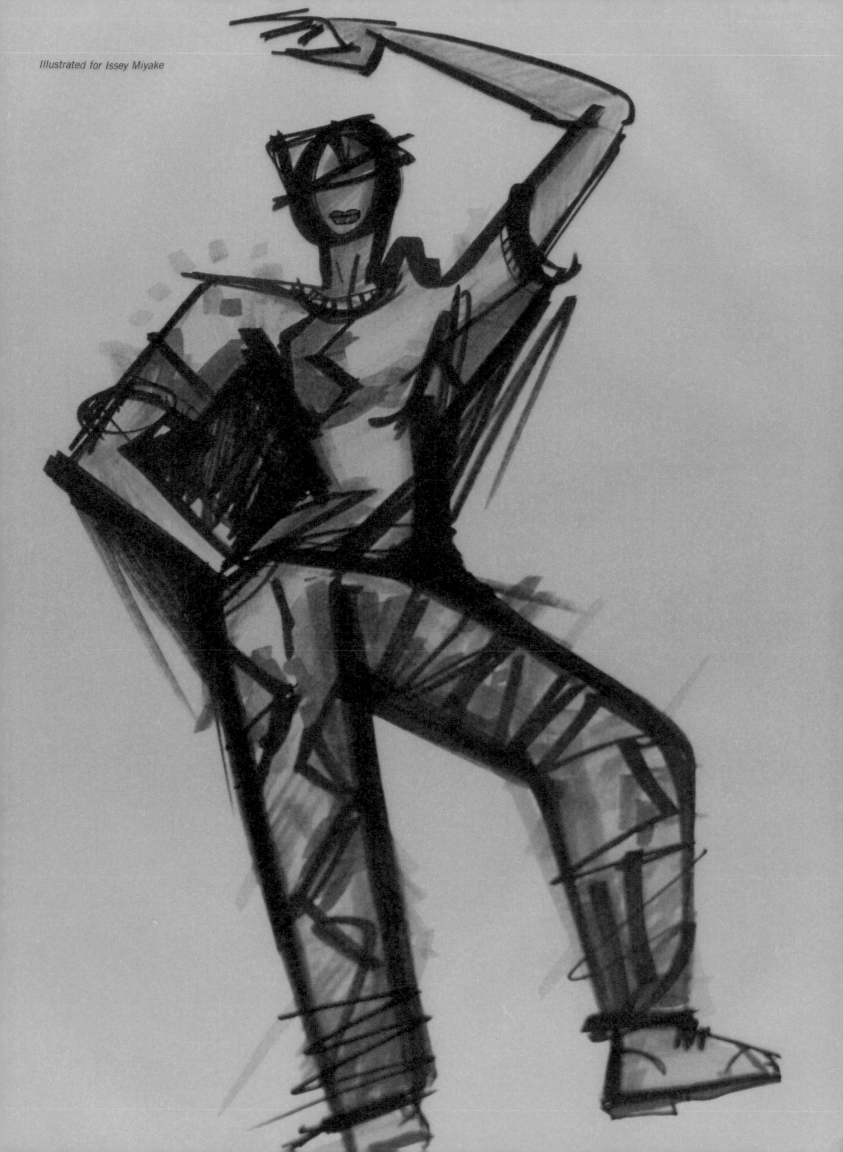

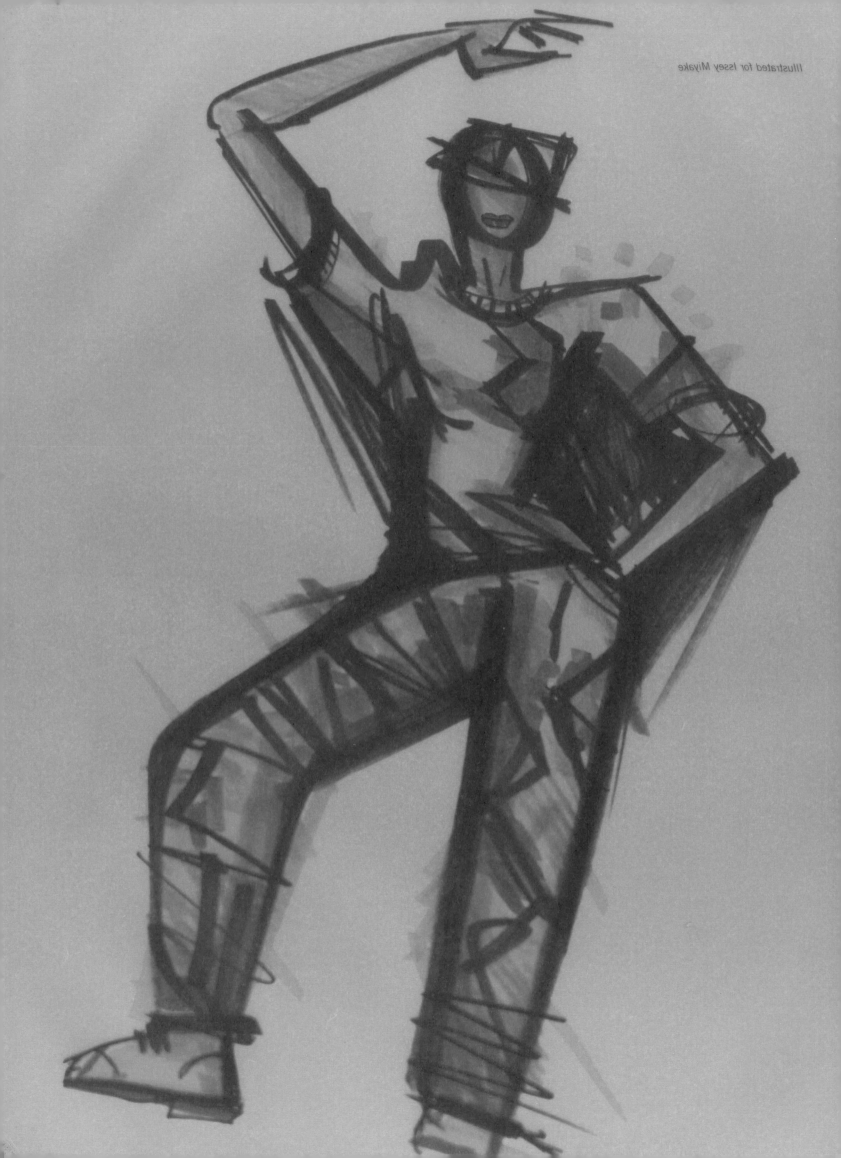

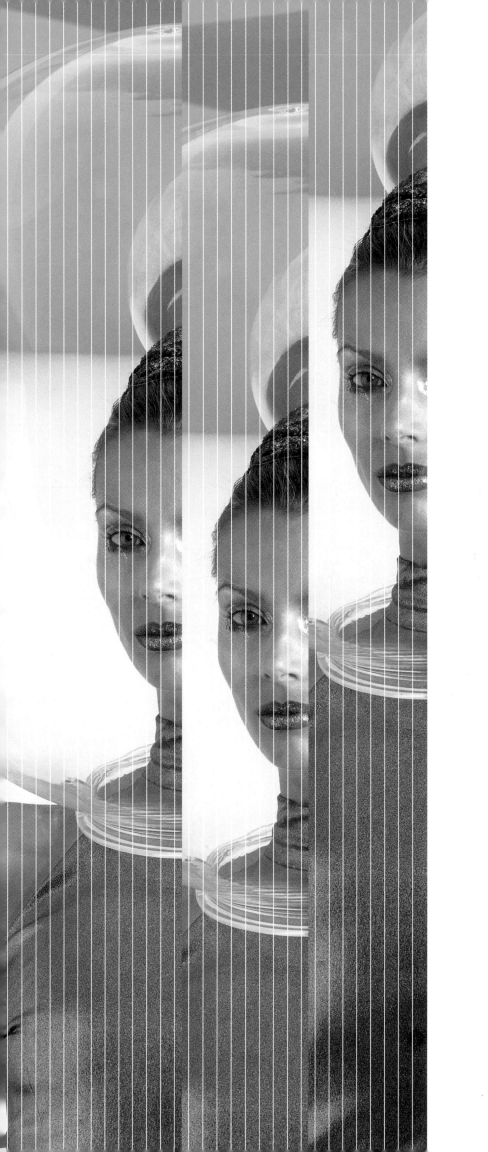

TOMMY HILFIGER |

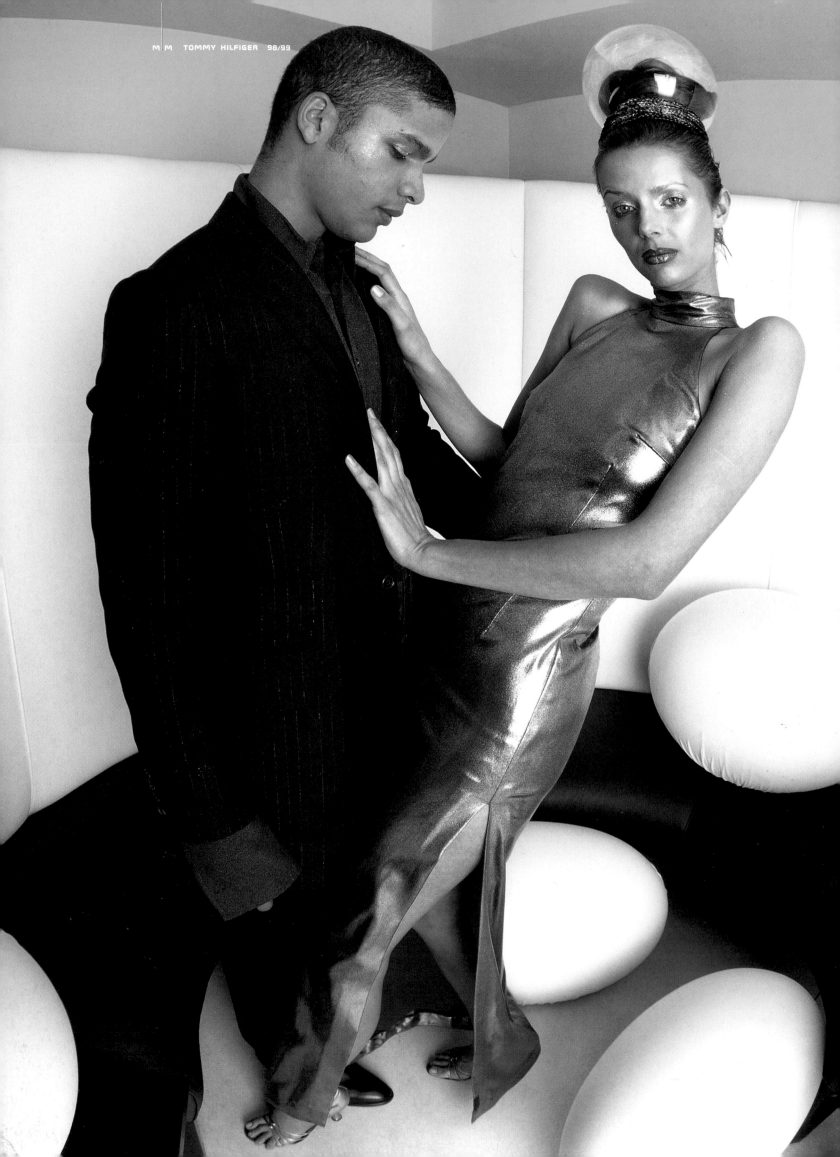

The silver gown represents the future with a nod to past glamour. It is one of my favorite pieces because it combines the latest technology in fabric development with couture workmanship. The bodice of the dress reminds me of a bathing suit—athletic, young, and strong.

I love creating styles that [make] women feel beautiful...while being completely comfortable at the same time. The challenge I face as a designer in the next millennium is finding a balance between high and low technologies as they affect the process of designing clothes.

—Tommy Hilfiger

| BULGARI

Technology is an undeniable force in the present and future of fashion. This force manifests itself in the use of innovative materials, techno-inspired colors, and access to new methods of production. Bulgari has always been on the forefront in this respect, incorporating steel in its jewelry, and recently, aluminum and rubber in its watches.

In the next millennium, the ever-increasing role of technology will be counterbalanced by the quest for pleasure and individuality. It is undeniably human to love the sensual, to seek pleasure from our surroundings. Fashion will be as much about the aesthetic as about one's self. Women will wear what suits their lifestyles, rather than what trends dictate. Fashion will be less for the pleasure of others, more for one's own personal satisfaction. The hidden detail, a badge of individuality gone unnoticed by others and obvious only to one's self, will be increasingly in vogue. Fashion will become more and more organic, influenced less by the high arts than by the people of the world, and the energy coursing through our cities.

—Bulgari family

| CELLULAR PHONE CUFF BRACELET

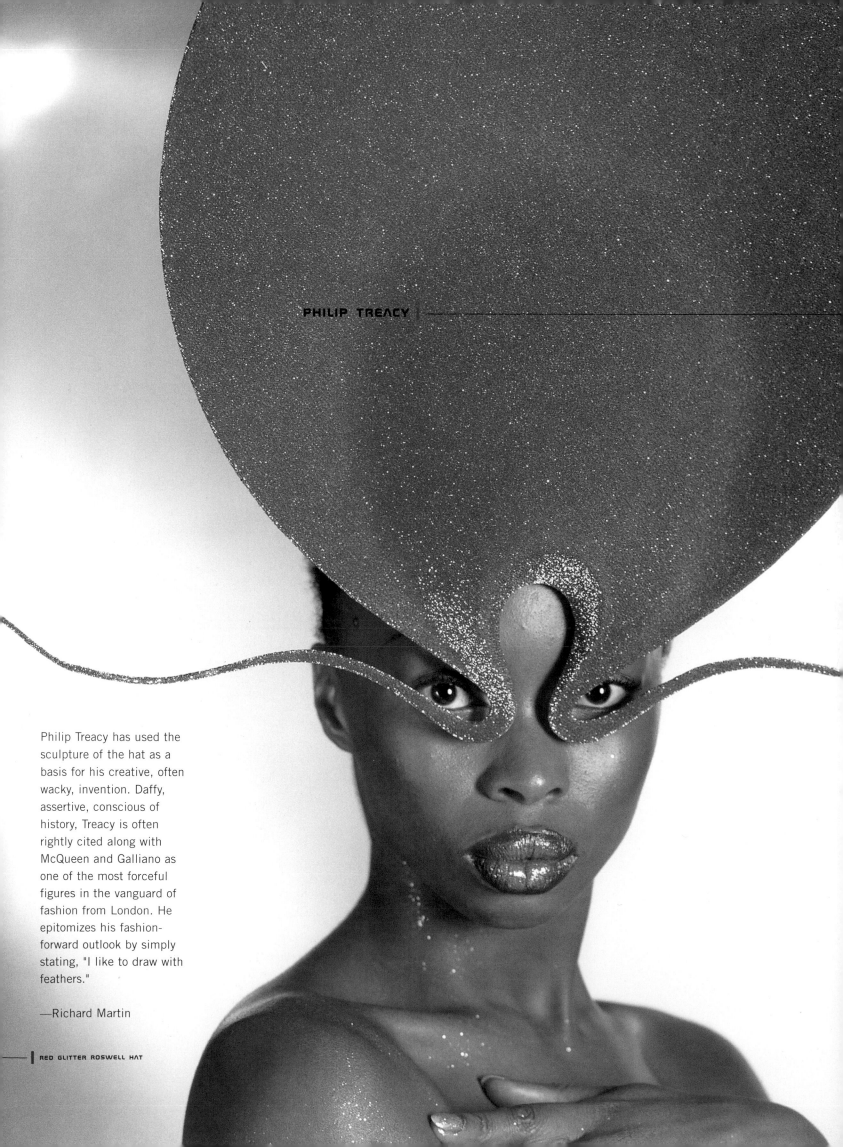

PHILIP TREACY

Philip Treacy has used the sculpture of the hat as a basis for his creative, often wacky, invention. Daffy, assertive, conscious of history, Treacy is often rightly cited along with McQueen and Galliano as one of the most forceful figures in the vanguard of fashion from London. He epitomizes his fashion-forward outlook by simply stating, "I like to draw with feathers."

—Richard Martin

RED GLITTER ROSWELL HAT

ON BETSEY: BLACK THREE-TIERED COTTON FULL CIRCLE PETTICOAT WITH COTTON OFF-THE-SHOULDER LACE-UP TOP AND HOOK-AND-EYE WAIST CINCHER

ON LULU: BLACK SILK GEORGETTE ULTRA BIAS SLIP DRESS WITH RHINESTONE DETAIL AND "CHOLITA" SLIDES

HOT PINK RUBBER NYLON BOOTS

I believe spiritualism and fantasy will always be part of determining fashion. In the 1960s, I envisioned women in the year 2000 wearing computerized spacesuits with push buttons that would melt the space suit right on you. My vision at the moment for fashion in the millennium is to go back to the '60s, '70s, and '80s in order to move fashion forward with a personal twist, keeping it organic and old-fashioned, by integrating *Little House on the Prairie*–ruffled skirts with spandex.

—Betsey Johnson

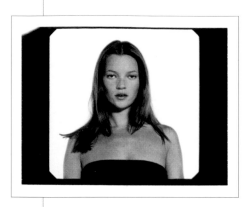

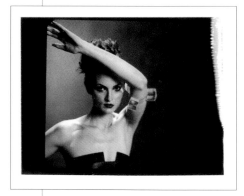

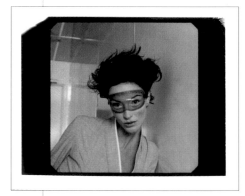

In the 25 years since she succeeded Anne Klein upon her death, **DONNA KARAN** has been a mover and shaker of the American fashion world. Bold in business and personality, Karan has called her secondary lines DKNY with good reason— for Karan's style is unapologetically about New York. The sportswear concepts of wrapping, layering, and using stretch that Karan learned at Anne Klein remain mainstays of Karan's bodysuits, wraps, and elegant draping collections. Comfort is assured because Karan is her own best model. One of Karan's most important traits is her magical skill with the body: her famous "Cold-Shoulder Dress" (1992) daringly bared one shoulder while all the rest of body was securely covered.

White liquid cashmere long-sleeve crewneck dress with organza insert
MODEL: Esther Cañades/Wilhelmina
HAIR: William Williams/ARTISTS by Timothy Priano
MAKEUP: Todra Payne/ARTISTS by Timothy Priano

CALVIN KLEIN has defined American fashion for the final third of the twentieth century. His majestic overview has been to render fashion cool and its advertising hot. He has understood that fashion advertising is essentially the culture of fashion. At the same time, he has refined the fashion product into his own purified construct: often puritanical, sometimes Zen, sometimes unmistakably mainstream, Klein's fashion is quiet, good taste made with the consumer and consumption in mind. Some critics would want Klein to exude pure creativity and denounce his efforts as styling. What it really is is the triumph of American sportswear and of Seventh Avenue, the pure essence of what people want taken from all the myriad and confusing things fashion has to offer.

Black, superfine cotton, stretch, strapless, side-zippered, panel dress*
MODEL: Kate Moss/Women Model Mgt. NYC
HAIR: Patrick Melville
MAKEUP: Mark Carrasquillo
LOCATION: Industria Studios

GEOFFREY BEENE is, without question, the greatest living American fashion designer. For 35 years, Beene has combined the pragmatic principles of American sportswear with the quality of couture. His eminently modern devices in aprons, boleroes, and serviceable hardware testify to his practical ethos, but Beene can also swirl around the body like no other designer, with the possible exception of Vionnet. An enthusiast for new materials and a virtuoso designer, Beene ultimately cherishes the woman in the dress, never forgetting the wearer.

Dress with geometric top and pink tulip skirt*
MODEL: Teresa Stewart/Next Model Mgt. NYC
HAIR: Alberto Luengo/ARTISTS by Timothy Priano
MAKEUP: Alberto Luengo/ARTISTS by Timothy Priano

KENZO [Takada] was a boy-wonder designer in Paris in the 1970s, known for his fresh color and sophisticated prints in versatile separates for sportswear. He is very much back in the 1990s, a boy-wonder all over again with even juicier colors, new garden-fresh flowers, and worthy separates. In reality, Kenzo never stopped designing; we just stopped looking. When we look again, the joyousness of Kenzo's disposition and easy clothes is our happy déjà vu. Kenzo, a world traveler, had begun in his father's teahouse in Japan, listening to kimono merchants talk of their fabrics. Building upon these experiences, he treats his fashion world as a place where vivid patterns, jubilant colors, and many clothing traditions converge.

Bi-color, jersey stretch, kimono jumpsuit with V-neck*
Goggles by Antonio Branco
MODEL: Kat Mack/Karin Models NYC
HAIR: Alberto Luengo/ARTISTS by Timothy Priano
MAKEUP: Alberto Luengo/ARTISTS by Timothy Priano

* THE FOLLOWING GARMENTS HAVE BEEN DESIGNED WITH LYCRA

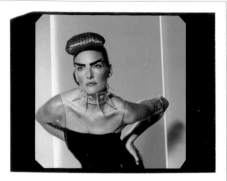

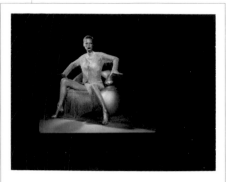

Today Italy is perhaps best known for its male designers, though earlier generations had been led by Irene Galitzine, the Fontana Sisters, and other women. Mariuccia Mandelli for **KRIZIA** is the exception—a leading female designer making genuine luxury sportswear of the Italian tradition. Knitwear, sports separates for evening, and cashmere wraps are among the many conventions of Krizia. Mariuccia is known for her virtual zoo of animals and birds that populate various collections with droll humor and relief from any fashion pretension.

Black dress with clear plastic tubes*
Choker and cuff by Antonio Branco
MODEL: Sophie Patitz/Elite
HAIR: Antonio Branco/Trilese
MAKEUP: Siu Ming/Trilese

Founded in Germany in 1976 by Wolfgang and Margarethe Ley, **ESCADA** is a design powerhouse with international outreach. Following a brief setback at Margarethe Ley's death in 1992, Escada, now under the stewardship of Brian Rennie, has consistently produced high-quality merchandise for women of international scope and means at commensurate prices. Escada clothing has an uncanny sense of color and offers a range of styles for women who do not wish to appear national or regional, opting instead to mix in with flair anywhere in the world. For this reason, Escada avoids trends, preferring classic indicators of wealth and good taste.

Silver stretch bikini with long silver hand-crocheted cardigan*
MODEL: Liskula/Karin Models
HAIR: David Frank Ray/Elray Creative
MAKEUP: David Frank Ray/Elray Creative; Eleonora Flyash (body makeup)

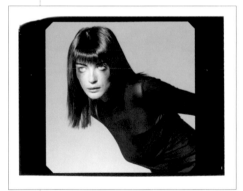

Fashion designers are often worldly, even commercial. **ROMEO GIGLI**, on the contrary, is a true romantic, ardent in cherishing a feminine ideal, passionate in choosing exotic and opulent materials. One of the most striking fashion Orientalists of the 1980s and 1990s, Gigli creates with a painter's imagination and palette. At times, Gigli seems more fine artist than fashion designer, but his fashion is fostered by his ideal of woman and of textiles: their mutual expression becomes the Gigli fashion epic of timeless, landless apparel caught somewhere in a territory between a tangible East and a Shangri-La, a time of modern women performing in efficiency and of female saints in impeccable robes.

Black stretch dress with geometric illusion details and plastic coat (as seen in sketch)*
Lucite jewelry by Antonio Branco
MODEL: Martina Gordon/NY Models
HAIR: Patricia Morales
MAKEUP: Davide/ARTISTS by Timothy Priano
STYLIST: Antonio Branco/Trilese

A family company that controls all aspects of production, from textile to final product, **ETRO** embodies the post-War Italian acheivement in apparel. As Nicoletta Bosi and Enrica Morini wrote in *Italian Fashion* (1987), "Italian fashion was born out of the union between stylists and a special kind of manufacturer"; this is represented by Etro. Gimmo Etro designs for the label in a generally classical style; other Etro fabrics live equally vivid lives in designs by other designers.

Wire-cage skirt with computer chips and clear plastic down-filled jacket*
MODEL: Jacqui/Karin Models
HAIR: Matthew Williams/Trilese
MAKEUP: Davide/ARTISTS by Timothy Priano

* THE FOLLOWING GARMENTS HAVE BEEN DESIGNED WITH LYCRA

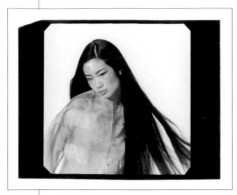

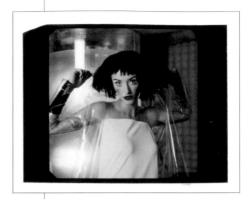

Many fashion designers are travelers; **MARY MCFADDEN** is fashion's scholar-adventurer, returning not just with absorbed sights and exoticism, but with deep knowledge and insight. A former editor, she translates vast knowledge into her clothes. She cites Balenciaga as her favorite designer, but McFadden knows so much about Asian design, especially pattern and color, that Balenciaga never knew. In fact, McFadden suffers for her scholarship: her ethnographic expertise is so great that some cannot see McFadden's transforming aesthetic, simplifying the silhouette and setting decoration within limits, and assume that a McFadden creation is little more than travelogue. Fortunately, McFadden has a faithful and intelligent clientele for her ingenious, very knowledgeable art.

Pink-and-red gown with gold underpiece
MODEL: Christina The/Karin Models
HAIR: Stephano Antoniazzi/Trilese NY Hair
MAKEUP: Siu Ming/Trilese

Like Vivienne Westwood and Anna Sui, **STEPHEN SPROUSE** arrives at the specifics of fashion through the phenomenon of rock music and performance. Designing for performers and club kids, Sprouse is a vital, if quixotic, figure in fashion. He conveys energy and the worldly knowledge of youth that one associates with rock music and partying at night. A consultant to the inaugural display of the Rock and Roll Hall of Fame and Museum in Cleveland, Sprouse pursued the original clothing of the stars, as he does with his own collections and special-order work, in a perfect synthesis of music and fashion.

Day-Glo yellow gown with clear plastic overcoat, oversized "bug" goggles, black stretch cuff bracelet, and black wedge shoes with clear plastic straps*
MODEL: Kat Mack/Karin Models NYC
HAIR: Alberto Luengo/ARTISTS by Timothy Priano
MAKEUP: Alberto Luengo/ARTISTS by Timothy Priano
LOCATION: Idlewild, NYC (Thank you Rob Lumerman, Jim Chu, and Eric Rasmusen)

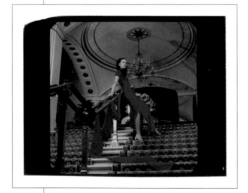

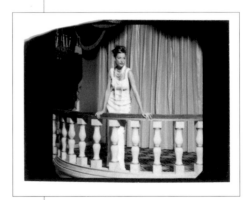

For **TODD OLDHAM**, fashion has always been the Duchess of Windsor meets the *Dukes of Hazard*, a whimsical juncture of craft, appliqué, and decoration with a strong sense of high style. What unifies the work, if anything does, is Oldham's cleverness and charm, a personal trait, but one manifest in the work as well. Scavenging from high and low culture (American and global), Oldham picks the best of both with a kind of flea-market know-how that keeps the work lighthearted. In 1998, Oldham dropped his designer collection to focus on other products, but his distinct and idiosyncratic expression will continue to be felt throughout fashion like a breath of fresh air.

Long hot pink jersey T-shirt with train*
MODEL: Tracy Galligan/Elite NYC
HAIR: Yusuke/ARTISTS by Timothy Priano
MAKEUP: Todra Payne/ARTISTS by Timothy Priano
STYLIST: Nolé Marin for Trilese
LOCATION: The Pierre Hotel (Thank you Jessica Rogers)
SKETCH ILLUSTRATOR: Cliff Pershes

CAROLINA HERRERA lived a life of style in Venezuela long before she became a fashion designer in New York in 1981 and has perhaps remained her own best model, succeeded in the later 1990s only by her daughter. Known for her discreet, well-cut tailoring for day and evening, Herrera's style is an offshoot of her own personal taste, and is associated with a light, coquettish femininity. Similarly, Herrera easily moves in the same circles with her clients.

Beige-and-white lace dress*
MODEL: Pascale/Karin Models NYC
HAIR: Yusuke/ARTISTS by Timothy Priano
MAKEUP: Todra Payne/ARTISTS by Timothy Priano
STYLIST: Nolé Marin for Trilese
LOCATION: The Pierre Hotel (Thank you Jessica Rogers)

Carolina Herrera's quote on page 44 was taken from *Moderna* magazine, Winter 1997

* THE FOLLOWING GARMENTS HAVE BEEN DESIGNED WITH LYCRA

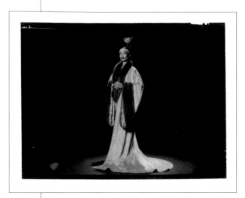

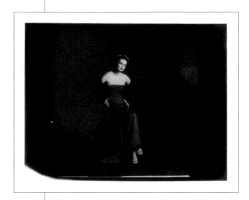

JOHN GALLIANO is a fashion prodigy of indisputable talent. Not since Saint Laurent has fashion claimed such a mythic figure. His graduation collection from St. Martin's was sold to Brown's and was known worldwide. After rocky business enterprises, Galliano became designer for Givenchy followed by Dior, Paris. Throughout his work, Galliano is fashion's most famous postmodernist, raiding history for its imputation to the present. Poiret, classic Dior, and the post-Revolutionary Incroyables are favored historical periods: epochs of excess and extravagance to which Galliano adds even more opulence and theater-style grandeur. Ultimately, immoderation is Galliano's theme: he is always over the top.

White velvet kimono with purple embroidered flowers and white fox fur trim
MODEL: Jihae/DNA Models
Long gold brocade kimono with sable collar and leopard fur trim
MODEL: Melba Mathurin/Women Model Mgt. NYC
HAIR AND MAKEUP (BOTH SHOOTS): Joe J. Simon

Colin McDowell's quote on page 48 was taken from *Galliano* (Rizzoli, 1997)

Though born in the Dominican Republic and working today in Paris as designer for the couture collections of Pierre Balmain, **OSCAR DE LA RENTA** is a quintessentially American designer. A design conglomerate with many licensees, in addition to his own New York firm, produces a vast range of products unified by the de la Renta name, signifying a very feminine, dress-maker approach to sportswear with bursts of exuberance and exoticism for evening. In 1973, de la Renta was one of the five Americans to show at Versailles; he returned to France in another triumph when, twenty years later, he became the first American to design couture at Balmain.

Red claret satin strapless gown with a fitted torso, V-back, and bustle train back, worn with a black cashmere shrug sweater
MODEL: Paulina Porizkova/Elite NYC
HAIR AND MAKEUP: Alberto Luengo/ARTISTS by Timothy Priano

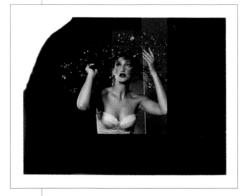

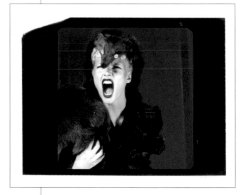

Sarah Mower of *British Vogue* (Sept. 1989) described **ISAAC MIZRAHI** as "that rare thing that is contemporary design: a life-enhancing intelligence on the loose." Today with the closing of Mizrahi's 11-year-old fashion house, that assessment is melancholy as Mizrahi's wondrous wit and energy will likely be directed into fields other than fashion. Even as Mizrahi became a familiar figure in various media, his fashion moved with a ravenous appetite from idea to idea, never staying long enough to implant a signature style beyond Mizrahi himself. Mizrahi is a gifted artist and "intelligence" who has a lot to offer the new millennium; it would be great if he remained involved with fashion in some way.

Silk gown with tulle
Hat by David Cohen
Shoes by Manolo Blahnik
MODEL: Maron von Gerkau/Elite
HAIR: Yusuke/ARTISTS by Timothy Priano
MAKEUP: Siu Ming/Trilese
STYLIST: Antonio Branco/Trilese

If Chanel were to have been reborn, she might have been **SONIA RYKIEL** who, more than any other designer, has continued the Chanel nonchalant lifestyle fashions of flat, no-nonsense dressing elements for modern women, often redolent of the 1920s. Rykiel's famous knits, usually with reverse seams, sometimes incorporating language, update Chanel's knits and suits; Rykiel's insouciant sense for making clothing for intellectual women rivals Chanel's pioneering efforts. Rykiel can be so spare and down-to-earth in some ways because she, like Chanel, always imparts luxurious materials and finishes to the clothes.

Dark red plaid suit with red fox and fur shoes
MODEL: An Mayward/Karin Models for Benefit
HAIR AND MAKEUP: Joe J. Simon/ARTISTS by Timothy Priano

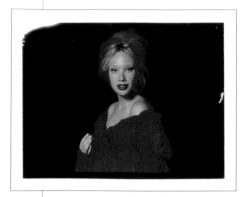

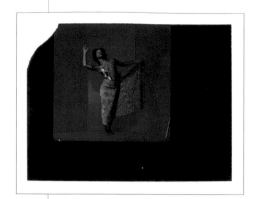

A heavenly zephyr flutters through everything **HAN FENG** creates. Her soft fabrics billow, twist, pleat, or layer with Feng's brilliant Asian sensibility combined with a sportswear pragmatism. Her serene wrap dressing is as practical as Claire McCardell, but as elegant and resolved as Madame Grès. Feng always begins with the fabric, letting the waft of chiffon or organza or the drape of jersey take its own, self-fulfilling form on the body. Feng is known for being an extraordinary cook for dishes Asian and American, and her fashion works in the same way: it enhances the ingredients and lets the endemic elements express themselves.

Crushed red velvet cape*
MODEL: Julie Chaikosky/Karin Models NYC
HAIR: Matthew Williams/Trilese
MAKEUP: Todra Payne/ARTISTS by Timothy Priano
STYLIST: Nolé Marin for Trilese

Italy has long had mosaics and intarsia work; since 1953, it has had knits by **MISSONI,** an art in its own right. Ottavia and Rosita Missoni founded the company now run by their children, with Angela Missoni in charge of design. It reports an excess of $200 million in worldwide sales. Hebe Dorsey reported in *The International Herald Tribune* in 1974, "The Missonis do what only the great designers know how to do: they make a style and work on it, improving it instead of changing it at every season." Weathering seasons of intense interest and some of disinterest, a dynastic tradition continually cultivates its archetype and its production. The result is pure Missoni of a new generation for a new generation.

Black-and-white geometric wrap
MODEL: Carla Phillips/NY Models
HAIR: Patricia Morales
MAKEUP: Davide/Next
STYLIST: Antonio Branco/Trilese

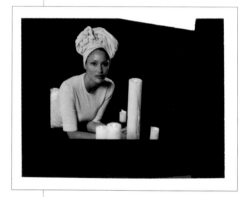

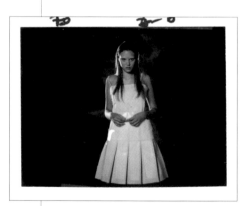

There was a time when **MICHAEL KORS** seemed the most underestimated designer on Seventh Avenue. David Cameron, Isaac Mizrahi, and Michael Leva handily won prizes and adulation; Kors just kept on working. Now, that tortoise has won a plum job designing for **CELINE** in Paris as well as the esteem of all of New York. His sexy, well-cut leather skirts, smart tops, and chic jackets are no longer confused for Donna Karan's—Michael Kors has finally come into his rightful place as one of America's best young designers. His receipt of the 1999 CFDA award for womenswear has definitively established this position. His eye is on the client, his mother's friends, the girls he knows, but it is a brilliant, assaying eye. It's an eye that's on the prize, not on the glitz.

Cashmere voile T-shirt with matching pareo and chocolate brown thongs
MODEL: Brenda Schad/Elite NYC
HAIR: Matthew Willams/Trilese
MAKEUP: Todra Payne/ARTISTS by Timothy Priano
STYLIST: Nolé Marin for Trilese

The leather and luxury-goods firm of **PRADA** founded in Milan in 1913 has been expanded by Miuccia Prada, granddaughter of the founder. Distinctive, often provocative, collections have given Prada runway cachet and a special identity with artists and designers, though much of the business remains in accessories. Innovative materials are a company hallmark, the greatest success having been the black nylon Prada bag (and backpack) popular in the 1970s and ubiquitous in the 1980s. As many have remarked, the exceptional profit on these expensive nylon bags could keep the runway creative and experimental for many years.

White plastic tank with matching reflective pleated skirt and red-and-white patent ankle-strap platforms
MODEL: Elizora/IMG Models NYC
HAIR: Yusuke/ARTISTS by Timothy Priano
MAKEUP: Todra Payne/ARTISTS by Timothy Priano
STYLIST: Nolé Marin for Trilese
LOCATION: The Pierre Hotel (Thank you Jessica Rogers)

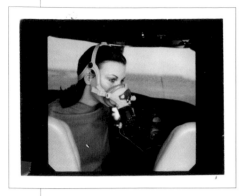

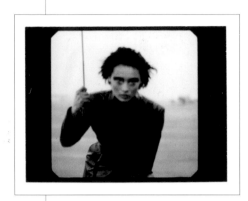

Though born in South Africa, **MARK EISEN** is the embodiment of a southern Californian. His spare practical clothing is supremely body-conscious; you almost have to own a convertible and a beach house to wear his clothing. His ethos of relaxed clothing is given another California interpretation for evening when Eisen trades the sun-drenched for the glamour-laden images of rock and Hollywood, again with strong notes of sensuality. His secondary line, Urchin, launched in 1996 with a strong emphasis on knits, demonstrates Eisen's new and broader outreach in geography: these are easily New York, Chicago or, even Paris clothes.

Charcoal mohair sweater with mist stretch flannel cape and pants*
MODEL: Sterling Knight/Boss Models NYC
HAIR AND MAKEUP: Alberto Luengo/ARTISTS by Timothy Priano
PRODUCER: David Goldsmith
LOCATION: Allaire Airport, Farmington, NJ
TRANSPORTATION: Anton Matos for Industry Productions
PILOT: Art Penrose

Subject of the *Time* (August 24, 1998) feature headlined "The Anti-Calvin is Here," **JOHN BARTLETT** is the brilliant young American designer designing not only for his own label, but also for Byblos in Italy. His meteoric rise in menswear in the 1990s was due chiefly to the clothes, intellectually conceived and sensuously expressed, both novelties for the field. Now in womenswear as well, his clothing is decisive and distinctive, already a sign for thinking clients, whether they be young men or women. Breaking the rules by starting in menswear and by putting out an avant-garde signature, Bartlett is cannily achieving mainstream recognition.

Camouflage leather coat with matching boots
MODEL: Jasmine Taylor/Company Management NYC
HAIR AND MAKEUP: Alberto Luengo/ARTISTS by Timothy Priano
PRODUCER: David Goldsmith
LOCATION: Allaire Airport, Farmington, NJ
TRANSPORTATION: Anton Matos for Industry Productions
PILOT: Art Penrose

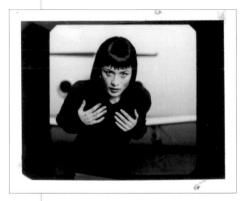

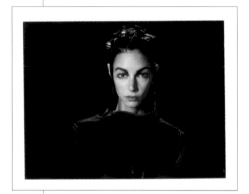

Malyasian-born **YEOHLEE** works in New York, but she could be working in a clinical laboratory anywhere in the world. Her clothes are always about problem-solving, rational responses to the dissatisfactions and oddity of dress. Keenly analytical, Yeohlee considers fashion as puzzles accorded to behaviors and bodies, cloth and wrapping. She has the soul of a philosopher, but the hands of an artisan. Rich materials are efficiently used in Yeohlee's no-waste, no-nonsense system—unusual in its respect for fashion. Amidst luxury materials, Yeohlee is the chaste scholar, never cutting if not necessary and using every scrap of fabric available.

Pinstripe suit with high raglan armholes*
MODEL: Jasmine Taylor/Company Management NYC
HAIR AND MAKEUP: Alberto Luengo/ARTISTS by Timothy Priano
PRODUCER: David Goldsmith
LOCATION: Allaire Airport in Farmington, NJ
TRANSPORTATION: Anton Matos for Industry Productions
PILOT: Art Penrose

When she won the CFDA's 1996 Perry Ellis Award for Womenswear, **DARYL K.** could have gone from "downtown" to "uptown" in a flash. But Daryl Kerrigan is intractably a designer of "downtown," watching the club scene, the street, and all kinds of cultural mixing. Of her famous hip-huggers, she found her originals in an abandoned South Bronx warehouse and tailored them to fit her. Her bodices—often shrunken with exposed midriff, sometimes slashed—are equally easy and reminiscent of the sleazy early 1970s. Kerrigan has become indicative of those fashion designers in the 1990s who have chosen to stay small and disestablishment, avoiding the pitfalls of Seventh Avenue boom or bust.

Black wool dress with geometric cutouts*
MODEL: Stacey Ness/Elite NYC
HAIR AND MAKEUP: Joe J. Simon

* THE FOLLOWING GARMENTS HAVE BEEN DESIGNED WITH LYCRA

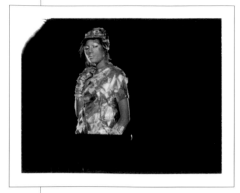

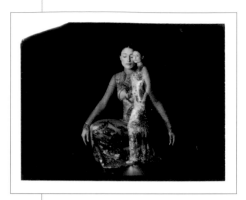

ISSEY MIYAKE, who started out in fashion by asking such fundamental questions as, "What constitutes clothing?" is today still pursuing those same provocative questions. They unfold from his pleated garments; they abide in every gesture of this talented artist. Since 1970, he has tested materials and preconceptions of fashion, yet this philosophical inquiry has never been scholastic or un-beautiful. Miyake's unerring instinct for beauty makes each question an elegant resolution. He is Leonardo da Vinci of our time—scientist, artist, and humanist.

Gold-covered camouflage suit, hat, and bag
MODEL: Fatim Kissa/Karin Models
HAIR: Gianluca Mandecci/ARTISTS by Timothy Priano
MAKEUP: Scott Barnes/Shu Vemary NYC

Ironically, **GIANFRANCO FERRE** is a designer of such prodigious talent that he will always be known best by his own label. Yet, he was behind some of the best dresses ever made by the House of Dior during his tenure there as couturier from 1989 to 1996. Ferre builds on his architectural training, cutting coats and blouses with a Balenciaga-like crispness and certainty and enjoying the harmonic measure of ready-to-wear garments in ensemble. Yet for all the rigor of his architectural background, Ferre is a fashion visionary and dreamer, piling luxuries into a dress and implying the transfigurations of Cinderella.

Long silk tulle dress with silver pailletes on the shoulder and fishtail
Silver helmet by Nicholas Verlaine
MODEL: Brenda Schad/Elite NYC
HAIR: Alberto Luengo/ARTISTS by Timothy Priano
MAKEUP: Todra Payne/ARTISTS by Timothy Priano

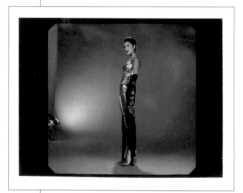

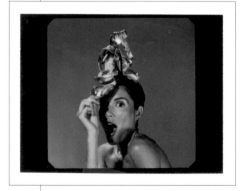

Domenico Dolce and Stefano Gabbana founded their business **DOLCE & GABBANA** in 1982; since then, they have followed the path of spectacle and sensuality to make noticeable clothing for women who wish to be noticed. Their inspiration is probably the unabashed sexuality of Italian movie heroines, voluptuous beauties such as Sophia Loren and Gina Lollabrigida, occasionally inflected by extravagant history, a cinematic costume drama of "corset movies." Flaunting glamour, Dolce & Gabbana excel in bold, sensual eveningwear and enjoy special favor with a Hollywood clientele, including Madonna.

Metallic silver corset and skirt with hand-painted flowers worn with black shawl with fringe*
MODEL: Siew Longhorn/Company Management NYC
HAIR AND MAKEUP: Joe J. Simon

In an era in which many accessories have been forsaken and others neglected, **MANOLO BLAHNIK** is now the foremost footwear designer in the tradition of Roger Vivier, letting shoes tell a story of their own or allowing them to confirm the ideas of a fashion designer. A charming raconteur in shoe leather and a teller of tales in footwear silhouettes, Blahnik makes expressive shoes. Blahnik shoes are characterized by Hockney-vivid color, texture that varies from leather to silk, and imagination. Little wonder that so many women of style refer, as if in one perfect and euphonious word, to "my-Manolo-Blahniks."

BRAZIL shoe: gunmetal napa stiletto sandal with velcro closures
MODEL: Siew Longhorn/Company Management NYC
HAIR AND MAKEUP: Joe J. Simon

* THE FOLLOWING GARMENTS HAVE BEEN DESIGNED WITH LYCRA

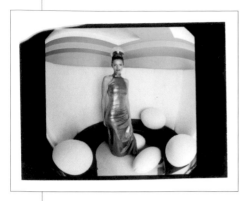

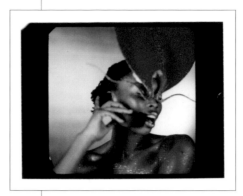

Too often regarded only as a "phenomenon," **TOMMY HILFIGER** has emerged as one of the leading lifestyle designers of the 1990s by unstinting principles of bold, vivid design and conspicuous value and quality. In an era when designer names were more than enough to sell clothing, Hilfiger kept insisting on showing the consumer quality points in the product. Perhaps it was necessary for Hilfiger to stress value to achieve his position on American fashion's Olympus and his faithful following across his fashion consumers—notably from urban youth to middle-class America. However, now that position is essential to the designer's identity and one of his chief distinctions from his designer colleagues.

Metallic silver sleeveless stretch gown with a high slit*
MODEL: Heather Stewart-Whyte/ Monique Pillard, Elite Celebrities
HAIR: Alberto Luengo/ARTISTS by Timothy Priano
MAKEUP: Alberto Luengo/ARTISTS by Timothy Priano
LOCATION: Cafeteria Restaurant, 119 7th Avenue, NYC (Thank you Adam Newton and colleagues)
STYLIST: Alexander Guiterrez

Jewelry, watches, the tabletop, and the desktop are all product areas for **BULGARI** today, a company founded by the Greek-born Sotirio Bulgari, a master silversmith, who established the family business in Rome. The credo of the firm is that it is built upon silver, gold, and precious jewels and that anything produced by Bulgari must be of equal excellence "from the least expensive object to the most precious."

Cellular phone cuff bracelet
MODEL: Phina Oruche/Elite NYC
MAKEUP: Joe J. Simon
STYLIST: Alexander Gutierrez
GOLD TOP: Richard Singh

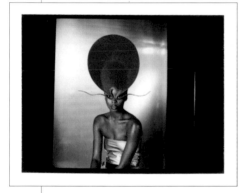

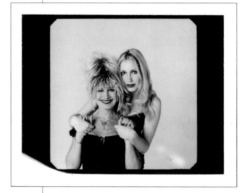

PHILIP TREACY makes hats, but the hats are fanciful sculptures and their role is more like magical crowns and tiaras than hats. Brilliantly resourceful, Treacy invents subjects of all kinds. In a largely hat-less epoch, Treacy gives good reason for the return of the hat not as a pedestrian accessory, but as radiant flourish. Thus, Treacy's millinery imaginings appear on fashion runways as well as at the races and the best parties.

Red glitter Roswell hat*
MODEL: Phina Oruche/Elite NYC
MAKEUP: Joe J. Simon
STYLIST: Alexander Gutierrez
GOLD TOP: Richard Singh

BETSEY JOHNSON designs for the uninhibited, nonconformist woman who, like the designer, refuses to grow up and revels in an animated fashion akin to Pop Art, which is Johnson's point of intersection with mentor Andy Warhol. T-shirt dresses, do-it-yourself clothes, and sparkling materials blast from Johnson's imagination in a colorful explosion like that of a confetti cannon. The only sign of age is that she now splits design duties with her daughter **LULU**.

On Betsey: Black three-tiered cotton full circle petticoat with cotton off-the-shoulder lace-up top and hook-and-eye waist cincher.* Worn with hot pink rubber nylon boots.
On Lulu: Black silk georgette ULTRA bias slip dress with rhinestone detail and "Cholita" slides*
MODELS: Betsey and LuLu Johnson
HAIR: Alberto Luengo/ARTISTS by Timothy Priano
MAKEUP: Alberto Luengo/ARTISTS by Timothy Priano
STYLIST: Alexander Gutierrez

| ABOUT THE AUTHORS

Trudy Schlachter is an award-winning photographer and creative director of her own agency, Inventive Eye Ltd. For the past 15 years, she has shot photography for fashion advertising campaigns, celebrity portraits, album covers, and books. Her work has appeared in *Harper's Bazaar*, *Vogue*, *Elle*, *Vanity Fair*, and *Fashion of the Times*. She has received creativity awards from *Communication Arts* magazine and the Art Directors Club. She has also been the photographer for many books, including *The Elegant Epergne* (1995). Trudy has three sons, and resides with her husband in New York City.

Roberta Wolf is a freelance public relations and special events consultant. She began her career at the William Morris Agency, and was a vice president of advertising, publicity, and licensing for the Albert Nipon Co. for twelve years. She serves on the boards of the Mount Sinai Breast Health Resource Center, the Hamptons International Film Festival, and Concerned Parents for AIDS in addition to planning major events for these organizations. Roberta has two sons and resides in New York City with her husband and their shar-pei, Irving.